ART HISTORY
Selected Readings

Brucia Witthoft

Framingham State College

Prentice-Hall Englewood Cliffs, N.J. 07632

Library of Congress Cataloging in Publication Data
Main entry under title:

ART HISTORY.

Includes bibliographical references and index.
1. Art—History—Addresses, essays, lectures.
I. Witthoft, Brucia
N5303.A75 1986 709 85-25645
ISBN 0-13-047176-3

Editorial/production supervision
 and interior design by Eva Jaunzems
Cover design by George Cornell
Manufacturing buyer: Harry P. Baisley

Printed in the United States of America

10 9 8 7 6 5 4 3 2 1

0-13-047176-3 01

Prentice-Hall International (UK) Limited, *London*
Prentice-Hall of Australia Pty. Limited, *Sydney*
Prentice-Hall of Canada Inc., *Toronto*
Prentice-Hall of Hispanoamericana, S.A., *Mexico*
Prentice-Hall of India Private Limited, *New Delhi*
Prentice-Hall of Japan, Inc., *Tokyo*
Prentice-Hall of Southeast Asia Pte. Ltd., *Singapore*
Editora Prentice-Hall do Brasil, Ltda., *Rio de Janeiro*
Whitehall Books Limited, *Wellington, New Zealand*

To my teachers:
especially, in memoriam, *Henry Rago*

CONTENTS

ART HISTORY

Selected Readings

ILLUSTRATIONS

PREFACE

ONE OF THE PLEASURES OF STUDYING the history of art is discovering the many different kinds of investigation art historians perform. This book has been assembled to provide a sample of some of the approaches to the subject, drawn largely from important sources and from examples of innovative research techniques. These selections are intended to accompany college courses surveying the history of western art. Rather than trying to provide an essay for each topic usually covered in such courses, however, my primary aim has been to present readings that develop critical and analytical skills and that expose students to a wide, even eclectic, variety of material.

The selections range from examples of ancient literature to the words of twentieth-century art historians. Included are writings that change the accepted view of styles or periods, and writings that reflect the view of ages past; literature that inspired works of art, and literature inspired by an artist; iconographic analyses as practiced by skilled modern thinkers, and an excerpt from a Medieval chronicle. The problem of artistic style is treated in works by both historians and critics. The social history of art is considered in selections written by academic historians but is also reflected in popular journalism.

I have drawn the theme that links these diverse materials from Baudelaire's critical insight. That the work of art conforms to a style delimited by the time, place, and culture from which it comes is a cornerstone of

art historical methods. The fact that perceptions of style and purpose are deeply affected by the time, place, and culture of the perceiver is equally important. Baudelaire's remark that "nearly all our originality comes from the stamp that time impresses upon our sensibility" applies not only to the artist but also to the interpreter of art. These selections provide opportunities for the reader to compare studies contemporary with the works they discuss to studies made from the perspective of centuries. The experience is meant to help students become aware of the way contemporary values influence their picture of the past.

Each selection is accompanied by its own introduction, which aims to answer some questions of fact or context that may not be familiar, and to point out some of the ideas the reader will encounter in the essay. Some selections needed more explication than others; the length of the introductions varies accordingly. Readings are arranged to approximate the order of topics in most textbooks. The selection from the Bible is placed just before the essay on Early Christian art, but it is assumed that students will return to it when studying Medieval topics and Renaissance and Baroque art.

After choosing the works included, I understood why anthologists often feel a need to apologize for what they leave out. My selections were limited by considerations of space and of balance as well as by the need to choose only writings that could present some significant idea in short form. Needless to say I also apologize for any important writings that I have left out because of the limits of my own knowledge. Friends and colleagues generously helped to compensate for some of the gaps in my own resources. But in any case, this volume is not intended to substitute for a comprehensive history. It is meant to provide a set of interesting, useful readings for beginners to cut their teeth on.

* * *

Most of the essays that follow have been abridged. When the selection chosen dealt with only part of the author's original argument, I have given the excerpt a new title to distinguish it from the complete work. Illustrations have been included when they seemed essential to the argument. If it seemed likely that a suitable visual reference would appear in the survey texts with which this anthology will be used, then no additional picture was provided. Authors' footnotes have frequently been renumbered, both because notes to sections not reprinted are omitted and because I have supplied some additional explanatory notes. The latter bear my initials.

I am grateful for the suggestions and comments of friends and colleagues, particularly Professor Liana Cheney and Professor Leah Lipton. I sincerely thank the authors and publishers who kindly consented to my reproducing these essays. My students at Framingham State College

willingly read and criticized preliminary selections. Judy Grande and her word processor turned my manuscript into legible form. Eva Jaunzems at Prentice-Hall edited portions of the text and supervised production. The index was efficiently prepared by Marilyn Flaig.

B.W.

1

Howard Carter

THE DISCOVERY
OF TUTANKHAMEN'S
TOMB

"EITHER OPENLY OR SECRETLY the world loves Romance," wrote Lord Carnarvon's sister in a short sketch of his life at the beginning of *The Tomb of Tut·Ankh·Amen*. Romance, adventure, and the thrill of discovery certainly were an important part of early excavations in Egypt, and the magic of that long-ago civilization still arouses feelings of wonder today. Every grade-school trip to a large museum demonstrates the appeal of the mummies to children as well as adults. Egypt's exceptionally dry climate preserved rich evidence of the life and art of her ancient inhabitants, and the discoveries of modern Egyptologists dramatically reveal that past to the present. When man someday receives evidence of intelligent life in outer space, the long-traveled relics of other worlds will no doubt arouse similar feelings.

By chance, the Tomb of "King Tut" was nearly undisturbed until it was found in 1922. Its discoverers were two very different men. The fifth earl of Carnarvon was an Englishman of great wealth whose interest in collecting art and antiques developed before he was out of his teens. Carnarvon never graduated from college, nor did he ever work at any regular profession. He was an adventurer who had sailed a private yacht almost around the world and had hunted big game before becoming interested in Egypt in his forties. Carter, on the other hand, was the child of a middle-class English Victorian painter. His talent for drawing was apparent in his youth. In 1890, at the age of 17, he was hired to draw Egyptian antiquities for an archaeological expedition.

The two men met about 1905. Carnarvon was a man with a passion for Egyptology; Carter, a trained excavator, was fitted by experience and

personality to lead an excavation team. Carnarvon financed Carter's expeditions, and Carter assembled a crew and set to work.

By 1922 Carter had been working for six years in the "Valley of the Kings" near Thebes, turning over the earth and discovering one almost empty tomb after another. Carnarvon had already spent nearly £20,000 (the equivalent today of close to a million dollars), with almost nothing to show for his money. The digging season began with a gloomy forecast: Carnarvon declared that he could no longer pay for Carter's expensive and fruitless efforts. In fact, Carter had had a hard time convincing his backer to pay for the 1922–1923 trip.

Carter's excavation methods lay on the boundary between the old "treasure hunting" mentality and modern scientific archaeology. Egyptian explorers in the early nineteenth century had behaved rather like gold rush prospectors: Carter wrote of them (Ch. 11, p. 108): "Anything to which a fancy was taken, from a scarab to an obelisk, was just appropriated, and if there was a difference of opinion with a brother excavator one laid for him with a gun." But despite his eager desire to find "wonderful things," Carter worked with all the care and science at his command. He wrote (Ch. 8, p. 178):

> *The things [the archaeologist] finds are not his own property, to treat as he pleases, or neglect as he chooses. They are a direct legacy from the past to the present age, he but the privileged intermediary through whose hands they come: and if, by carelessness, slackness, or ignorance, he lessens the sum of knowledge that might have been obtained from them, he knows himself to be guilty of an archaeological crime of the first magnitude.*

One of the purposes of this anthology is to demonstrate the difference between primary and secondary sources. Primary sources are documents contemporary with the works or events they concern. Secondary sources are later interpretations. Sometimes the question is easily resolved. Homer (Chapter 3) is clearly a primary source for ancient art, Carpenter's analysis of the construction of the Parthenon (Chapter 4) a secondary source. But what about this selection? It is a primary source in one sense, a secondary source in another.

The discovery of Tut's Tomb created immediate worldwide excitement. As soon as the tomb was opened it was reported in newspaper headlines that fed the public hunger for sensation. One result of this was the arrival of large numbers of tourists who virtually camped around the site, waiting to see fresh finds as they were carried out from underground. (An exhibit of the tomb's contents, which traveled to America in 1977, caused a similar outpouring of public interest.) Carter's account of his researches, from which this chapter is excerpted, was doubtless motivated by the demand for information. The sudden tragic death of Lord Carnarvon perhaps made the volume something of a memorial as well. Writing for the general public, Carter combined both a sense of his personal emotions and actions with good, sound advice on what archaeologists should do in field work.

From

The Tomb of Tut·Ankh·Amen

This was to be our final season in The Valley. Six full seasons we had excavated there, and season after season had drawn a blank; we had worked for months at a stretch and found nothing, and only an excavator knows how desperately depressing that can be; we had almost made up our minds that we were beaten, and were preparing to leave The Valley and try our luck elsewhere; and then—hardly had we set hoe to ground in our last despairing effort than we made a discovery that far exceeded our wildest dreams. Surely, never before in the whole history of excavation has a full digging season been compressed within the space of five days. . . .

I arrived in Luxor on October 28th, and by November 1st I had enrolled my workmen and was ready to begin. Our former excavations had stopped short at the north-east corner of the tomb of Rameses VI, and from this point I started trenching southwards. It will be remembered that in this area there were a number of roughly constructed workmen's huts, used probably by the labourers in the tomb of Rameses. . . . By the evening of November 3rd we had laid bare a sufficient number of these huts for experimental purposes, so, after we had planned and noted them, they were removed, and we were ready to clear away the three feet of soil that lay beneath them.

Hardly had I arrived on the work next morning (November 4th) than the unusual silence, due to the stoppage of the work, made me realise that something out of the ordinary had happened, and I was greeted by the announcement that a step cut in the rock had been discovered underneath the very first hut to be attacked. This seemed too good to be true, but a short amount of extra clearing revealed the fact that we were actually in the entrance of a steep cut in the rock, some thirteen feet below the entrance to the tomb of Rameses VI, and a similar depth from the present bed level of The Valley. . . . Work continued feverishly throughout the whole of that day and the morning of the next, but it was not until the afternoon of November 5th that we succeeded in clearing away the masses of rubbish

Howard Carter and A. C. Mace, *The Tomb of Tut·Ankh·Amen, Discovered by the Late Earl of Carnarvon and Howard Carter* (New York: George H. Doran Company, 1923). Excerpts from Chapter V, "The Finding of the Tomb."

that overlay the cut, and were able to demarcate the upper edges of the stairway on all its four sides. . . . It was with ill-suppressed excitement that I watched the descending steps of the staircase, as one by one they came to light. The cutting was excavated in the side of a small hillock, and, as the work progressed, its western edge receded under the slope of the rock until it was, first partially, and then completely, roofed in, and became a passage, 10 feet high by 6 feet wide. Work progressed more rapidly now; step succeeded step, and at the level of the twelfth, towards sunset, there was disclosed the upper part of a doorway, blocked, plastered, and sealed. . . .

It was a thrilling moment for an excavator. Alone, save for my native workmen, I found myself, after years of comparatively unproductive labour, on the threshold of what might prove to be a magnificent discovery. Anything, literally anything, might lie beyond that passage, and it needed all my self-control to keep from breaking down the doorway, and investigating then and there. . . .

One thing puzzled me, and that was the smallness of the opening in comparison with the ordinary Valley tombs. The design was certainly of the Eighteenth Dynasty. Could it be the tomb of a noble buried here by royal consent? Was it a royal cache, a hiding-place to which a mummy and its equipment had been removed for safety? Or was it actually the tomb of the king for whom I had spent so many years in search?

Once more I examined the seal impressions for a clue, but on the part of the door so far laid bare only those of the royal necropolis seal . . . were clear enough to read. Had I but known that a few inches lower down there was a perfectly clear and distinct impression of the seal of Tut·ankh·Amen, the king I most desired to find, I would have cleared on, had a much better night's rest in consequence, and saved myself nearly three weeks of uncertainty. It was late, however, and darkness was already upon us. With some reluctance I re-closed the small hole that I had made, filled in our excavation for protection during the night, selected the most trustworthy of my workmen—themselves almost as excited as I was—to watch all night above the tomb, and so home by moonlight, riding down The Valley.

Naturally my wish was to go straight ahead with our clearing to find out the full extent of the discovery, but Lord Carnarvon was in England, and in fairness to him I had to delay matters until he could come. Accordingly, on the morning of November 6th I sent him the following cable:— "At last have made wonderful discovery in Valley; a magnificent tomb with seals intact; re-covered same for your arrival; congratulations." . . . On the 8th I had received two messages from Lord Carnarvon in answer to my cable, the first of which read, "Possibly come soon," and the second, received a little later, "Propose arrive Alexandria 20th." . . .

. . . On the night of the 18th I went to Cairo for three days, to meet Lord Carnarvon and make a number of necessary purchases, returning to

Luxor on the 21st. On the 23rd Lord Carnarvon arrived in Luxor with his daughter, Lady Evelyn Herbert, his devoted companion in all his Egyptian work, and everything was in hand for the beginning of the second chapter of the discovery of the tomb. Callender had been busy all day clearing away the upper layer of rubbish, so that by morning we should be able to get into the staircase without any delay.

By the afternoon of the 24th the whole staircase was clear, sixteen steps in all, and we were able to make a proper examination of the sealed doorway. On the lower part the seal impressions were much clearer, and we were able without any difficulty to make out on several of them the name of Tut·ankh·Amen. This added enormously to the interest of the discovery. If we had found, as seemed almost certain, the tomb of that shadowy monarch, whose tenure of the throne coincided with one of the most interesting periods in the whole of Egyptian history, we should indeed have reason to congratulate ourselves.

With heightened interest, if that were possible, we renewed our investigation of the doorway. Here for the first time a disquieting element made its appearance. Now that the whole door was exposed to light it was possible to discern a fact that had hitherto escaped notice—that there had been two successive openings and re-closings of a part of its surface. . . . The tomb then was not absolutely intact, as we had hoped. Plunderers had entered it, and entered it more than once—from the evidence of the huts above, plunderers of a date not later than the reign of Rameses VI—but that they had not rifled it completely was evident from the fact that it had been re-sealed.[1] . . .

On the morning of the 25th the seal impressions on the doorway were carefully noted and photographed, and then we removed the actual blocking of the door, consisting of rough stones carefully built from floor to lintel, and heavily plastered on their outer faces to take the seal impressions.

This disclosed the beginning of a descending passage (not a staircase), the same width as the entrance stairway, and nearly seven feet high. As I had already discovered from my hole in the doorway, it was filled completely with stone and rubble, probably the chip from its own excavation. . . .

As we cleared the passage we found, mixed with the rubble of the lower levels, broken potsherds, jar sealings, alabaster jars, whole and broken, vases of painted pottery, numerous fragments of smaller articles, and water skins, these last having obviously been used to bring up the water needed for the plastering of the doorways. These were clear evidence of

[1] From later evidence we found that this re-sealing could not have taken place later than the reign of Hor·em·heb, i.e. from ten to fifteen years after the burial.

plundering, and we eyed them askance. By night we had cleared a considerable distance down the passage, but as yet saw no sign of second doorway or of chamber.

The day following (November 26th) was the day of days, the most wonderful that I have ever lived through, and certainly one whose like I can never hope to see again. Throughout the morning the work of clearing continued, slowly perforce, on account of the delicate objects that were mixed with the filling. Then, in the middle of the afternoon, thirty feet down from the outer door, we came upon a second sealed doorway, almost an exact replica of the first. The seal impressions in this case were less distinct, but still recognisable as those of Tut·ankh·Amen and of the royal necropolis. Here again the signs of opening and re-closing were clearly marked upon the plaster. We were firmly convinced by this time that it was a cache that we were about to open, and not a tomb. The arrangement of stairway, entrance passage and doors reminded us very forcibly of the cache of Akh·en·Aten and Tyi material found in the very near vicinity of the present excavation by Davis, and the fact that Tut·ankh·Amen's seals occurred there likewise seemed almost certain proof that we were right in our conjecture. We were soon to know. There lay the sealed doorway, and behind it was the answer to the question.

Slowly, desperately slowly it seemed to us as we watched, the remains of passage debris that encumbered the lower part of the doorway were removed, until at last we had the whole door clear before us. The decisive moment had arrived. With trembling hands I made a tiny breach in the upper left hand corner. Darkness and blank space, as far as an iron testing-rod could reach, showed that whatever lay beyond was empty, and not filled like the passage we had just cleared. Candle tests were applied as a precaution against possible foul gases, and then, widening the hole a little, I inserted the candle and peered in, Lord Carnarvon, Lady Evelyn and Callender standing anxiously beside me to hear the verdict. At first I could see nothing, the hot air escaping from the chamber causing the candle flame to flicker, but presently, as my eyes grew accustomed to the light, details of the room within emerged slowly from the mist, strange animals, statues, and gold—everywhere the glint of gold. For the moment—an eternity it must have seemed to the others standing by—I was struck dumb with amazement, and when Lord Carnarvon, unable to stand the suspense any longer, inquired anxiously, "Can you see anything?" it was all I could do to get out the words, "Yes, wonderful things." Then widening the hole a little further, so that we both could see, we inserted an electric torch.

2

Sir Leonard Woolley

THE "ROYAL TOMBS" OF UR

THE CITY OF UR IS ONE OF THE MOST dramatic discoveries of modern archaeology. Woolley's excavations at the site in Iraq, which he identified with the Biblical Ur, revealed that a sophisticated urban culture had existed in the Near East—in what today looks like barren desert—at least as early as the time of the pyramids in Egypt. The splendid works Woolley recovered from the tombs of kings and queens of the city include the "Standard of Ur"; a magnificent bull-headed harp inlaid with mosaics that look like scenes from Aesop's fables; a statuette of a ram standing on his hind legs to nibble foliage in a thicket; a queen's headdress; and countless other works of jewelry and decorative art. These objects were made between 2700 and 2500 B.C.

Woolley began his work in 1922 and found the objects mentioned here during the 1927–1928 season while excavating the "Royal Cemetery." The finds are divided among museums in Iraq, in London, and at the University of Pennsylvania. Queen Puabi's headdress and a beautiful harp are among the objects in the University of Pennsylvania Museum, where they were reinstalled in 1983 after thirty years in storage.

Woolley wrote an account of his excavations at Ur in 1929 as a way of introducing the public to the discoveries he had made. (The official scholarly publication of his work is L. Legrain and C. L. Woolley, *Ur Excavations*, Volume II, *The Royal Cemetery*, London, 1934). A number of Woolley's conclusions about his discoveries were contested by other scholars. Some of the questions they raised were discussed in Woolley's revised study, pub-

lished in 1954. In 1982 P. R. S. Moorey edited the work once more, taking account of recent scholarship. Perhaps the most striking difference from the original is Moorey's greater caution in drawing conclusions.

Woolley had what his modern editor calls a "vivid historical imagination," a quality that can be both a virtue and a liability. It is Woolley's ability to bring the past to life and to paint vivid word-pictures that makes his writing communicate so well. However, imaginative guesses need to be carefully separated from proof. The modern edition preserves Woolley's enthusiasm but modifies his conclusions where necessary.

In the selection that follows, Woolley began by describing and listing what he actually found. (His ample description has been shortened for inclusion here.) He then proceeded to demonstrate two important aspects of the archaeologist's work. After the objects have been discovered, dug up, and dusted off, what then? The archaeologist must interpret his finds. Woolley shows us how to "read" ritual from things found in the ground. What actually happened at a royal funeral? The arrangement of objects, bones, and bricks tells a story.

In comparison to the appearance of culture and sophistication that the beautifully crafted art suggests, the ritual itself seems very remote from our way of life. It is a shock to find ourselves confronting human sacrifice apparently freely accepted by the victims. Woolley had an eye for the dramatic way of telling his tale: the story of the girl who was literally late for her own funeral provides an example of his talent for writing as well as of his archaeological skills. The analysis of the actual burial ritual seems incontrovertible. We can follow the events of the funeral—although it is hard to say whether they took place over a few days, weeks, or an even longer span—without doubting Woolley's conclusions.

The greatest controversy arose over the meaning of the tombs. As soon as Woolley's first version appeared, other archaeologists challenged his view that the tombs he found belonged to kings and queens of Ur. Some of these scholars pointed to the differences among the various "royal" tombs and to the lack of any proof that the bodies within belonged to rulers. Others suggested that the tombs belonged, instead, to special sacrificial victims.

Societies based on an agricultural economy often include among their religious beliefs the idea of a king or god who dies each spring and then returns to life, like dormant seeds that spring up green and fresh each year. In many cultures the sacrificial death is reenacted annually. There are numerous examples of ancient cultures whose people actually dressed a victim in the costume of a ruler, allowed him to "rule" over a festival, and then put him to death. Such ceremonies are designed to renew the fertility of the earth by a kind of magical imitiation of nature's processes.

At the time Woolley wrote, no account of Sumerian funeral practices was known. Moorey's edition summarizes the one fragmentary text (originally published by S. Kramer, "The Death of Gilgamesh," *Bulletin of the American Schools of Oriental Research,* No. 94, [April 1944]), which may tell us something about royal funerals. Woolley's problem is one that archae-

ologists must often face. The record from the earth does not tell us everything we want to know. Even in the case of literate societies, like that of Ur, the written record does not always explain what the archaeologist finds in the ground. How is he to draw a balance between imagination and caution?

From
Ur "of the Chaldees"

... at the beginning of 1927, we started to dig the cemetery. As we found out, there were really two cemeteries, one above the other, belonging to different periods. The upper graves were dated by inscriptions on cylinder seals to the time of Sargon of Akkad and his dynasty; those will be described later. Below them, dug into the rubbish-mounds which lay outside the Sacred Area, was what we call "The Royal Cemetery." . . .

The burials were of two sorts, the graves of the common folk and the tombs of rulers; of the former we cleared about two thousand, and of the later sixteen were more or less preserved. . . .

There were sixteen "royal" graves found in the cemetery, and although no two of them were exactly alike, yet they all shared certain characteristics which set them altogether apart from the ordinary graves. The dead was laid not merely in a coffin but in a built tomb of stone or of stone and burnt or mud-brick—it might be a single chamber or it might be a more elaborate structure with several rooms. The ritual of burial included human sacrifice; the number of victims might vary from a mere half-dozen to seventy or eighty, but a certain number had to accompany the owner of the tomb. The refilling of the tomb-shaft was not a simple matter of throwing back the earth; it was a long-drawn ceremony involving elaborate rites. . . .

In that season, . . . digging in another part of the cemetery area, we came upon five bodies lying side by side in a sloping trench; except for the copper daggers at their waists and one or two small clay cups they had none of the normal furniture of a grave and the mere fact of there being a number thus together was unusual. Then, below them, a layer of matting was found, and tracing this along we came to another group of bodies, those of ten women carefully arranged in two rows; they wore head-dresses of gold, lapis lazuli, and carnelian,[1] and elaborate bead necklaces, but they

P. R. S. Moorey, *Ur "of the Chaldees"* (Ithaca, N.Y.: Cornell University Press, 1982), a revised and updated edition of Sir Leonard Woolley's *Excavations at Ur*. Excerpts from the chapter "The 'Royal' Tombs of the Early Dynastic Period, c. 2600–2450 B.C.," pp. 51–103. Reprinted by permission of Dr. P. R. S. Moorey.
[1]Lapis lazuli: a bright-blue stone used in jewelry and pigments. Carnelian: a reddish stone (a form of chalcedony). [BW]

too possessed no regular tomb furnishings. At the end of the row lay the remains of a wonderful lyre, the wood of it decayed but its decoration intact, making its reconstruction only a matter of care; the upright wooden beam was capped with gold, and in it were fastened the gold-headed nails which secured the strings; the sounding-box was edged with a mosaic in red stone, lapis lazuli, and white shell, and from the front of it projected a splendid head of a bull wrought in gold with eyes and beard of lapis lazuli; across the ruins of the lyre lay the bones of the gold-crowned harpist.

By this time we had found the earth sides of the pit in which the women's bodies lay and could see that the bodies of the five men were on the ramp which led down to it. Following the pit along, we came upon more bones which at first puzzled us by being other than human, but the meaning of them soon became clear. A little way inside the entrance to the pit stood a wooden sledge chariot decorated with red, white, and blue mosaic along the edges of the framework and with golden heads of lions having manes of lapis lazuli and shell on its side-panels In front of the chariot lay the crushed skeletons of two oxen with the bodies of the grooms by their heads, and on the top of the bones was the double ring, once attached to the pole, through which the reins had passed; it was of silver, and standing on it was a gold "mascot" in the form of a donkey most beautifully and realistically modelled.

Close to the chariot were an inlaid gaming-board and a collection of tools and weapons, including a set of chisels and a saw made of gold. . . .
. . . The perplexing thing was that with all this wealth of objects we had found no body so far distinguished from the rest as to be that of the person to whom all were dedicated; logically our discovery, however great, was incomplete.

The objects were removed and we started to clear away the remains of the wooden box, a chest some 6 feet long and 3 feet across, when under it we found burnt bricks. They were fallen, but at one end some were still in place and formed the ring-vault of a stone chamber (RT789). The first and natural supposition was that here we had the tomb to which all the offerings belonged, but further search proved that the chamber was plundered, the roof had not fallen from decay but had been broken through, and the wooden box had been placed over the hole as if deliberately to hide it. Then, digging round the outside of the chamber, we found just such another pit as that 6 feet above. At the foot of the ramp lay six soldiers, orderly in two ranks, with copper spears by their sides and copper helmets crushed flat on the broken skulls; just inside, having evidently been backed down the slope, were two wooden four-wheeled wagons each drawn by three oxen—one of the latter so well preserved that we were able to lift the skeleton entire; . . .

Against the end of the stone chamber lay the bodies of nine women wearing the gala head-dress of lapis and carnelian beads from which hung

golden pendants in the form of beech leaves, great lunate ear-rings of gold, silver "combs" like the palm of a hand with three fingers tipped with flowers whose petals are inlaid with lapis, gold, and shell, and necklaces of lapis and gold; their heads were leaned against the masonry, their bodies extended on to the floor of the pit, and the whole space between them and the wagons was crowded with other dead, women and men, while the passage which led along the side of the chamber to its arched door was lined with soldiers carrying daggers, and with women. Of the soldiers in the central space one had a bundle of four spears with heads of gold, two had sets of four silver spears, and by another there was a remarkable relief in copper with a design of two lions trampling on the bodies of two fallen men which may have been the decoration of a shield.

On the top of the bodies of the "court ladies" against the chamber wall had been placed a wooden lyre, . . . by the side wall of the pit, also set on the top of the bodies, was a second lyre with a wonderful bull's head in gold, its eyes, beard, and horn-tips of lapis, and a set of engraved shell plaques not less wonderful; there are four of them with grotesque scenes of animals playing the parts of men, and while the most striking feature about them is that sense of humour which is so rare in ancient art, the grace and balance of the design and the fineness of the drawing make these plaques one of the most instructive documents that we possess for the appreciation of the art of early Sumer. . . .

The tomb-chamber of RT789 lay at the far end of an open pit; continuing our search behind it we found a second stone chamber (RT800) built up against it either at the same time or, more probably, at a later period. This chamber, roofed like the king's with a vault of ring arches in burnt brick, was the tomb of the queen to whom belonged the upper pit with its chariot and other offerings: her name, Puabi, was given us by a fine cylinder seal of lapis lazuli which was found in the filling of the shaft a little above the roof of the chamber and had probably been thrown into the pit at the moment when the earth was being put back into it. The vault of the chamber had fallen in, but luckily this was due to the weight of earth above, not to the violence of tomb-robbers; the tomb itself was intact.

At one end, on the remains of a wooden bier, lay the body of the queen, a gold cup near her hand; the upper part of the body was entirely hidden by a mass of beads of gold, silver, lapis lazuli, carnelian, agate, and chalcedony, long strings of which, hanging from a collar, had formed a cloak reaching to the waist. . . .

The head-dress whose remains covered the crushed skull was a more elaborate edition of that worn by the court ladies: its basis was a broad gold ribbon festooned in loops round the hair—and the measurement of the curves showed that this was not the natural hair but a wig padded out to an almost grotesque size; over this came three wreaths, the lowest hanging down over the forehead, of plain gold ring pendants, the second of beech

leaves, the third of long willow leaves in sets of three with gold flowers whose petals were of blue and white inlay; all these were strung on triple chains of lapis and carnelian beads. Fixed into the back of the hair was a golden "Spanish comb" with five points ending in lapis-centered gold flowers. Heavy spiral rings of gold wire were twisted into the side curls of the wig, huge lunate ear-rings of gold hung down to the shoulders, and apparently from the hair also hung on each side a string of large square stone beads with, at the end of each, a lapis amulet, one shaped as a seated bull and the other as a calf. Complicated as the head-dress was, its different parts lay in such good order that it was possible to reconstruct the whole and exhibit the likeness of the queen with all her original finery in place.

The discovery was now complete and our earlier difficulty was explained: RTs 789 and 800 were exactly alike, but whereas the former was all on one plane, the queen's tomb-chamber had been sunk below the general level of her grave-pit. Probably they were husband and wife: the king had died first and been buried, and it had been the queen's wish to lie as close to him as might be; for this end the grave-diggers had reopened the king's shaft, going down in it until the top of the chamber vault appeared; then they had stopped work in the main shaft, but had dug down at the back of the chamber a pit in which the queen's stone tomb could be built. But the treasures known to lie in the king's grave were too great a temptation for the workmen; the outer pit where the bodies of the court ladies lay was protected by 6 feet of earth which they could not disturb without being detected, but the richer plunder in the royal chamber itself was separated from them only by the bricks of the vault; they broke through the arch, carried off their spoil, and placed the great clothes-chest of the queen over the hole to hide their sacrilege.

No other explanation than this would account for the plundered vault lying immediately below the unplundered grave of the queen. And on this showing we have two almost identical burials, the sole difference being that in the queen's case the tomb-chamber is below the level at which the other victims lie, and for this too the sentimental motive is sufficient. What the two graves tell us is quite clear so far as it goes.

To begin with, a more or less rectangular shaft was dug into the mixed soil of the rubbish-mounds to a depth of some 30 feet; at the top the shaft might measure as much as 45 feet by 30 feet; the earth walls were necessarily sloped but were kept as nearly vertical as might be, and on one side there was cut an entrance in the form of a steeply sloped or stepped passage running down from ground-level. On the bottom of the shaft, but occupying only a small part of its area, the tomb-chamber was built, with stone walls and brick vaulted roof and a door in one of the longer sides. The royal body was carried down the sloping passage and laid in the chamber. . . . Three or four of the personal attendants of the dead had their place with him or her in the tomb-chamber; . . . These attendants

must have been killed, or drugged into insensibility, before the door of the tomb-chamber was walled up. . . . The owner of the tomb was decked with all the finery befitting his station and with him in the chamber were set all such objects as we find in the graves of commoners, the only difference being that they are more numerous and of more precious material—the vessels for food and drink may be of gold and silver instead of clay—the attendants, on the other hand, while they wear what we may call their court dresses, are not laid out properly as for burial but are in the attitudes of those who serve, and they are unprovided with any grave equipment of their own; they are part of the tomb furniture.

When the door had been blocked with stone and brick and smoothly plastered over, the first phase of the burial ceremony was complete. The second phase, as best illustrated by the tomb of Puabi and by RT 789, was more dramatic. Down into the open pit, with its mat-covered floor and mat-lined walls, empty and unfurnished, there comes a procession of people, the members of the dead ruler's court, soldiers, men-servants, and women, the latter in all their finery of brightly coloured garments and head-dresses of carnelian and lapis lazuli, silver and gold, officers with the insignia of their rank, musicians bearing harps or lyres, and then, driven or backed down the slope, the chariots drawn by oxen, the drivers in the cars, the grooms holding the heads of the draught animals, and all take up their allotted places at the bottom of the shaft and finally a guard of soldiers forms up at the entrance. Each man and woman brought a little cup of clay or stone or metal, the only equipment needed for the rite that was to follow. There would seem to have been some kind of service down there, at least it is certain that the musicians played up to the last, then each of them drank from their cups a potion which they had brought with them or found prepared for them on the spot—in one case we found in the middle of the pit a great copper pot into which they could have dipped—and they lay down and composed themselves for death. . . . Earth was flung in from above, over the unconscious victims, and the filling-in of the grave-shaft was begun.

This account is based for the most part on the two tombs, RTs 789 and 800 (Puabi), which have been described in detail; the royal tombs, as I have said, differed a good deal one from another, but not to the extent that the account would not apply broadly to them all. Where the single built chamber was elaborated into a building containing several rooms and oc-cupying the whole area of the shaft, one of these was clearly the monarch's actual burial-chamber and the others were for the members of his court, taking the place of the open death-pit which is invariably associated with the single-chamber tombs; in one case the sacrifice of the human victims took place before even the tomb was prepared for the great dead, for the stone chamber was built on the earth which covered the bodies lying at the bottom of the mat-lined shaft, but normally the rite must have followed the

order described above. The best example of the death-pit was that of our royal grave RT 1237; the tomb-chamber had been completely destroyed by robbers, . . . but the death-pit was intact, . . . Six men-servants carrying knives or axes lay near the entrance, lined up against the wall; in front of them stood a great copper basin, and by it were the bodies of four women harpists, one with her hands still on the strings of her instrument. Over the rest of the pit's area there lay in ordered rows the bodies of sixty-four ladies of the court. All of them wore some sort of ceremonial dress The head-dress was much like that of Queen Puabi; a long ribbon of gold or silver was looped several times round the hair and, at any rate with those of higher rank, a triple band of gold, lapis lazuli, and carnelian beads was fastened below the ribbon with gold beech-leaf pendants hanging across the forehead. Twenty-eight of these court ladies wore golden hair-ribbons, the rest silver. Unfortunately silver is a metal which ill resists the action of the acids in the soil, and where it was but a thin strip and, being worn on the head, was directly affected by the corruption of the flesh, it generally disappears altogether, and at most there may be detected on the bone of the skull slight traces of a purplish colour which is silver chloride in a minutely powdered state: we could be certain that the ribbons were worn, but we could not produce material evidence of them.

But in one case we had better luck. The great gold ear-rings were in place, but not a sign of discoloration betrayed the existence of any silver head-dress, and this negative evidence was duly noted: then, as the body was cleared, there was found against it, about on the level of the waist, a flat disc a little more than 3 inches across of a grey substance which was certainly silver; it might have been a small circular box. Only when I was cleaning it in the house that evening, hoping to find something which would enable me to catalogue it more in detail, did its real nature come to light: it was a silver hair-ribbon, but it had never been worn—carried apparently in the woman's pocket, it was just as she had taken it from her room, done up in a tight coil with the ends brought over to prevent its coming undone; and since it formed thus a comparatively solid mass of metal and had been protected by the cloth of her dress, it was very well preserved and even the delicate edges of the ribbon were sharply distinct. Why the owner had not put it on one could not say; perhaps she was late for the ceremony and had not time to dress properly, but her haste has in any case afforded us the only example of a silver hair-ribbon which we were able to preserve. . . .

Now the ritual of the interment could be understood. The royal body with its attendants, many or few, was laid in the tomb, and the door was sealed and sacrifice was made in the little court before the entrance, and then this was filled in until only the crown of the dome was left above ground. Round it fires were lit and a funeral feast was held, and libations to the dead were poured into the clay drain which ran down into the soil

beside the tomb, and then more earth was thrown into the shaft. Next an offering to the underworld gods was set out and covered with a clay bowl to shield it from the fresh earth which buried it; and then, in the half-filled pit, there was constructed in mud-brick what was to be a subterranean building.

The filling-up of this building was done by degrees; clay was brought and trampled hard to make a floor over which offerings were spread and on which was laid the body of a human victim sacrificed in these later rites; earth buried these, and another floor was made and more offerings placed in order and another victim did honour to the dead below, and this went on till the top of the walls was nearly reached; then half of the building was roofed in with a vault of mud-brick, and in this subsidiary tomb was put the coffin of one whom we may suppose to have been the chief sacrifice, . . . Then this chamber too was buried under the filling of the shaft, and probably on the top of it all there was erected on the ground-surface some kind of funerary chapel which should perpetuate the sanctity of the spot.

The complexities of form and ritual found in all the sixteen "royal" tombs were such that no single explanation of what we found carries complete conviction. . . .

Fifty years later nothing like these tombs has yet been found in Mesopotamia. There is no archaeological parallel to the wealth, the architecture, and, above all, to the ritual which they display. Who then were the people who received such rites?

When the cemetery was dug, it was assumed that tombs differing so much from the common run must be those of kings and in the preliminary report this view was put forward. It was immediately challenged, and scholars are still not in agreement. The main alternative theory maintained that the primary burials were of priests and priestesses put to death after they had represented the chief god and goddess of Ur in a "Sacred Marriage Ceremony" upon which the annual fertility of the land was believed to depend. Some scholars introduced a secondary hypothesis which sought to identify the participants as substitute kings and queens ritually slaughtered with their attendants once their brief reign was over. Neither view explains all the evidence revealed in our excavations. The textual sources for substitute kings, from Assyria, are very much later and from a different cultural background and even in their own cultural context they are not yet fully understood. Since, according to the Fertility Sacrifice theory, the occupants of the tombs should be the couple chosen to represent the deities in the "sacred marriage," we should expect to find in each tomb a man and a woman buried together, but this is never the case—each tomb has only one principal occupant, a man or a woman. The bride chosen for the god would surely be a virgin, probably good-looking, certainly young; Puabi, however, was a woman of about forty years of age. The Fertility rite was,

naturally, an annual affair; our cemetery, with its thousands of graves, superimposed sometimes five or six deep, must represent a considerable length of time (indeed we now know it to be over six hundred years), but there are only sixteen tombs of the kind in dispute; did then the ancient people of Ur celebrate only occasionally the rite that was to assure a good harvest and in most years leave the whole thing to chance? That is hard to believe.

For human sacrifice at a king's grave plenty of analogies can be quoted from other lands, most apposite being that of the pharaohs of the earliest dynasties in Egypt, a few hundred years before these tombs at Ur; what is even more important is that something of the sort seems to have persisted in Sumer itself right down to the end of the third millennium B.C. . . . The famous burial of Puabi, already described in some detail, produced three inscribed seals. That found by the tomb-chamber bears the lady's name and the title *nin;* at Ur at this time this is normally taken as the feminine equivalent of *lugal.* When applied to deities they are now translated as "lady" and "lord"; when applied to mortals, "queen" and "king," . . .

The mystery of the royal burials is not yet resolved by any known reference in Sumerian literature. Professor Kramer has translated a possibly relevant passage in the *Epic of Gilgamesh,* but it only survives in fragmentary form and is tantalizingly obscure. It seems to describe a royal male burial:

> His beloved wife, his beloved son, . . .
> His beloved household, the palace attendants,
> His beloved caretaker,
> The purified palace. . . . the heart of
> Uruk—whoever lay with him in that place,
> Gilgamesh, the son of Ninsun,
> Weighed out their offerings to
> Ereshkigal . . .

The answer to this intriguing problem of identity will only come from more information, both from excavated graves at Ur and from elsewhere in Sumer, and from an increasing knowledge of Sumerian texts. We still know too little of family relationships within Early Dynastic Sumerian ruling families, of the nature of their marriages and concubinage, of their lines of inheritance, of the distribution of ranks, titles, and religious offices, and, what is more important for this purpose, their precise ancient terminology, to allow us confidently to analyse the sociology of the "royal" and associated tombs. . . .

3

The Odyssey of Homer

TELÉMAKHOS
AT THE COURT
OF NESTOR

TWO EPIC POEMS TRADITIONALLY ascribed to Homer, the *Iliad* and the *Odyssey*, were as familiar to Greeks as the Bible has been familiar to most Americans (at least until recently). The poems are about the Trojan War, but they are not a history of a war. Each is concerned with one narrow aspect of the campaign. The *Iliad* recounts the story of a battle delayed and then fought before the walls of Troy. The *Odyssey* describes a victorious hero's long journey home.

We know virtually nothing of either the Trojan War or of Homer. The war takes place in some nearly mythical ancient time—often loosely dated around 1200 B.C.—when great heroes, and indeed gods, moved among men. Although we speak of a poet called Homer, some scholars believe that two different poets are responsible for the two works. The poems were written down sometime before 700 B.C.

Written language in an alphabetic script was introduced to Greece in the eighth century B.C. The Minoan-Mycenaean syllabic script known as "Linear B" had disappeared during the Dark Age between 1200 and 800 B.C. Homer's works were composed for recitation, not for the pages of a book. A poet was a "bard," who spoke, or chanted, his tale to musical accompaniment for an audience of listeners. In the centuries before Homer, writing was unknown and the oral tradition was the only means of preserving either history or myth. At the dawn of Greek Classical culture, a new system of writing was adopted in Greece. Then someone wrote down what may have been Homer's special performance of a spoken poem.

By comparing the Homeric poems to oral poetry still recited in re-mote areas of Yugoslavia in the twentieth century, Milman Parry was able to explain many puzzling features of the *Iliad* and *Odyssey*. (A good account of these discoveries can be read in Albert Lord, *The Singer of Tales*.)[1] Bards do not memorize: they compose their recitation in a slightly different way each time they perform, like players in an improvisational theater. But as with those players, the "new" composition is made up of themes, phrases, and word-groups that were often used before. Familiar repetitions—"Dawn's fingertips of rose," for instance—are part of the singer's stock of formulas that he uses to fill out the lines and add rhythmic repetition to the poetic performance.

Understanding the way in which oral epic was composed is helpful in appreciating Homeric poetry as literature. However, another way of look-ing at the *Odyssey* is to try to read history in the poems. What world and what customs is Homer describing? Is it the remote world, that "heroic age" of long ago when the Trojan War is supposed to have taken place? Recall the cities of Knossos or Mycenae as modern archaeology has dis-closed them. We have to ask whether oral tradition can preserve descrip-tions of social customs, of technological procedures, of speeches, and of events over hundreds of years. Or is Homer retelling the story of Troy in "modern dress" (as when Shakespeare is updated to become "West Side Story")? Are the people, the weapons, the religious ceremonies described those of the eighth century B.C.? (The most familiar works of art of this period are large Geometric Dipylon vases.)

M. I. Finley has argued that the Homeric poems describe neither Mycenaean nor Geometric Greece, but reflect the warrior culture of the Dark Age that came between them.[2] Absent from both poems are the large cities that we know existed in both Mycenaean and eighth-century Greece. Finley points out, too, that the world of which Homer sang is a "world without writing or record-keeping," while in both the Mycenaean age and Homer's own time (obviously) people knew how to write. Some elements in the poems are probably modern—that is, similar to things Homer knew in his own time; yet others do go back to memories and traditions older than the Dark Ages and do reflect some aspects of Mycenaean culture.

To the student of art traces of ancient tradition may be more appar-ent than they are to political or social historians. In the scene from the *Odyssey* that follows, we can compare Homer's descriptions of objects and ceremonies to archaeological records of the Mycenaean world (and the related Minoan culture). Are the customs described in the poem like any-thing found in the palace at Knossos or the graves at Mycenae?

In Book III of the *Odyssey*, Odysseus' son Telémakhos has traveled to the court of wise King Nestor to try to find out why his father has not come home. Odysseus has been gone for almost twenty years. For ten years he

[1]Albert Lord, *The Singer of Tales* (Cambridge, Mass.: Harvard University Press, 1960).

[2]M. I. Finley, *The World of Odysseus*, second revised edition (London: Chatto & Windus, 1978; New York: Viking Press, 1978).

fought at Troy, but where have the next ten years gone? The other leaders of the Greek forces have been home for many years. Accompanying Telémakhos is the Goddess Athena disguised as an old man.

Many cultural traditions in the ancient world stressed the importance of hospitality. (In the Bible, for instance, Abraham entertained three strangers who are later revealed to be angels. The moral is obvious.) King Nestor follows this tradition. He calls for a specially prepared meal in order to honor Telémakhos, his human guest, and Athena, the divine guest who accompanied him. Nestor's feast begins with a ritual religious ceremony. A young cow is specially prepared and sacrificed to the gods. Then the same animal is roasted over an open fire and eaten by the assembled company. Perhaps we can imagine that as the feast took place, a "singer of tales" like Homer entertained host and guests with song and story.

From

The Odyssey of Homer

Translated by Robert Fitzgerald

[Telémakhos, the son of Odysseus, is visiting the court of King Nestor to ask for news of his father. It is the Goddess Athena herself who has accompanied the young Telémakhos. King Nestor orders a feast prepared for his guests.]

When Dawn spread out her finger tips of rose,
Lord Nestor of Gerênia, charioteer,
left his room for a throne of polished stone,
white and gleaming as though with oil, that stood
before the main gate of the palace; Neleus here
had sat before him—masterful in kingship,
Neleus, long ago a prey to death, gone down
to the night of the underworld.
So Nestor held his throne and scepter now,
lord of the western approaches to Akhaia.
And presently his sons came out to join him,
leaving the palace: Ekhéphron and Stratíos,
Perseus and Arêtós and Thrasymêdês,
and after them the prince Peisístratos,
bringing Telémakhos along with him.
Seeing all present, the old lord Nestor said:

"Dear sons, here is my wish, and do it briskly
to please the gods, Athena first of all,
my guest in daylight at our holy feast.
One of you must go for a young heifer
and have the cowherd lead her from the pasture.
Another call on Lord Telémakhos' ship
to invite his crewmen, leaving two behind;

Homer, *The Odyssey*, translated by Robert Fitzgerald (Garden City, N.Y.: Anchor Press, 1961). Excerpt from Book III, "The Lord of Western Approaches." Copyright © 1961 by Robert Fitzgerald. Reprinted by permission of Doubleday & Company, Inc., New York, and William Heinemann Ltd., London.

and someone else again send for the goldsmith,
Laerkès, to gild the horns.
The rest stay here together. Tell the servants
a ritual feast will be prepared in hall.
Tell them to bring seats, firewood and fresh water."

Before he finished, they were about these errands.
The heifer came from pasture,
the crewmen of Telémakhos from the ship,
the smith arrived, bearing the tools of his trade—
hammer and anvil, and the precision tongs
he handled fiery gold with,—and Athena
came as a god comes, numinous, to the rites.

The smith now gloved each horn in a pure foil
beaten out of the gold that Nestor gave him—
a glory and delight for the goddess' eyes—
while Ekhéphron and Stratíos held the horns.
Arêtós brought clear lustral water
in a bowl quivering with fresh-cut flowers,
a basket of barley in his other hand.
Thrasymêdês, who could stand his ground in war,
stood ready, with a sharp two-bladed axe,
for the stroke of sacrifice, and Perseus
held a bowl for the blood. And now Nestor,
strewing the barley grains, and water drops,
pronounced his invocation to Athena
and burned a pinch of bristles from the victim.
When prayers were said and all the grain was scattered
great-hearted Thrasymêdês in a flash
swung the axe, at one blow cutting through
the neck tendons. The heifer's spirit failed.
Then all the women gave a wail of joy—
daughters, daughters-in-law, and the Lady Eurydíkê,
Klyménos' eldest daughter. But the men
still held the heifer, shored her up
from the wide earth where the living go their ways,
until Peisístratos cut her throat across,
the black blood ran, and life ebbed from her marrow.
The carcass now sank down, and they disjointed
shoulder and thigh bone, wrapping them in fat,
two layers, folded, with raw strips of flesh.
These offerings Nestor burned on the split-wood fire
and moistened with red wine. His sons took up

five-tined forks in their hands, while the altar flame
ate through the bones, and bits of tripe went round.
Then came the carving of the quarters, and they spitted
morsels of lean meat on the long sharp tines
and broiled them at arm's length upon the fire.

Polykásté, a fair girl, Nestor's youngest,
had meanwhile given a bath to Telémakhos—
bathing him first, then rubbing him with oil.
She held fine clothes and a cloak to put around him
when he came godlike from the bathing place;
then out he went to take his place with Nestor.
When the best cuts were broiled and off the spits,
they all sat down to banquet. Gentle squires
kept every golden wine cup brimming full.
And so they feasted to their heart's content. . . .

4

Rhys Carpenter

BUILDING
THE PARTHENON

ACCORDING TO GREEK MYTHOLOGY, the Goddess Athena was not born like other infants but sprang full-grown from the forehead of her father Zeus. Thus it was not necessary for her to grow up, exposed to all the accidents and hazards that face ordinary people (or even the other gods). When we look at Athena's best-known temple, we may unconsciously assume that the Parthenon, too, appeared suddenly in all its golden white perfection on some miraculous morning in ancient Athens. For the Parthenon symbolizes "the glory that was Greece" and seems even in its present damaged state to represent all the order, beauty, and harmony of Greek art.

But the Parthenon was designed and built by men. It is a large structure and it took time to construct. Politics and warfare played a part in motivating or delaying its builders. To the careful observer, evidence of the Parthenon's own history—its birth and growth—can still be seen. In discovering that history we can observe a miracle: we can see how such moving beauty was achieved not by magic but through the work of human beings who struggled with day-to-day problems.

In the extracts from Carpenter's study that are included here, some of the difficulties of rediscovering the Parthenon's story are obvious. Carpenter's still-debatable conclusions are based on the use of many different techniques or tools to reconstruct architectural history. These tools are taken from the disciplines of history, archaeology, and art history—that is, from the study of written records, from the excavation and measurement of the site, and from the study of style in building and in sculpture.

How has Carpenter made use of history? First, he has turned to

Greek written history for the dates and events of the fifth century: the Persian wars (490 and 480–479 B.C.), the period of Kimon's domination of Athens (468 to 450 B.C.), and the subsequent period under Pericles (450 to 429 B.C.). The first writer from whose work he quotes is Herodotus (*c*.454–*c*.425 B.C.), who wrote a history of the *Persian Wars* in the years after 443 B.C. A landmark in western civilization, Herodotus' work is usually considered the first true written history. Its author not only listed dates and names (such a work is a *chronicle*) but also interpreted the motivations for human events. Carpenter also refers to the great historian of the next generation, Thucydides (*c*.460–*c*.400 B.C.), who wrote a history of the Peloponnesian War in the last ten years of his life; and to Demosthenes (*c*.384–322 B.C.), the most famous Greek political orator. One of the special pleasures derived from reading Carpenter's study is the opportunity to sample the works of the Greek historians themselves.

Political and military history, however, do not exhaust the historical record. Carpenter makes use of another kind of record—the tablets recording payments and revenues during the building of the Parthenon—to aid in determining when the temple was begun, built, and completed. These remarkable marble slabs provide factual information about prices and wages, that is, about economic history.

Carpenter combined his reading of historical documents with his knowledge of architectural practice (for example, see the passage beginning "the first stage in building a Greek temple . . .") and his ability to reason from physical data (the asymmetric placement of the Parthenon on its platform, small differences in the sizes of columns, etc.). Carpenter concludes that the present building combined new materials with elements of an earlier structure. He supports this conclusion by observing the style of the sculptural decoration. Carpenter uses both *style* and *physical evidence* to support his idea that part of the sculpture, like some of the columns, was "recycled" from an earlier Parthenon. Can the available facts be interpreted to yield another conclusion? Whether or not one believes that Carpenter proves his case, his essay is a valuable demonstration of the methods of scholarly research.

From

The Architects of the Parthenon

For more than a hundred miles the modern motor road from Patras to Athens runs beside the sea until, after Eleusis, it finally turns away to ascend the pine-clad ridge of Mt Aigaleos. From the top, . . . there suddenly opens a view across the Attic plain with Athens in the middle ground and Mt Hymettos against the horizon sky. After nightfall a million electric lights will make magic of the scene. But during day-time closer approach will bring disenchantment at sight of the welter of houses without architectural distinction lining crowded narrow streets. Yet disillusion at sight of the modern city gives place, even before the city is entered, to a breathtaking glimpse above the red-tiled roofs where, high on its bare outcropping of rock, clear and brilliant in the sunlight gleams the columned Parthenon.

One may climb the Acropolis many times and examine its famous triad of fifth-century architectural masterpieces—Propylaea, Erechtheion, and Parthenon—without ever suspecting that the first far-away impression that Athena's temple perches on the exact summit of the Acropolis rock is not literally true, since actually it is raised aloft on a huge foundation of invisible masonry.

This great substructure, covering an area roughly 250 feet long and 100 feet wide, . . . and in part built up to a height of more than 30 feet . . . over bed rock, now lies (except for its topmost courses) wholly hidden underground, much as it was throughout Antiquity after the Parthenon was raised upon it. But, rather recently, the long southern flank of its great pile of squared limestone blocks stood exposed, laid bare by modern probing into the unexpectedly deep adjoining soil [Figure 1].

[The next section describes the archaeologists' discovery of five stages of wall-building under the Parthenon's platform, ranging from Mycenaean times to the fifth-century-B.C. walls built by Kimon and then Pericles. The work of W. B. Dinsmoor is used to

Rhys Carpenter, *The Architects of the Parthenon* (Harmondsworth, England: Penguin Books, 1970). Excerpts from Chapter I, "The Parthenon of Kallikrates," pp. 21–68. Reprinted by permission of Penguin Books Ltd.

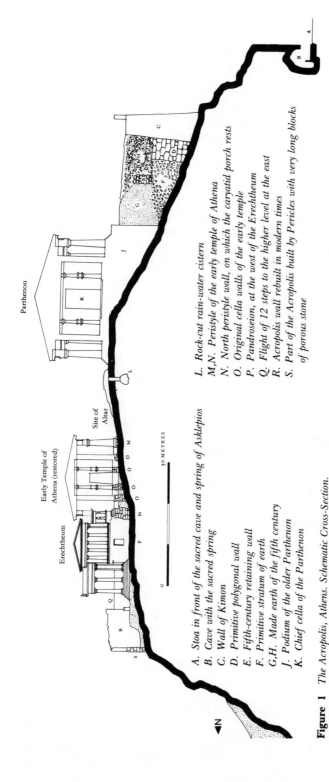

Figure 1 *The Acropolis, Athens. Schematic Cross-Section.*

From Rhys Carpenter, *The Architects of the Parthenon*, (Pelican Books 1970), fig. 3. Reproduced by permission of Penguin Books Ltd.

Parthenon

Early Temple of
Athena (restored)

Erechtheum

Site of
Altar

N

30 METRES

A. *Stoa in front of the sacred cave and spring of Asklepios*
B. *Cave with the sacred spring*
C. *Wall of Kimon*
D. *Primitive polygonal wall*
E. *Fifth-century retaining wall*
F. *Primitive stratum of earth*
G,H. *Made earth of the fifth century*
J. *Podium of the older Parthenon*
K. *Chief cella of the Parthenon*

L. *Rock-cut rain-water cistern*
M,N. *Peristyle of the early temple of Athena*
N. *North peristyle wall, on which the caryatid porch rests*
O. *Original cella walls of the early temple*
P. *Pandroseion, at the west of the Erechtheum*
Q. *Flight of 12 steps to the higher level at the east*
R. *Acropolis wall rebuilt in modern times*
S. *Part of the Acropolis built by Pericles with very long blocks
of porous stone*

27

establish the fact that building began shortly after the Athenian victory over the Persians at Marathon in 490 B.C.[1]]

The inference from Professor Dinsmoor's observation is as reasonable as it is attractive, to the effect that the project of a new temple for the city-goddess Athena was an outcome of the victory of Marathon, and that its realization was begun by the construction of an ambitiously large and high platform to raise the new temple to the topmost elevation of Athena's citadel. Accordingly, when we read in Demosthenes (XXII, 13) that "the Parthenon was built from the spoils of Marathon," we must understand this to mean that these were the funds with which the temple's construction was begun. Presumably, Athena's own share of the proceeds of the captured accoutrements from the battlefield provided some of the money, although popular support of the undertaking may well have brought additional contributions from private resources and the public exchequer.

Judging by the height of the fill heaped against the platform in stratum II, construction of the platform was completed in this initial campaign, and . . . there is evidence that construction of the temple itself had also been started, even though it did not progress very far before it was violently interrupted. This evidence is still to be seen today, in the shape of a peculiar feature in the fortification wall enclosing the Acropolis. For there, in its northern sector, not far from the place where the Persians stormed the citadel in 480 B.C. and, more precisely, just to the north of the later fifth-century temple of Erechtheus, a series of large column drums of marble may be seen, solidly built into the outer face of the wall. Closer inspection will reveal that most of these are *bottom* drums of columns. Largely by elimination of any other possible place for them elsewhere, they have been identified by general agreement as having been moved to their present position from previous location on the Parthenon platform. There they must have stood on the uppermost of the steps outlining a temple under construction.

It should be observed that the first stage in building a Greek temple was normally the material delineation of its plan in terms of its exterior circuit of steps with, on the top step or stylobate, a bottom drum for each of the columns, to fix that column's precise location. These drums were roughly shaped, undressed cylinders of solid marble with no indication of the final appearance of the column except where the drum rested on the stylobate. There, for an inch or two of height, the start of the column's twenty flutes was carefully carved as a guide for the final dressing of the entire shaft—an operation not to be performed until all the rest of the. temple had been erected.

[1]Dinsmoor, W. B., "The Date of the Older Parthenon," *American Journal of Archaeology* 1934.

The fact that mainly *bottom* drums together with discarded step blocks of hard limestone or marble are found built into the Acropolis wall indicates that a temple plan had been laid out on its platform in the manner just described, but the work on the structure had not progressed beyond a preliminary stage. For some reason, construction of the temple had been halted.

What this reason was, is not in the least in doubt.

In the autumn of the year 480 B.C. the Athenian people fled from their endangered city, leaving only a few of the more destitute inhabitants, together with some of the priests. These barricaded themselves on the Acropolis behind wooden gates and timber shoring, while the invading Persians, as Herodotus tells the story,

> encamped over against the Acropolis on the hill that the Athenians call Areopagos and thence began the siege in the following way: wrapping their arrows in tow, which they then set on fire, they shot these against the wooden hoarding, so that the besieged were betrayed by their own defences. Nevertheless, though at the very extremity of ill, they continued to hold out, so that Xerxes was long at a loss, for that he could not capture them.
>
> At length, however, a way out of the difficulty was discovered by the barbarian. At the edge of the rock, behind the gates and the entrance ascent, where no guard was set since no one expected that any man could climb up there, some succeeded in making the ascent at the sanctuary of Cecrops' daughter Aglauros, despite the sheer steepness of the spot.
>
> When the Athenians beheld them already up, some hurled themselves over the wall and so perished, while others sought refuge in the inner room of the temple. But the Persians who had made the ascent turned first to the gates and after they had opened these, massacred the refugees. Then, when all were laid low, they plundered the temple and fired all the hilltop.
>
> So Xerxes was complete master of Athens. . . .

. . . No temple was built at this time, because the Persian capture of Athens put a sudden end to the project. During the decade of the 480s, which is to say between the Greek victory at Marathon in 490 B.C. and the terrible Persian reprisal of 480–479, the great platform was built, the steps for a temple were set in place upon it, and erection of one long row of peripteral columns had been barely begun. Then all further work was suspended as a result of the Persian destruction of the city. . . . To revert to the immediate aftermath of the Persian retreat, the most urgent task for the shelterless and defenceless Athenians on reoccupying their ravaged city was to rebuild their houses and repair and extend their protecting city wall. Thucydides, in an early chapter of his *History,* gives an account of this latter enterprise and how it was accomplished in circumvention of Spartan diplomatic attempts to prevent the fortification of a city already sensed as a potential adversary to Spartan military supremacy. The passage in the *History* begins:

After the barbarians had departed from the land, the Athenian citizenry at once began transporting their children and womenfolk and surviving possessions back from their place of refuge and started rebuilding the city and its walls. For only short stretches of the circuit remained standing and most of the private houses were in ruins (although some few had survived, in which the Persian commanders had lodged).

There follows an account of the delaying *pourparlers* with Sparta, after which Thucydides continues his narrative:

And so in this way the Athenians walled their city in brief time; and even today it is apparent that the building was performed in haste. For, the foundations are laid of all kinds of stone, in some places not even trimmed to fit, but brought up just as they were; and many upright tombstones and wrought marble slabs have been built in. For, the circuit of the city was everywhere increased and on this account they laid hands on anything and everything in their haste.

Once again it is the buried walls south of the Parthenon from which we must derive, if we can, some understanding of events that took place nearly two thousand five hundred years ago. It is the ashlar retaining wall . . . on which the argument depends. This wall can be shown to date from the late 470s or early 460s . . . and since its construction argues a resumption of building activity on the temple platform we must assume that work on a temple was under way at least twenty years before Pericles succeeded Kimon in 449 B.C. and initiated the present Parthenon, with Iktinos as its master-builder, in 447 B.C.

Much the same conclusion may be reached from careful consideration of an otherwise baffling and disappointing historic document. Annual statements of receipts and disbursements in connexion with the construction of the Periclean Parthenon were rendered by the Treasurers of Athena and the Treasurers of the Public Funds (known as the *Hellenotamiai*). These summary accounts were engraved on the four faces of a thin upright marble slab which, in the course of centuries, was broken into minute disordered fragments. Some ten per cent of these small pieces have been recovered (Epigraphical Museum, Athens) and with great ingenuity and patience reassembled and assigned appropriate positions in an imaginary reconstitution of the shattered monument. A probable, but extremely incoherent text results, comprising a great many incomplete numerical notations of money received and expended, together with still more fragmentary indications of the purposes for which the various amounts were paid.

The accounts cover the fifteen years between 447 and 432 B.C.; but in the last five years of this period there were no disbursements for the Parthenon except in connexion with sculpture for the pediments. It appears certain that in all other respects the temple was complete by 438 B.C., during which year surplus material was sold publicly (there is mention of wood, probably from scaffolding such as had been erected for carving the famous frieze and for decorating in colour the marble ceiling coffers). For

the preceding year of 439–438 there is mention of purchase of ivory and payments made to woodworkers and gilders; and it is presumed that these items refer to the final decoration and adornment of the completed structure. The great doors of the temple are included in the very fragmentary record of the next earlier year (440–439)—again suggesting a closing phase of the work; . . . From all these considerations it would follow with almost entire certainty that, apart from the final detail of the surface dressing of the marble and the application of colouring, the Periclean Parthenon took only five years to build!

Yet, it is physically impossible that such a massive and magnificent structure of perfectly cut and fitted marble could have been produced in so short a space of time with no materials more immediately available than the marble-veined mid-height of Mt Pentelikon, eleven miles away.

It is now more than fifty years since the late B. H. Hill published his brilliant paper, "The Older Parthenon," in which he deduced the ground plan . . . of an earlier temple set out and partly erected on much the same foundation as the present Parthenon.

The resulting temple plan is presented in drawing [Figure 2] superimposed in solid black on the existing Parthenon at identical scale. It is instantly apparent that the two temples have much in common.

Except that the Later Parthenon is slightly longer (by a single column) and noticeably wider (by two columns), the later plan reproduces the earlier in almost every detail. In both, shallow porticoes with free-standing columns are set at either end of the interior sanctuary, itself divided into two rooms by a closed partition wall. . . . Accordingly, the later plan reproduces the essential disposition of the earlier one in an expanded form.

It is hardly arguable that this very extraordinary procedure of enlarging the size of a temple without any corresponding increase in the dimensions of its component elements was due to the restrictive area of the platform. For the length of the platform was sufficient to accommodate seventeen slightly larger columns at slightly greater intervals; while, in order to permit an increase in the temple's width from six to eight columns, some sort of supplementary extension of the platform on the north side was unavoidable. We must seek some other explanation why so many of the dimensions of the structural elements of the earlier temple were kept unaltered in the later one.

If the plan [Figure 2] is scrutinized closely, the platform may be identified as the outermost rectangle delineated by a solid line. (The broken dotted lines describe the exterior steps of the Later Parthenon; and the *inner* series of solid lines gives the plan of the older temple.) With these identifications in mind, it will be seen that the smaller earlier temple is symmetrically centred on the platform, whereas the existing Parthenon is not.

As laid out in the ground plan, an open walk or freeway surrounded

0 5 10 15 20 METRES

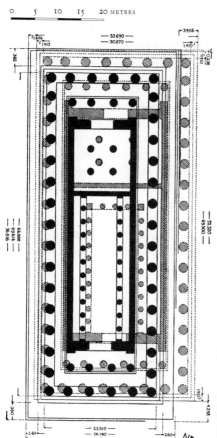

Figure 2 *Plans of the earlier and later Parthenon. Black: Kallikrates' plan (earlier). Shaded: Iktinos' plan (later).*

From Rhys Carpenter, *The Architects of the Parthenon*, (Pelican Books 1970), fig. 10. Based on a drawing by W. B. Dinsmoor, *American Journal of Archaeology* (1912), plate 9. Reproduced by permission of Penguin Books Ltd.

the older temple between its lowest step and the platform's verge, leaving a space nearly 12 feet wide at either end of the temple and one of 8½ feet along either flank. In marked contrast the present Parthenon is placed on the platform without regard to symmetrical disposition, as is clearly shown in the plan. On the west (i.e. at the upper end of the plan) the temple steps extend along the very border of the platform (shown in solid line); whereas at the other or eastern end the platform stretches 14 feet beyond the temple steps, and on the south (at the left of the plan) the open space beyond the bottom step measures barely 5½ feet. These relationships between the extant Parthenon and the platform are distinguishable in diagram [Figure 1]; but for the north side the plan [Figure 2] must again be consulted. There the colonnade of the present Parthenon has been carried far out beyond the platform upon newly added masonry with its bed at the east cut down into the living rock of the Acropolis. There could be no more convincing proof that platform and earlier temple were conceived as inte-

gral parts of a single design and that the present Parthenon was an intruder upon a differently intended project.

Yet several questions arise that have not hitherto been satisfactorily answered, notably "Whose project was this Older Parthenon?" and "How much of it was ever actually built?"

Hill believed that he had recovered the plan for the temple under construction at the time of the Persian invasion and abruptly abandoned after the Persian sack of the city and its citadel when (according to Herodotus) Mardonius, the Persian commander, "retreated from Attica after having set fire to Athens and overturned and demolished everything still standing—city walls, private dwellings, sanctuaries." But it now appears— from the evidence we have just deduced from the retaining walls and fills—that the plan so ingeniously elicited by Hill was not that of the pre-Persian project (which may, or again may not, have been the same), but reproduces the plan of a temple in course of construction *after* the departure of the Persians. . . .

[The next section answers the question, "What happened to the second 'Old Parthenon,' begun after the Persian invasions?" by showing that parts of the "Old Parthenon" were reused in building the existing Parthenon. They account for anomalies such as the slight difference in diameter of the columns on the front and the back of the building.]

The evidence that I have reviewed shows that an earlier Parthenon was in course of construction during the period of Kimon's ascendancy, which lasted with only brief interruption from the death of Aristides in 468 B.C. until Kimon's own death in 450. It was then that Pericles, putting Iktinos in charge of the altered project for the temple, substituted for the Kimonian Parthenon the more ambitious and considerably more costly building, whose impressive remains still stand after 2,500 years.

A more difficult task than proving the existence of a partially completed Kimonian Parthenon is that of determining how much of it had actually been built before Pericles halted it. Granted the validity of Hill's claim that "when the present Parthenon was planned, it was made in many dimensions precisely the same as the older temple, so that blocks from the latter might be used in the new building," it is this very identity of dimensions that seems to preclude any possibility of distinguishing between old and new material in the present temple. . . . It is true, of course, that the slightly diminished column interval necessitated an equal abbreviation of the architrave beams, if these were re-used; but this would leave no discoverable trace on the marble blocks. An equivalent curtailment would have been necessary in the frieze, if any of the alternating triglyph and metope blocks had been cut and carved preparatory to setting in place. But here again the re-use of these pieces might not be detectable, since two or three inches might be trimmed from the border of each of the metopes and

the triglyphs would not have to be recut. If the work were done carefully and the sculptured reliefs were not mutilated, no trace of the operation would be visible.

And yet there was one feature of the metopes that no change of measurements could alter and no resetting could obscure. That persisting feature was the sculptural style of the metope reliefs.

No visitor to the British Museum who examines the Elgin Marbles with any attention to their artistic qualities will fail to be struck by the lack of stylistic harmony between the metopes [Figure 3] on the one hand and the pedimental statues and the wall-frieze on the other. So great is the naturalistic advance in rendering anatomic detail and posing figures in action and so fully developed are the aesthetic devices for representing drapery on the Panathenaic gathering in the frieze and on the surviving

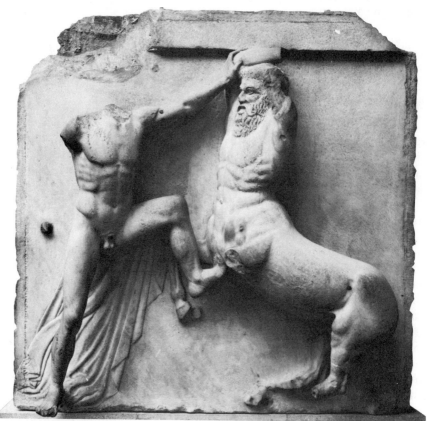

Figure 3 *Lapith and Centaur from the Parthenon, South Metope XXVI. The British Museum, London.*

statues from the two pediments, that no technical diversity of medium between low relief and high, or again between high relief and figures in the round, can mitigate or explain away the semi-archaic severity and anatomic rigidity displayed on the metopes. The contrast of style is too pronounced to be due to mere variety of manner among contemporary sculptural workshops, but betokens an interval of a full artistic generation measurable at some twenty years.

Students of Greek sculpture have long been aware of this stylistic discrepancy and are wholly at a loss to explain it. Yet the explanation is surprisingly simple and entirely convincing: the existing metopes showing the contest of Lapiths and Centaurs *were carved for the Kimonian Parthenon.*

A second criterion, complementary to that of sculptural style, confirms the Kimonian origin of these metopes.

When viewed from below, the metopes of a Doric temple appear to fit snugly against the triglyphs that frame them; but actually the metopes are a few inches broader than they seem and extend behind the face of the triglyph into a narrow vertical slot cut in the triglyph block. This overlap, amounting to no more than a couple of inches at each end of the slab, secures the metope in place. It will naturally be smooth and blank, lest any of the carved relief be hidden.

Because the Kimonian column span had been shortened by about 4½ inches in the Periclean version, any metope from the older structure would have proved oversize for the later one by half this amount, or a trifle more than 2 inches. . . . Therefore, the older metopes would either have had to be discarded entirely or else cut down to a suitable size. It is scarcely surprising that the latter alternative was chosen, since it was a minor task to cut off a couple of inches of marble in comparison with the expense and loss of time involved in carving a new set of metopes. . . .

Had the reduction of the metopes to the narrower width been done carefully, the operation would have left no discernible trace. But fortunately for our modern interest in architectural history, the work was done hastily and crudely—a sure indication that the work was done "on the job" in the course of fitting the metopes into place. They would never have been delivered from the sculptors' shop in this condition, whereas the masons whose task it was to set them in the frieze were well aware that, once these metopes had been lowered into the triglyph slots, no one would know whether their edges were rough or smooth. . . .

. . . More than half of them have one or both of their end surfaces rudely cut [Figure 3]. . . . On four metopes small portions of the reliefs have been cut away at the border with consequent loss of the centaur's tail in two instances and, in another, an undercutting of his hindquarter so that the chamfered edge of a triglyph could be fitted in behind it. The centaur's tail has been shaved in [Figure 3]. . . .

The evidence is now in. When duly weighed and evaluated, it admits

no other conclusions than those advanced in the course of this study. These conclusions may be combined into three basic propositions to the effect that:

1. In or shortly after 490 B.C. a temple for Athena was projected on the Acropolis. A high stone platform to carry the temple-to-be was erected. The bottom drums for one colonnade had been laid out by 480 B.C when the Persian invasion intervened. These bottom drums were dispersed, together with other building materials assembled on the site, during or after the Persian invasion. This projected temple is that generally known as the "Older Parthenon."

2. Between *c.* 468 and 465 B.C., under the initiative of Kimon, the leading Athenian statesman of the period, a new temple to Athena was projected on the same site and following the same plan as that of the "Older Parthenon." The supervising master-builder is to be identified as Kallikrates. This temple was begun and carried rather less than half way to completion when all work on it was peremptorily halted by Pericles on his assumption of political control after Kimon's death in 450 B.C.

3. At this stage a third temple on the same site, but on an enlarged plan, was projected. Kallikrates was dismissed from office and replaced by Iktinos, who was commissioned to design and build a new temple on a more impressive scale, utilizing whatever material from the unfinished building could be turned to account. This temple was completed structurally by 438 B.C. The pediment sculptures were completed by 432 B.C. This is the temple the ruins of which still stand on the Acropolis. . . .

5

Jocelyn M. C. Toynbee

THE ARA PACIS
RECONSIDERED

THE ARA PACIS (ALTAR OF PEACE) is one of the most beautiful and significant Roman sculptural works. Today the reconstructed altar stands under a protective roof near its original location in Rome. Its portraits of Roman dignitaries, its idealized image of *Tellus* (Mother Earth, especially the fertile land of Italy), and its decorative motifs seem to have been carved for eternity. What does this marble monument have in common with wedding cakes and parade floats? Like these the Ara Pacis was originally a *temporary* work of art. Its appearance is based upon, and commemorates, an altar that had been built for use on one day. Although temporary works of art are today often trivial in character, at many times in the past they were elaborate devices used to celebrate and reinforce the power of rulers. Famous artists like Dürer and Rubens were employed in their design. The Ara Pacis is one of the earliest examples of an important aspect of the arts.

Toynbee's paper explains the events that led, first, to the construction of a temporary altar and, next, to its reproduction in marble. The sculpture of the Ara Pacis is characteristically Roman, because Roman art had very early called for the representation of real events from recent history. Rather than disguising history under the cover of traditional mythological tales as the Greeks had done at Pergamon, the Romans chose a new, direct, approach. Emperor Augustus's temporary altar had played a part in history. It was used to celebrate an important event in his reign. The Ara Pacis we know commemorates that celebration by reproducing in marble both the temporary altar and the people who had attended the ceremony.

All future historical works of art—"Washington Crossing the Dela-

ware," for instance—follow the Roman example. Of course, the Ara Pacis's influence on Roman art itself was substantial, and Toynbee mentions a few of the well-known works that show its influence. It is also interesting to compare the style of the Ara Pacis reliefs to earlier works that dealt with history in an idealized or mythicized form. Relations between form and content can be observed by comparing such works as the Parthenon frieze and the reliefs on the Altar at Pergamon to the procession carved on the Ara Pacis.

Toynbee originally delivered "The Ara Pacis Reconsidered . . ." as a lecture to the members of the British Academy, an honorary society including scholars from many different disciplines. Hence, the article, while clearly addressed to a scholarly audience, retains a freshness and immediacy characteristic of a live performance. Certainly the author's enthusiasm is transmitted to us as we follow her skillful deciphering of the meaning of the monument. This excerpt has been greatly abridged and most of Professor Toynbee's scholarly apparatus, including many footnotes, have been left out for the sake of emphasizing the immediacy of her speech.

From

The Ara Pacis Reconsidered

The modern visitor to Rome, approaching the left bank of the Tiber at the Ponte Cavour, observes, just to the north of the bridge, between the Mausoleum of Augustus and the river, a large, square-shaped "box." It is the reconstruction of the Ara Pacis Augustae, perhaps the first, and certainly the noblest, of those storied public monuments, devoted to the pictorial record of contemporary history, which rank with the perfection of "veristic" portraiture and of three-dimensional painting as Roman Italy's signal contributions to classical art.

Historical art, the "officially-sponsored" narration in sculpture or painting of past and present happenings of national import, was already well established in eastern Mediterranean lands when Italy's destiny as pivot of the ancient world was finally sealed at Actium. Behind the figure-groups dedicated *c.* 200 B.C. by Attalus I of Pergamon on the south wall of the Athenian Acropolis lay the vision of contemporary events, the victories of Pergamenes over Gauls, as enacted in the foreground of a great receding vista of triumphs of civilization over barbarism—of Greeks over Persians, of Greeks over Amazons, and of gods over giants. In the great frieze of the altar of Zeus at Pergamon contemporary achievement is portrayed entirely in terms of the timeless, divine action of the Gigantomachy,[1] while the lesser frieze presents the current history of the reigning dynasty under the veil of the saga of Telephus, its legendary ancestor, told "continuously" in a long succession of incidents, in which, as in a film, the hero reappears again and again in rapidly shifting scenes and circumstances. There, indeed, we have a new method of narration applied to a traditional type of theme. But in 168 B.C. another Hellenistic artist produced on Greek soil a work of novel content. He recorded in quasi-documentary fashion a specific event, the contemporary victory of Romans under Lucius Aemilius

Jocelyn M. C. Toynbee, "The Ara Pacis Reconsidered and Historical Art in Roman Italy," *Proceedings of the British Academy* (London: Oxford University Press, 1953), pp. 67–95, plates V–XXII. Excerpts.
 [1]Gigantomachy: battle of the gods and giants. The great Altar at Pergamon, erected *c.* 180 B.C., used this traditional sculptural subject as a metaphor for the victories of a human ruler, Attalus I. Telephus: in mythology, a son of Hercules. [B.W.]

Paullus over Macedonians under Perseus, in the frieze of the monument set up at Delphi to celebrate Pydna— . . .

Certainly in the case of this frieze, . . . and very probably in that of the earlier triumphal Roman paintings of the third and early-second centuries, of which we have records, the artists were Greeks. But the impulse to make them came from a genuinely Roman demand for the direct and literal representation of present history. In fact, all the ingredients of historical art, as Rome was to know it, had been prepared, either independently in Hellenism, or in Hellenism in Roman service, by the time that the main artistic focus in the Mediterranean world moved westwards across the Adriatic in the early-first century before our era. How these ingredients were fused, perfected, and transformed into a new creation on Italian soil can be read most clearly in the structure and sculptures of the Ara Pacis, which, familiar, long-studied, and thoroughly published as it is, I am venturing to reconsider. . . .

The main features of the monument, as it has been re-erected, are familiar to all students of Roman art and archaeology [Figure 4]. The precinct-walls measured *c.* 11.60 metres [38 feet] from east to west and *c.* 10.50 metres [34 feet] from north to south and were in the region of 6.30 metres [20 feet] high. They were pierced by two doorways, in the centre of the east and west sides respectively, which were originally open, but closed later by sliding doors. . . . The precinct was open to the sky. The exterior of its walls was decorated with two zones of relief-sculpture, figures above and floral scrolls below. On the interior of the walls were again two zones of decoration; below, a dado of vertical fluting, above, a series of festoons of fruit and flowers, suspended between *bucrania,* with a sacrificial *patera* in the space above each festoon.[2] The inner altar proper, also adorned with figured friezes, was raised above the floor of the enclosure on four steps. . . . The heart of our subject [is] the significance of the Ara Pacis in the story of ancient historical art. The solution of its whole problem turns upon the answer to the following question—What was the occasion of the processions portrayed in the figure-friezes on the exterior of the precinct-walls and in the miniature figure-friezes on the altar proper?

The clue to the right answer to this question has been given first by Augustus himself, in *Res Gestae* 12, and secondly by E. Welin in a paper in ΔΡΑΓΜΑ *M. P. Nilsson dedicatum,* 1939. Augustus tells us that, in honour of his return (*pro reditu meo*) to Rome in 13 B.C., after a prolonged absence in the provinces, the site of the Ara Pacis was consecrated in the Campus Martius by decree of the Senate and an annual sacrifice ordained, in which magistrates, priests, and Vestal Virgins were to participate. Welin shows that this specially-ordained annual sacrifice cannot have been the normal

[2]Festoon: garland, rope of flowers. *Bucrania:* bull's heads. *Paterae:* shallow dishes used in religious ceremonies. [B.W.]

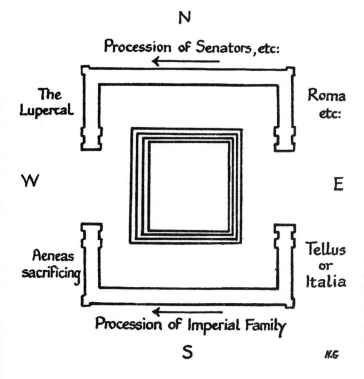

N

Procession of Senators, etc:

The Lupercal

Roma etc:

W

E

Aeneas sacrificing

Tellus or Italia

Procession of Imperial Family

S

N.G

Figure 4
Ara Pacis: Scheme of reliefs on the exterior of the precinct-walls.
From the *Proceedings of the British Academy*, XXXIX, 1953, p. 76. Reproduced by courtesy of the British Academy.

dedicatory sacrifice entered in the Roman Calendar under 30 January 9 B.C., *quod eo die Ara Pacis Augustae in Campo Martio dedicata est,*[3] but must have been the sacrifice entered under 4 July 13 B.C., *quod eo die Ara Pacis Augustae in Campo Martio constituta est,*[4] and that 4 July, the day of the altar's founding, was thus its principal feast. The altar was, then, most intimately connected with Augustus' homecoming, hymned by Horace in *Odes* iv.2; this explains the choice for it of a site, not, as we might have expected, in the Forum or on the Palatine, or elsewhere in the central part of Rome, but in the Campus Martius, outside the *pomerium.*[5] Even the Field of Mars was to realize that wars had ceased and that Pax was presiding over the great highway, the Via Flaminia, by which the Emperor had returned from his peace-bringing mission in the west and north.

On the foundation-day itself, 4 July 13 B.C., Augustus, accompanied by members of his family and by priests, Vestals, members of the religious

[3]"On this day the Altar of Peace of Augustus in the Campus Martius was dedicated." The *Campus Martius,* or "field of Mars" (god of war), was the army's parade ground. [B.W.]

[4]"On this day the Altar of Peace of Augustus in the Campus Martius was established." [B.W.]

[5]*Pomerium:* open space around the perimeter of a walled city. [B.W.]

fraternities, magistrates, senators, and other notables,[6] presumably went in procession to the site chosen for the altar to consecrate it and offer sacrifice. . . . There a temporary altar was doubtless erected, most probably with enclosure-walls of wood hung with fillets, garlands, &c. Some of the elements in the precinct-walls of the Ara Pacis—the pilasters, *podium*, cornice, and internal fluted dado, appear to be . . . direct reminiscences of such a temporary wooden structure. . . . The inner fluting definitely suggests close-set vertical planks, while the festoons, *bucrania*, and *paterae* on the interior look like translations into marble of real swags, *bucrania*, and *paterae* suspended on the framework on the foundation-day. . . . Its ground-plan and dimensions may well have been identical with those already determined for the permanent structure. . . .

This fossilizing of the temporary wooden precinct-walls and altar, erected for 4 July 13 B.C., in their marble successors, reveals the fundamental significance for the latter of the consecration-day and consecration-ceremonies; and it is only in the light of that day and those ceremonies that the relief-sculptures can be fully appreciated.

The side of the precinct now turned towards the north originally faced east and its doorway, through which we catch a glimpse of the back of the altar proper, was the "back-door," or secondary entrance. The procession depicted on the left and right of this doorway faces away from it; and we must imagine that on 4 July 13 B.C., the imperial cortège, starting from the centre of the city, approached the temporary enclosure from the side facing the Via Flaminia on the east and then, perhaps, divided, the first half of the procession, including the Emperor and his suite, passing along the south side of the enclosure, the second half, including the fraternities, magistrates, &c., passing along its north side, both to rejoin at the main, or "front," entrance on the west. Up the steps on the western side . . . the celebrating priests would go to offer sacrifice at the inner table; while the sacrificial animals could have been halted at the "back-door" on the east and slaughtered there, the portions of them that were to be offered being carried directly into the enclosure, to the altar proper. The Vestals, some of the priests, and the victims with their attendants are portrayed on the miniature frieze of the inner altar, round which, within the enclosure, Vestals and priests very likely stood; . . .

The Ara Pacis sacrifice is the earliest scene of its kind which we can date to a day; and the friezes on the south and north precinct-walls and on the altar proper, immortalize the actual procession of the Emperor and his people on that specific occasion. This documentary precision, as regards

[6]The Vestals were priestesses dedicated to Vesta, the goddess of the home. The consuls were the two chief magistrates of the Roman State. Other Latin words designating various religious, civil, and military officials are *Lictor, Camillus, Flamines, Velatus.* [B.W.]

the time, place, and personnel of the event depicted, is the essence of Romanità in the Ara Pacis, of the new departure made by historical art in Roman Italy. . . . The Ara Pacis expresses a more intimate sense of history, deeper devotion to fact and actuality, in presenting contemporary, living people, some of them individuals whose identity we can fix with certainty, or with a very high degree of probability, caught in marble, just as they were at a given moment, on 4 July 13 B.C.

Centered round this date and this occasion, all the figure-scenes on the exterior of the precinct-walls fall into place [Figure 5]. As we have seen, the south side is occupied by the Emperor himself, with his immediate entourage of officials, priests, and relatives, the north side by members of the Roman religious fraternities, magistrates, senators, and other persons, with their families, who walked behind. On the east side, facing the great highway, are two groups of personifications symbolizing to all passers-by the far-reaching and enduring effects of the *Pax Romana* now solemnly established by Augustus' return—the warrior goddess Roma, seated at peace, and Tellus, or, more probably, the mother-land of Italy, rich in children and in all the other gifts which peace bestows. . . .

The great acanthus-dado, interwoven with vine and ivy and sheltering a lively populace of miniature birds, insects, snakes, frogs, and lizards, may possibly represent the freezing into marble of a ceremonial carpet, laid outside the temporary enclosure, over which the procession passed. . . .

The most original, the most Roman, and the most fascinating portions of the altar's sculptured decoration [are] the great processional friezes on the south and north precinct-walls . . . [Figure 5]. We begin at a point towards the western end of the south side with the veiled and wreathed figure of Augustus, . . .

To the left of the Emperor is a group of lictors and a *camillus* with an incense-box; while two wreathed persons stand on either side of him. These we may, with Moretti, safely identify as the two consuls of the year 13 B.C., the more elderly member of the pair, shown in the second plane and looking at Augustus, as Publius Quintilius Varus, the younger man in high relief in the front plane as his colleague, the future Emperor Tiberius, who, having been born in 42 B.C., would have been twenty-nine in the year 13. We note that this consul's attention is not absorbed by the ceremony, but that he is glancing back over his shoulder. . . .

[Toynbee in the next section determines that Augustus's son-in-law, Agrippa, is the "velatus," fifth after the Emperor.]

The small boy, clearly suffering from stage-fright and clinging to Agrippa's toga, must be one of his sons by Julia. The child wears circlet, torque, and short tunic and is attending on his father. . . . He is probably Lucius Caesar, who was born in 17 B.C. and was therefore four years old in

13 B.C., rather than the elder brother Gaius, who was born in 20 B.C. and was therefore seven years old in 13. . . . I shall assume provisionally that the woman in the background, who lays her hand upon the child's head, to give him confidence, is a relative or nurse, and that the dignified, veiled, and wreathed lady in the foreground, to whom he looks up for reassurance, is his mother, Julia, who in 13 B.C. was still Agrippa's wife. . . .

[Toynbee identifies other figures in the great frieze.]

Before leaving the procession . . . , let us take note of the moment in the proceedings which the artist and his patron have chosen to portray. It is not the culminating act in the ceremony, but a pause just before it, when this part of the cortège is coming to a halt and the tension of the participants is momentarily relaxed. The gaze even of one of the consuls and one of the *flamines* is, as we have seen, directed away from the imperial celebrant, and even Antonia Minor and her husband have so far forgotten themselves as to lapse into talk. Our peace is to be so profound that we are not allowed to feel that amount of emotional strain which presence at the supreme moment might induce in us. How delightful it is, this easy and familiar atmosphere, this absence of a uniform, rigid concentration on the matter in hand, and how Italian. How often have we not witnessed the same informality in modern Italy, at some great *funzione*, ecclesiastical or secular. Naturalism, spontaneity, love of variety, and a discreet and subtle sense of humour have captured the situation. . . .

The Ara Pacis opens, in Italy, a new chapter in the story of historical art, just as the *Aeneid* opens a new Italian chapter in the story of epic poetry.[7] As Gerhart Rodenwaldt put it so well in his *Kunst um Augustus,* the Ara Pacis is not a "classicizing" work, but as much a classic as is the *Aeneid* itself. This is no place for detailed discussion of our altar's well-known successors in Italy and beyond. The chief surviving remnants of what was once a vast array of official documentary sculptures and paintings pass like a pageant before our eyes—the pair of panels from the Arch of Titus, the two Domitianic friezes from the Cancelleria, Trajan's Column, the classic Roman example of the "continuous," film-like method first evolved at Hellenistic Pergamon, Trajan's Arch at Beneventum . . . [and a number of other examples] . . . and the early-fourth-century friezes on Constantine's Arch in Rome. All derive from the principles which animate the Ara Pacis, their actuality, their factual presentation of contemporary events with a wealth of circumstantial detail, their vivid likenesses of individuals, their effortless blending of two planes, the real and the imaginary. Many are more elaborate than the Augustan monument, more ambitious, and more spectacular. But the Ara Pacis has a peculiar quality which none of these

[7]The story of Aeneas, legendary founder of Rome, is the subject of Virgil's epic poem, the *Aeneid,* written c. 30–19 B.C. (during the reign of Augustus). [B.W.]

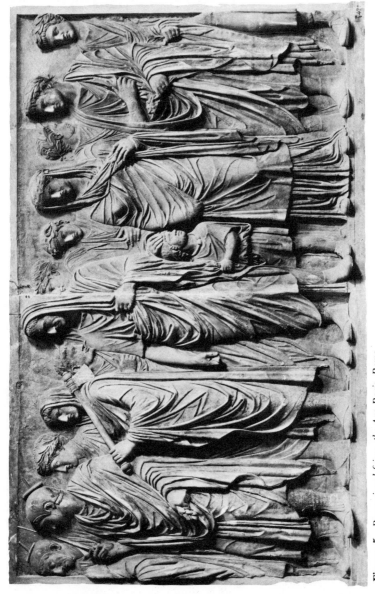

Figure 5 *Processional frieze, the Ara Pacis, Rome.*
Photo: Alinari-Scala. Art Resource, New York.

can rival. It appeals to us by its serene tranquility, its unpretentious stateliness, its homely intimacy, its gracious informality, its delight in Nature, its purposeful unity, and not least by its modest dimensions. It embodies the very best that Rome bestowed on Italy and it strikes that perfect balance between land and city on which Augustus claimed to build his empire.

6

Excerpts from the Old and New Testaments

THE BIBLE

FROM THE TIME OF THE OFFICIAL recognition of Christianity in the early fourth century until a few hundred years ago, the stories and imagery of the Bible inspired an overwhelming majority of the surviving works of art in the western world. Therefore one must be familiar with biblical narrative in order to understand Early Christian, Medieval, Renaissance, and much of Baroque art. Some sections of the Bible often represented in art are included here to serve as an introduction to biblical iconography: from *Genesis,* the first book of the Old Testament, the Creation, the fall, and the story of Noah; from the New Testament, portions of the Gospels that recount the birth and the passion of Jesus Christ.

These excerpts have been chosen to provide examples of bibical *narrative* (story-telling) art. They can only provide a sample of the material used by artists over many centuries. To understand the content of paintings or sculpture representing many other scenes, or to understand works showing other versions of events told in the New Testament, it is often necessary to do additional research. If the story is told somewhere in the Bible, it can be located with the help of a biblical index called a *concordance,* available in every library. Of course, some very familiar scenes are based on later traditions. Many saints and theologians amplified and interpreted biblical narratives, and their contributions are often reflected in works of art.

Our text is taken from the Revised Standard Version of the Holy

Bible, first published in 1952. This is a readable text based upon the "King James" English translation (1611 A.D.). The language is slightly modernized, and errors in the older text have been corrected in the light of modern scholarship. The original languages of the Old Testament were Hebrew and Aramaic. Although no early manuscript has survived, most scholars believe that the book of *Genesis* was written down in something like its present form about 700 B.C. The New Testament was written in Greek; the Gospels were composed at various times in the two centuries after Christ's death.

Selections from the Bible are included here in order to help you become familiar with the content of Christian art. Read the selections as narrative. Look at them as if for the first time. Approach them with the fresh eye of a visitor from a distant country where the Bible is unknown. Ask yourself, "What is happening in this scene? In this story?"

Then compare what you have read to representations of the scene in art. What does the Nativity look like in a Medieval version? A Renaissance version? Do artists follow the Bible exactly? What is left out? What does each artist include that the Bible did not mention? You will quickly observe that there is a complex process at work. Each artist draws on the Bible but is also influenced by later traditions and perhaps by personal interpretation. Yet however complex the whole process is, it is obvious that knowing the Bible is an essential first step in interpreting Christian art.

From

The Old Testament,
Book of Genesis

GENESIS, Chapter 1–3: The Creation.

1 In the beginning God created the heavens and the earth. The earth was without form and void, and darkness was upon the face of the deep; and the Spirit of God was moving over the face of the waters.

And God said, "Let there be light"; and there was light. And God saw that the light was good; and God separated the light from the darkness. God called the light Day, and the darkness he called Night. And there was evening and there was morning, one day.

And God said, "Let there be a firmament in the midst of the waters, and let it separate the waters from the waters." And God made the firmament and separated the waters which were under the firmament from the waters which were above the firmament. And it was so. And God called the firmament Heaven. And there was evening, and there was morning, a second day.

And God said, "Let the waters under the heavens be gathered together into one place, and let the dry land appear." And it was so. God called the dry land Earth, and the waters that were gathered together he called Seas. And God saw that it was good. And God said, "Let the earth put forth vegetation, plants yielding seed, and fruit trees bearing fruit in which is their seed, each according to its kind, upon the earth." And it was so. The earth brought forth vegetation, plants yielding seed according to their own kinds, and trees bearing fruit in which is their seed, each according to its kind. And God saw that it was good. And there was evening and there was morning, a third day.

And God said, "Let there be lights in the firmament of the heavens to separate the day from the night; and let them be for signs and for seasons and for days and years, and let them be lights in the firmament of the heavens to give light upon the earth." And it was so. And God made the two great lights, the greater light to rule the day, and the lesser light to rule the night; he made the stars also. And God set them in the firmament of the heavens to give light upon the earth, to rule over the day and over the

night, and to separate the light from the darkness. And God saw that it was good. And there was evening and there was morning, a fourth day.

And God said, "Let the waters bring forth swarms of living creatures, and let birds fly above the earth across the firmament of the heavens." So God created the great sea monsters and every living creature that moves, with which the waters swarm, according to their kinds, and every winged bird according to its kind. And God saw that it was good. And God blessed them, saying, "Be fruitful and multiply and fill the waters in the seas, and let birds multiply on the earth."

And there was evening and there was morning, a fifth day.

And God said, "Let the earth bring forth living creatures according to their kinds: cattle and creeping things and beasts of the earth according to their kinds." And it was so.

And God made the beasts of the earth according to their kinds and the cattle according to their kinds, and everything that creeps upon the ground according to its kind. And God saw that it was good.

Then God said, "Let us make man in our image, after our likeness; and let them have dominion over the fish of the sea, and over the birds of the air, and over the cattle, and over all the earth, and over every creeping thing that creeps upon the earth."

So God created man in his own image, in the image of God he created him; male and female he created them. And God blessed them, and God said to them, "Be fruitful and multiply, and fill the earth and subdue it; and have dominion over the fish of the sea and over the birds of the air and over every living thing that moves upon the earth." And God said, "Behold, I have given you every plant yielding seed which is upon the face of all the earth, and every tree with seed in its fruit; you shall have them for food.

And to every beast of the earth, and to every bird of the air, and to everything that creeps on the earth, everything that has the breath of life, I have given every green plant for food." And it was so. And God saw everything that he had made, and behold, it was very good. And there was evening and there was morning, a sixth day.

2 Thus the heavens and the earth were finished, and all the host of them. And on the seventh day God finished his work which he had done, and he rested on the seventh day from all his work which he had done. So God blessed the seventh day and hallowed it, because on it God rested from all his work which he had done in creation.

These are the generations of the heavens and the earth when they were created.

In the day that the Lord God made the earth and the heavens, when no plant of the field was yet in the earth and no herb of the field had yet sprung up—for the Lord God had not caused it to rain upon the earth, and there was no man to till the ground; but a mist went up from the earth and

watered the whole face of the ground—then the Lord God formed man of dust from the ground, and breathed into his nostrils the breath of life; and man became a living being. And the Lord God planted a garden in Eden, in the east; and there he put the man whom he had formed. And out of the ground the Lord God made to grow every tree that is pleasant to the sight and good for food, the tree of life also in the midst of the garden, and the tree of the knowledge of good and evil.

A river flowed out of Eden to water the garden, and there it divided and became four rivers. The name of the first is Pishon; it is the one which flows around the whole land of Havilah, where there is gold; and the gold of that land is good; bdellium and onyx stone are there. The name of the second river is Gihon; it is the one which flows around the whole land of Cush. And the name of the third river is Hiddekel, which flows east of Assyria. And the fourth river is the Euphrates.

The Lord God took the man and put him in the garden of Eden to till it and keep it. And the Lord God commanded the man, saying, "You may freely eat of every tree of the garden; but of the tree of the knowledge of good and evil you shall not eat, for in the day that you eat of it you shall die."

Then the Lord God said, "It is not good that the man should be alone; I will make him a helper fit for him." So out of the ground the Lord God formed every beast of the field and every bird of the air, and brought them to the man to see what he would call them; and whatever the man called every living creature, that was its name. The man gave names to all cattle, and to the birds of the air, and to every beast of the field; but for the man there was not found a helper fit for him. So the Lord God caused a deep sleep to fall upon the man, and while he slept took one of his ribs and closed up its place with flesh; and the rib which the Lord God had taken from the man he made into a woman and brought her to the man. Then the man said,

"This at last is bone of my bones
and flesh of my flesh;
she shall be called Woman,
because she was taken out ofMan."

Therefore a man leaves his father and his mother and cleaves to his wife, and they become one flesh. And the man and his wife were both naked, and were not ashamed.

3 Now the serpent was more subtle than any other wild creature that the Lord God had made. He said to the woman, "Did God say, 'You shall not eat of any tree of the garden'?" And the woman said to the serpent, "We may eat of the fruit of the trees of the garden; but God said, 'You shall

not eat of the fruit of the tree which is in the midst of the garden, neither shall you touch it, lest you die.'" But the serpent said to the woman, "You will not die. For God knows that when you eat of it your eyes will be opened, and you will be like God, knowing good and evil." So when the woman saw that the tree was good for food, and that it was a delight to the eyes, and that the tree was to be desired to make one wise, she took of its fruit and ate; and she also gave some to her husband, and he ate. Then the eyes of both were opened, and they knew that they were naked; and they sewed fig leaves together and made themselves aprons.

And they heard the sound of the Lord God walking in the garden in the cool of the day, and the man and his wife hid themselves from the presence of the Lord God among the trees of the garden. But the Lord God called to the man, and said to him, "Where are you?" And he said, "I heard the sound of thee in the garden, and I was afraid, because I was naked; and I hid myself." He said. "Who told you that you were naked? Have you eaten of the tree of which I commanded you not to eat?"

The man said, "The woman whom thou gavest to be with me, she gave me fruit of the tree, and I ate."

Then the Lord God said to the woman, "What is this that you have done?" The woman said, "The serpent beguiled me, and I ate." The Lord God said to the serpent,

"Because you have done this,
cursed are you above all cattle,
and above all wild animals;
upon your belly you shall go,
and dust you shall eat
all the days of your life.
I will put enmity between you and the woman,
and between your seed and her seed;
he shall bruise your head,
and you shall bruise his heel."
To the woman he said,
"I will greatly multiply your pain in childbearing;
in pain you shall bring forth children,
yet your desire shall be for your husband,
and he shall rule over you."
And to Adam he said,
"Because you have listened to the voice of your wife,
and have eaten of the tree of which I commanded you,
'You shall not eat of it,'
cursed is the ground because of you;
in toil you shall eat of it all the days of your life;
thorns and thistles it shall bring forth to you;

and you shall eat the plants of the field.
In the sweat of your face you shall eat bread
till you return to the ground,
for out of it you were taken;
you are dust,
and to dust you shall return."

The man called his wife's name Eve, because she was the mother of all living. And the Lord God made for Adam and for his wife garments of skins, and clothed them.

Then the Lord God said, "Behold, the man has become like one of us, knowing good and evil: and now, lest he put forth his hand and take also of the tree of life, and eat, and live for ever"—therefore the Lord God sent him forth from the garden of Eden, to till the ground from which he was taken. He drove out the man, and at the east of the garden of Eden he placed the cherubim, and a flaming sword which turned every way, to guard the way to the tree of life.

Genesis, Chapter 6–9: Noah

6 When men began to multiply on the face of the ground, and daughters were born to them, the sons of God saw that the daughters of men were fair; and they took to wife such of them as they chose. Then the Lord said, "My spirit shall not abide in man for ever, for he is flesh, but his days shall be a hundred and twenty years." The Nephilim were on the earth in those days, and also afterward, when the sons of God came in to the daughters of men, and they bore children to them. These were the mighty men that were of old, the men of renown.

The Lord saw that the wickedness of man was great in the earth, and that every imagination of the thoughts of his heart was only evil continually. And the Lord was sorry that he had made man on the earth, and it grieved him to his heart. So the Lord said, "I will blot out man whom I have created from the face of the ground, man and beast and creeping things and birds of the air, for I am sorry that I have made them." But Noah found favor in the eyes of the Lord.

These are the generations of Noah. Noah was a righteous man, blameless in his generation; Noah walked with God. And Noah had three sons, Shem, Ham, and Japheth.

Now the earth was corrupt in God's sight, and the earth was filled with violence. And God saw the earth, and behold, it was corrupt; for all flesh had corrupted their way upon the earth. And God said to Noah, "I have determined to make an end of all flesh: for the earth is filled with violence through them; behold, I will destroy them with the earth. Make yourself an ark of gopher wood; make rooms in the ark, and cover it inside

and out with pitch. This is how you are to make it: the length of the ark three hundred cubits, its breadth fifty cubits, and its height thirty cubits. Make a roof for the ark, and finish it to a cubit above; and set the door of the ark in its side; make it with lower, second, and third decks.

For behold, I will bring a flood of waters upon the earth, to destroy all flesh in which is the breath of life from under heaven: everything that is on the earth shall die. But I will establish my covenant with you: and you shall come into the ark, you, your sons, your wife, and your sons' wives with you. And of every living thing of all flesh, you shall bring two of every sort into the ark, to keep them alive with you; they shall be male and female. Of the birds according to their kinds, and of the animals according to their kinds, of every creeping thing of the ground according to its kind, two of every sort shall come in to you, to keep them alive. Also take with you every sort of food that is eaten, and store it up; and it shall serve as food for you and for them." Noah did this; he did all that God commanded him.

7 Then the Lord said to Noah, "Go into the ark, you and all your household, for I have seen that you are righteous before me in this generation. Take with you seven pairs of all clean animals, the male and his mate; and a pair of the animals that are not clean, the male and his mate; and seven pairs of the birds of the air also, male and female, to keep their kind alive upon the face of all the earth. For in seven days I will send rain upon the earth forty days and forty nights; and every living thing that I have made I will blot out from the face of the ground." And Noah did all that the Lord had commanded him.

Noah was six hundred years old when the flood of waters came upon the earth. And Noah and his sons and his wife and his sons' wives with him went into the ark, to escape the waters of the flood. Of clean animals, and of animals that are not clean, and of birds, and of everything that creeps on the ground, two and two, male and female, went into the ark with Noah, as God had commanded Noah. And after seven days the waters of the flood came upon the earth.

In the six hundredth year of Noah's life, in the second month, on the seventeenth day of the month, on that day all the fountains of the great deep burst forth, and the windows of the heavens were opened. And rain fell upon the earth forty days and forty nights. On the very same day Noah and his sons, Shem and Ham and Japheth, and Noah's wife and the three wives of his sons with them entered the ark, they and every beast according to its kind, and all the cattle according to their kinds, and every creeping thing that creeps on the earth according to its kind, and every bird according to its kind, every bird of every sort. They went into the ark with Noah, two and two of all flesh in which there was the breath of life.

And they that entered, male and female of all flesh, went in as God had commanded him; and the Lord shut him in.

The flood continued forty days upon the earth; and the waters increased, and bore up the ark, and it rose high above the earth. The waters prevailed and increased greatly upon the earth; and the ark floated on the face of the waters. And the waters prevailed so mightily upon the earth that all the high mountains under the whole heaven were covered: the waters prevailed above the mountains, covering them fifteen cubits deep. And all flesh died that moved upon the earth, birds, cattle, beasts, all swarming creatures that swarm upon the earth, and every man: everything on the dry land in whose nostrils was the breath of life died.

He blotted out every living thing that was upon the face of the ground, man and animals and creeping things and birds of the air; they were blotted out from the earth. Only Noah was left, and those that were with him in the ark. And the waters prevailed upon the earth a hundred and fifty days.

8 But God remembered Noah and all the beasts and all the cattle that were with him in the ark. And God made a wind blow over the earth, and the waters subsided; the fountains of the deep and the windows of the heavens were closed, the rain from the heavens was restrained, and the waters receded from the earth continually. At the end of a hundred and fifty days the waters had abated; and in the seventh month, on the seventeenth day of the month, the ark came to rest upon the mountains of Ararat. And the waters continued to abate until the tenth month; in the tenth month, on the first day of the month, the tops of the mountains were seen.

At the end of forty days Noah opened the window of the ark which he had made, and sent forth a raven; and it went to and fro until the waters were dried up from the earth. Then he sent forth a dove from him, to see if the waters had subsided from the face of the ground; but the dove found no place to set her foot, and she returned to him to the ark, for the waters were still on the face of the whole earth. So he put forth his hand and took her and brought her into the ark with him. He waited another seven days, and again he sent forth the dove out of the ark: and the dove came back to him in the evening, and lo, in her mouth a freshly plucked olive leaf; so Noah knew that the waters had subsided from the earth.

Then he waited another seven days, and sent forth the dove; and she did not return to him any more.

In the six hundred and first year, in the first month, the first day of the month, the waters were dried from off the earth; and Noah removed the covering of the ark, and looked, and behold, the face of the ground was dry. In the second month, on the twenty-seventh day of the month, the earth was dry. Then God said to Noah, "Go forth from the ark, you and your wife, and your sons and your sons' wives with you. Bring forth with you every living thing that is with you of all flesh—birds and animals and

every creeping thing that creeps on the earth—that they may breed abundantly on the earth, and be fruitful and multiply upon the earth."

So Noah went forth, and his sons and his wife and his sons' wives with him. And every beast, every creeping thing, and every bird, everything that moves upon the earth went forth by families out of the ark.

Then Noah built an altar to the Lord, and took of every clean animal and of every clean bird, and offered burnt offerings on the altar. And when the Lord smelled the pleasing odor, the Lord said in his heart, "I will never again curse the ground because of man, for the imagination of man's heart is evil from his youth; neither will I ever again destroy every living creature as I have done.

While the earth remains, seedtime and harvest, cold and heat, summer and winter, day and night, shall not cease."

[Chapter 9, verses 1–17, omitted]

9 ... The sons of Noah who went forth from the ark were Shem, Ham, and Japheth. Ham was the father of Canaan. These three were the sons of Noah; and from these the whole earth was peopled.

Noah was the first tiller of the soil. He planted a vineyard; and he drank of the wine, and became drunk, and lay uncovered in his tent. And Ham, the father of Canaan, saw the nakedness of his father, and told his two brothers outside. Then Shem and Japheth took a garment, laid it upon both their shoulders, and walked backward and covered the nakedness of their father; their faces were turned away, and they did not see their father's nakedness. When Noah awoke from his wine and knew what his youngest son had done to him, he said,

> "Cursed be Canaan;
> a slave of slaves shall he be to his brothers."
> He also said,
> "Blessed by the Lord my God be Shem;
> and let Canaan be his slave.
> God enlarge Japheth,
> and let him dwell in the tents of Shem;
> and let Canaan be his slave."

After the flood Noah lived three hundred and fifty years. All the days of Noah were nine hundred and fifty years; and he died.

From
The New Testament, Gospels
According to Luke and Matthew

The Gospel According to Luke, Chapter 1, verse 26–56, and Chapter 2, verse 1– 21: The Nativity

1 . . . the angel Gabriel was sent from God to a city of Galilee named Nazareth to a virgin betrothed to a man whose name was Joseph, of the house of David; and the virgin's name was Mary. And he came to her and said, "Hail, O favored one, the Lord is with you!" But she was greatly troubled at the saying, and considered in her mind what sort of greeting this might be. And the angel said to her, "Do not be afraid, Mary, for you have found favor with God.

And behold, you will conceive in your womb and bear a son, and you shall call his name Jesus.

> He will be great, and will be called
> the Son of the Most High;
> and the Lord God will give to him
> the throne of his father David,
> and he will reign over the house of Jacob for ever;
> and of his kingdom there will be no end."

> And Mary said to the angel, "How can this be, since I have no
> husband?"

> And the angel said to her,
> "The Holy Spirit will come upon you,
> and the power of the Most High will overshadow you;
> therefore the child to be born will be called holy,
> the Son of God.

And behold, your kinswoman Elizabeth in her old age has also conceived a son; and this is the sixth month with her who was called barren.

For with God nothing will be impossible." And Mary said, "Behold I am the handmaid of the Lord; let it be to me according to your word." And the angel departed from her.

In those days Mary arose and went with haste into the hill country, to a city of Judah, and she entered the house of Zechariah and greeted Elizabeth. And when Elizabeth heard the greeting of Mary, the babe leaped in her womb; and Elizabeth was filled with the Holy Spirit and she exclaimed

with a loud cry, "Blessed are you among women, and blessed is the fruit of your womb!

And why is this granted me, that the mother of my Lord should come to me? For behold, when the voice of your greeting came to my ears, the babe in my womb leaped for joy.

And blessed is she who believed that there would be a fulfillment of what was spoken to her from the Lord." And Mary said,

"My soul magnifies the Lord,
and my spirit rejoices in God my Savior,
for he has regarded the low estate of his handmaiden.
For behold, henceforth, all generations will call me blessed;
for he who is mighty has done great
things for me, and holy is his name.
And his mercy is on those who fear him
from generation to generation.
He has shown strength with his arm,
he has scattered the proud in the imagination of their hearts,
he has put down the mighty from their thrones,
and exalted those of low degree;
he has filled the hungry with good things,
and the rich he has sent empty away.
He has helped his servant Israel,
in remembrance of his mercy,
as he spoke to our fathers,
to Abraham and to his posterity for ever."

And Mary remained with her about three months, and returned to her home.

[Chapter 1, verses 57–80, omitted]

2 In those days a decree went out from Caesar Augustus that all the world should be enrolled. This was the first enrollment, when Quirinius was governor of Syria. And all went to be enrolled, each to his own city. And Joseph also went up from Galilee, from the city of Nazareth, to Judea, to the city of David, which is called Bethlehem, because he was of the house and lineage of David, to be enrolled with Mary, his betrothed, who was with child. And while they were there, the time came for her to be delivered. And she gave birth to her first-born son and wrapped him in swaddling cloths, and laid him in a manger, because there was no place for them in the inn.

And in that region there were shepherds out in the field, keeping watch over their flock by night. And an angel of the Lord appeared to them,

and the glory of the Lord shone around them, and they were filled with fear. And the angel said to them, "Be not afraid; for behold, I bring you good news of a great joy which will come to all the people; for to you is born this day in the city of David a Savior, who is Christ the Lord. And this will be a sign for you: you will find a babe wrapped in swaddling cloths and lying in a manger." And suddenly there was with the angel a multitude of the heavenly host praising God and saying,

"Glory to God in the highest,
and on earth peace among men
with whom he is pleased!"

When the angels went away from them into heaven, the shepherds said to one another, "Let us go over to Bethlehem and see this thing that has happened, which the Lord has made known to us." And they went with haste, and found Mary and Joseph, and the babe lying in a manger. And when they saw it they made known the saying which had been told them concerning this child; and all who heard it wondered at what the shepherds told them. But Mary kept all these things, pondering them in her heart. And the shepherds returned, glorifying and praising God for all they had heard and seen, as it had been told them.

And at the end of eight days, when he was circumcised, he was called Jesus, the name given by the angel before he was conceived in the womb. . . .

**The Gospel According to Matthew,
Chapter 2: The Visit of the Wise Men**

2 Now when Jesus was born in Bethlehem of Judea in the days of Herod the king, behold, wise men from the East came to Jerusalem, saying, "Where is he who has been born king of the Jews? For we have seen his star in the East, and have come to worship him." When Herod the king heard this, he was troubled, and all Jerusalem with him; and assembling all the chief priests and scribes of the people, he inquired of them where the Christ was to be born. They told him, "In Bethlehem of Judea; for so it is written by the prophet:

'And you, O Bethlehem, in the land of Judah,
are by no means least among the rulers of Judah;
for from you shall come a ruler
who will govern my people Israel.'"

Then Herod summoned the wise men secretly and ascertained from them what time the star appeared; and he sent them to Bethlehem, saying,

"Go and search diligently for the child, and when you have found him bring me word, that I too may come and worship him." When they had heard the king they went their way; and lo, the star which they had seen in the East went before them, till it came to rest over the place where the child was. When they saw the star, they rejoiced exceedingly with great joy; and going into the house they saw the child with Mary his mother, and they fell down and worshiped him. Then, opening their treasures, they offered him gifts, gold and frankincense and myrrh. And being warned in a dream not to return to Herod, they departed to their own country by another way.

Now when they had departed, behold, an angel of the Lord appeared to Joseph in a dream and said, "Rise, take the child and his mother, and flee to Egypt, and remain there till I tell you; for Herod is about to search for the child, to destroy him." And he rose and took the child and his mother by night, and departed to Egypt, and remained there until the death of Herod. This was to fulfil what the Lord had spoken by the prophet, "Out of Egypt have I called my son."

Then Herod, when he saw that he had been tricked by the wise men, was in a furious rage, and he sent and killed all the male children in Bethlehem and in all that region who were two years old or under, according to the time which he had ascertained from the wise men. Then was fulfilled what was spoken by the prophet Jeremiah:

"A voice was heard in Ramah,
wailing and loud lamentation,
Rachel weeping for her children;
she refused to be consoled,
because they were no more."

But when Herod died, behold, an angel of the Lord appeared in a dream to Joseph in Egypt, saying, "Rise, take the child and his mother, and go to the land of Israel, for those who sought the child's life are dead." And he rose and took the child and his mother, and went to the land of Israel. But when he heard that Archelaus reigned over Judea in place of his father Herod, he was afraid to go there, and being warned in a dream he withdrew to the district of Galilee. And he went and dwelt in a city called Nazareth, that what was spoken by the prophets might be fulfilled, "He shall be called a Nazarene."

The Gospel According to Matthew, Chapter 26–28: The Passion

26 When Jesus had finished all these sayings, he said to his disciples, "You know that after two days the Passover is coming, and the Son of man will be delivered up to be crucified."

Then the chief priests and the elders of the people gathered in the palace of the high priest, who was called Caiaphas, and took counsel together in order to arrest Jesus by stealth and kill him. But they said, "Not during the feast, lest there be a tumult among the people."

Now when Jesus was at Bethany in the house of Simon the leper, a woman came up to him with an alabaster jar of very expensive ointment, and she poured it on his head, as he sat at table. But when the disciples saw it, they were indignant, saying, "Why this waste? For this ointment might have been sold for a large sum, and given to the poor." But Jesus, aware of this, said to them, "Why do you trouble the woman? For she has done a beautiful thing to me. For you always have the poor with you, but you will not always have me. In pouring this ointment on my body she has done it to prepare me for burial.

Truly, I say to you, wherever this gospel is preached in the whole world, what she has done will be told in memory of her."

Then one of the twelve, who was called Judas Iscariot, went to the chief priests and said, "What will you give me if I deliver him to you?" And they paid him thirty pieces of silver. And from that moment he sought an opportunity to betray him.

Now on the first day of Unleavened Bread the disciples came to Jesus, saying, "Where will you have us prepare for you to eat the passover?" He said, "Go into the city to such a one, and say to him, 'The Teacher says, My time is at hand; I will keep the passover at your house with my disciples.'" And the disciples did as Jesus had directed them, and they prepared the passover.

When it was evening, he sat at table with the twelve disciples: and as they were eating, he said, "Truly, I say to you, one of you will betray me." And they were very sorrowful, and began to say to him one after another, "Is it I, Lord?" He answered, "He who has dipped his hand in the dish with me, will betray me. The Son of man goes as it is written of him, but woe to that man by whom the Son of man is betrayed! It would have been better for that man if he had not been born." Judas, who betrayed him, said, "Is it I, Master?" He said to him, "You have said so."

Now as they were eating, Jesus took bread, and blessed, and broke it, and gave it to the disciples and said, "Take, eat; this is my body." And he took a cup, and when he had given thanks he gave it to them, saying, "Drink of it, all of you; for this is my blood of the covenant, which is poured out for many for the forgiveness of sins. I tell you I shall not drink again of this fruit of the vine until that day when I drink it new with you in my Father's kingdom."

And when they had sung a hymn, they went out to the Mount of Olives. Then Jesus said to them, "You will all fall away because of me this night; for it is written, 'I will strike the shepherd, and the sheep of the flock will be scattered.' But after I am raised up, I will go before you to Galilee."

Peter declared to him, "Though they all fall away because of you, I will never fall away." Jesus said to him, "Truly, I say to you, this very night, before the cock crows, you will deny me three times." Peter said to him, "Even if I must die with you, I will not deny you." And so said all the disciples.

Then Jesus went with them to a place called Gethsemane, and he said to his disciples, "Sit here, while I go yonder and pray." And taking with him Peter and the two sons of Zebedee, he began to be sorrowful and troubled. Then he said to them, "My soul is very sorrowful, even to death; remain here, and watch with me." And going a little farther he fell on his face and prayed, "My Father, if it be possible, let this cup pass from me; nevertheless, not as I will, but as thou wilt." And he came to the disciples and found them sleeping; and he said to Peter, "So, could you not watch with me one hour? Watch and pray that you may not enter into temptation; the spirit indeed is willing, but the flesh is weak." Again, for the second time, he went away and prayed, "My Father, if this cannot pass unless I drink it, thy will be done." And again he came and found them sleeping, for their eyes were heavy. So, leaving them again, he went away and prayed for the third time, saying the same words. Then he came to the disciples and said to them, "Are you still sleeping and taking your rest? Behold, the hour is at hand, and the Son of man is betrayed into the hands of sinners. Rise, let us be going; see, my betrayer is at hand."

While he was still speaking, Judas came, one of the twelve, and with him a great crowd with swords and clubs, from the chief priests and the elders of the people. Now the betrayer had given them a sign, saying, "The one I shall kiss is the man; seize him." And he came up to Jesus at once and said, "Hail Master!" And he kissed him. Jesus said to him, "Friend, why are you here?" Then they came up and laid hands on Jesus and seized him. And behold, one of those who were with Jesus stretched out his hand and drew his sword, and struck the slave of the high priest, and cut off his ear.

Then Jesus said to him, "Put your sword back into its place; for all who take the sword will perish by the sword. Do you think that I cannot appeal to my Father, and he will at once send me more than twelve legions of angels? But how then should the scriptures be fulfilled, that it must be so?" At that hour Jesus said to the crowds, "Have you come out as against a robber, with swords and clubs to capture me? Day after day I sat in the temple teaching, and you did not seize me. But all this has taken place, that the scriptures of the prophets might be fulfilled." Then all the disciples forsook him and fled.

Then those who had seized Jesus led him to Caiaphas the high priest, where the scribes and the elders had gathered. But Peter followed him at a distance, as far as the courtyard of the high priest, and going inside he sat with the guards to see the end.

Now the chief priests and the whole council sought false testimony

against Jesus that they might put him to death, but they found none, though many false witnesses came forward. At last two came forward and said, "This fellow said, 'I am able to destroy the temple of God, and to build it in three days.'" And the high priest stood up and said, "Have you no answer to make? What is it that these men testify against you?" But Jesus was silent. And the high priest said to him, "I adjure you by the living God, tell us if you are the Christ, the Son of God." Jesus said to him, "You have said so, But I tell you, hereafter you will see the Son of man seated at the right hand of Power, and coming on the clouds of heaven."

Then the high priest tore his robes, and said, "He has uttered blasphemy. Why do we still need witnesses? You have now heard his blasphemy.

What is your judgment?" They answered, "He deserves death." Then they spat in his face, and struck him; and some slapped him, saying, "Prophesy to us, you Christ! Who is it that struck you?"

Now Peter was sitting outside in the courtyard. And a maid came up to him, and said, "You also were with Jesus the Galilean." But he denied it before them all, saying, "I do not know what you mean." And when he went out to the porch, another maid saw him, and she said to the bystanders, "This man was with Jesus of Nazareth." And again he denied it with an oath, "I do not know the man." After a little while the bystanders came up and said to Peter, "Certainly you are also one of them, for your accent betrays you." Then he began to invoke a curse on himself and to swear, "I do not know the man." And immediately the cock crowed. And Peter remembered the saying of Jesus, "Before the cock crows, you will deny me three times." And he went out and wept bitterly.

27 When morning came, all the chief priests and the elders of the people took counsel against Jesus to put him to death; and they bound him and led him away and delivered him to Pilate the governor.

When Judas, his betrayer, saw that he was condemned, he repented and brought back the thirty pieces of silver to the chief priests and the elders, saying, "I have sinned in betraying innocent blood." They said, "What is that to us? See to it yourself." And throwing down the pieces of silver in the temple, he departed; and he went and hanged himself. But the chief priests, taking the pieces of silver, said, "It is not lawful to put them into the treasury, since they are blood money." So they took counsel, and bought with them the potter's field, to bury strangers in. Therefore that field has been called the Field of Blood to this day. Then was fulfilled what had been spoken by the prophet Jeremiah, saying, "And they took the thirty pieces of silver, the price of him on whom a price had been set by some of the sons of Israel, and they gave them for the potter's field, as the Lord directed me."

Now Jesus stood before the governor; and the governor asked him,

"Are you the King of the Jews?" Jesus said to him, "You have said so." But when he was accused by the chief priests and elders, he made no answer. Then Pilate said to him, "Do you not hear how many things they testify against you?" But he gave him no answer, not even to a single charge; so that the governor wondered greatly.

Now at the feast the governor was accustomed to release for the crowd any one prisoner whom they wanted. And they had then a notorious prisoner, called Barabbas. So when they had gathered, Pilate said to them, "Whom do you want me to release for you, Barabbas or Jesus who is called Christ?" For he knew that it was out of envy that they had delivered him up. Besides, while he was sitting on the judgment seat, his wife sent word to him, "Have nothing to do with that righteous man, for I have suffered much over him today in a dream." Now the chief priests and the elders persuaded the people to ask for Barabbas and destroy Jesus.

The governor again said to them, "Which of the two do you want me to release for you?" And they said, "Barabbas." Pilate said to them, "Then what shall I do with Jesus who is called Christ?" They all said, "Let him be crucified." And he said, "Why, what evil has he done?" But they shouted all the more, "Let him be crucified."

So when Pilate saw that he was gaining nothing, but rather that a riot was beginning, he took water and washed his hands before the crowd, saying, "I am innocent of this man's blood; see to it yourselves." And all the people answered, "His blood be on us and on our children!"

Then he released for them Barabbas, and having scourged Jesus, delivered him to be crucified.

Then the soldiers of the governor took Jesus into the praetorium, and they gathered the whole battalion before him. And they stripped him and put a scarlet robe upon him, and plaiting a crown of thorns they put it on his head, and put a reed in his right hand. And kneeling before him they mocked him, saying, "Hail, King of the Jews!" And they spat upon him, and took the reed and struck him on the head. And when they had mocked him, they stripped him of the robe, and put his own clothes on him, and led him away to crucify him.

As they were marching out, they came upon a man of Cyrene, Simon by name; this man they compelled to carry his cross. And when they came to a place called Golgotha (which means the place of a skull), they offered him wine to drink, mingled with gall; but when he tasted it, he would not drink it. And when they had crucified him, they divided his garments among them by casting lots; then they sat down and kept watch over him there. And over his head they put the charge against him, which read, "This is Jesus the King of the Jews." Then two robbers were crucified with him, one on the right and one on the left. And those who passed by derided him, wagging their heads and saying, "You who would destroy the temple and build it in three days, save yourself! If you are the Son of God, come

down from the cross." So also the chief priests, with the scribes and elders, mocked him, saying, "He saved others; he cannot save himself. He is the King of Israel; let him come down now from the cross, and we will believe in him.

He trusts in God; let God deliver him now, if he desires him; for he said, 'I am the Son of God.'" And the robbers who were crucified with him also reviled him in the same way.

Now from the sixth hour there was darkness over all the land until the ninth hour. And about the ninth hour Jesus cried with a loud voice, "Eli, Eli, lama sabachthani?" that is, "My God, my God, why hast thou forsaken me?" And some of the bystanders hearing it said, "This man is calling Elijah." And one of them at once ran and took a sponge, filled it with vinegar, and put it on a reed, and give it to him to drink. But the others said, "Wait, let us see whether Elijah will come to save him." And Jesus cried again with a loud voice and yielded up his spirit.

And behold, the curtain of the temple was torn in two, from top to bottom; and the earth shook, and the rocks were split; the tombs also were opened, and many bodies of the saints who had fallen asleep were raised, and coming out of the tombs after his resurrection they went into the holy city and appeared to many. When the centurion and those who were with him, keeping watch over Jesus, saw the earthquake and what took place, they were filled with awe, and said, "Truly this was a son of God!"

[Verses 55–66 omitted]

28 Now after the sabbath, toward the dawn of the first day of the week, Mary Magdalene and the other Mary went to see the sepulchre. And behold, there was a great earthquake; for an angel of the Lord descended from heaven and came and rolled back the stone, and sat upon it. His appearance was like lightning, and his raiment white as snow. And for fear of him the guards trembled and became like dead men. But the angel said to the women, "Do not be afraid; for I know that you seek Jesus who was crucified. He is not here; for he has risen, as he said. Come, see the place where he lay. Then go quickly and tell his disciples that he has risen from the dead, and behold, he is going before you to Galilee; there you will see him. Lo, I have told you." So they departed quickly from the tomb with fear and great joy, and ran to tell his disciples. And behold, Jesus met them and said, "Hail!" And they came up and took hold of his feet and worshiped him. Then Jesus said to them, "Do not be afraid; go and tell my brethren to go to Galilee, and there they will see me."

[Verses 11–16 omitted]

7

Ernst Kitzinger

LATE ANTIQUE
AND EARLY CHRISTIAN
ART

KITZINGER'S INTRODUCTION TO HIS BOOK *Early Medieval Art* is a landmark in modern scholarship. Most earlier authors thought of Early Christian art as a wasteland, a "no-man's-land," sandwiched between the art of Rome and the great achievements of the later Middle Ages. Specialists in Classical art thought Early Christian art was decadent, while students of Medieval art regarded it as too primitive to be of interest. Not so, according to Kitzinger: the strange looking objects produced by European artists and craftsmen from the time of the late Roman empire until the reign of Charlemagne "occupied a key position between the Classical and Medieval periods."

Kitzinger's reevaluation of the importance of Early Christian art is part of a longer process. At one time, in the Renaissance, the art of *all* of the Middle Ages was condemned as inferior. Renaissance writers of the fifteenth and sixteenth centuries, excited by the rediscovery of ancient Rome, valued only Classical works, because they had inspired the new Renaissance style (see Chapter 11). These writers invented the very idea of a "Middle Age" (between the Classical period and the Renaissance) when the "wrong" kind of art was in favor. Medieval buildings had strange, un-Roman, pointed arches. Medieval statues lacked the physical solidity and anatomical accuracy of Roman and Renaissance painting and sculpture.

Gradually the various styles of Medieval art began to interest first a few specialists and then a wider public. Yet even after Gothic and Romanesque churches, Carolingian manuscript painting, and Byzantine icons had become the objects of study and admiration, the very earliest Christian art still interested few people.

There is good reason why the twentieth century is the time when Early Christian art began to arouse interest. By 1940, when Kitzinger's book was first published, the world had grown accustomed to a kind of art that was neither idealized nor realistic (see Chapter 19, selection by Schapiro). Like Early Christian art, twentieth-century art is abstract, symbolic, often arbitrary in its distortion of the human figure and in its treatment of space. Modern art had prepared us to see the value of Early Christian art. It was Kitzinger who put that value into words.

Early Medieval Art was written partly as a guidebook to help visitors to the British Museum understand what they would see in the exhibit halls. Most of its examples were necessarily small works—ivory carvings, book pages, silver dishes—that had somehow found their way to England's great national collections. (The British Museum is also one of the world's greatest libraries, and it provided Professor Kitzinger with excellent examples of Medieval manuscript painting, discussed especially in later chapters.) It is a measure of Kitzinger's achievement that the ideas he sets forth, based on these small examples, can easily be applied to Early Christian and Late Antique art that is neither small nor portable, and thus of course not inside the British Museum. His description of a fourth-century ivory panel [Figure 6] can serve as an example. Kitzinger's method can be applied to almost any of the larger works illustrated in an art history text—mosaics, sarcophagi, catacomb paintings—without any difficulty.

Kitzinger's essay covers three areas: (1) the *roots* of Early Christian artistic style; (2) the *purpose* of Early Christian artistic style, and positive and negative judgments of the style based upon its own purpose; and (3) the *fruits* of Early Christian art, that is, the part it played in the development of Medieval art.

From
Early Medieval Art

The Late Antique and Early Christian Period

The student of Early Medieval art is faced with the difficult task of decid-
ing at what date the Middle Ages began. Some historians have settled for
313, the year of the Edict of Milan, through which Christianity became
recognised as a state religion; others hold that the abdication of the last
Roman emperor in 476 marks the turning point between the Classical and
Medieval periods, while yet another view favours the foundation of the
first Germanic empire under Charlemagne in the year 800.

The last date is the one most frequently adopted by art historians: it is
not customary to talk of Medieval art before the ascendancy of a Christian
civilisation in northern Europe. The preceding centuries, known in art
history as "Late Antique" and "Early Christian," were long a kind of no-
man's-land, rarely entered by the Classical archaeologist and even more
seriously neglected by the medievalist. Art was thought to have come to an
end under the later Roman emperors, and the five hundred years which
elapsed between the age of Constantine (306–337) and that of Char-
lemagne (768–814) were regarded as devoid of interest from the art histor-
ical point of view. What attention they did attract was warranted by re-
ligious rather than aesthetic considerations, this being the period when the
first churches were built and representations of Christ and of many Chris-
tian subjects took shape.

During the last few decades, however, research has revealed more
and more clearly the great importance of the art of these intermediate
centuries. Far from having been merely decadent and dull, it is now
known to have played a vital role in the evolution of Medieval style. Its
significance is twofold: first, it ensured the continuance of the Classical
tradition, which was in grave danger of dying out with the disappearance
of pagan religion and pagan civilisation, and, secondly, it provided the
starting point for that process of transformation by which the Classical style

Ernst Kitzinger, *Early Medieval Art*, third edition, revised by David Buckton (London: British
Museum Publications Ltd., 1983). Excerpts from Chapter I, pp. 11–24. First published in
London, 1940. Published in the United States by Indiana University Press, Bloomington,
Indiana.

of the Greeks and Romans changed into the abstract and transcendental style of the Middle Ages.

It may be surprising to hear that the Classical tradition continued into Medieval art, but we must understand that the very existence of representational art in the Middle Ages is an illustration of Classical survival. At first Christianity was averse to any kind of image, rejecting it not only as a possible source of idolatry but also as a symbol of worldly splendour and luxury; it was as a concession to paganism that art was admitted into the Church, and consequently many details of Antique iconography and style found their way into Christian art and survived into the Middle Ages. Neither do we always realise that what appears fundamentally to distinguish Medieval from Classical art—its naive, primitive and archaic character—was the result not so much of the influence of the barbarians of northern Europe as of a gradual internal transformation detectable in Late Classical art even before pagan Roman art had come to an end. The Early Christian centuries thus occupied a key position between the Classical and Medieval periods, and, however brief, a survey of the development during these centuries is essential to an understanding of Early Medieval art.

It was during the third and fourth centuries that the Christians began to adapt classical art to their purposes. We have little evidence of what may properly be called artistic activity among Christian communities during the first two centuries of their existence, but the more followers they attracted in the large cities of the Graeco-Roman world the more difficult it became to maintain the austerity of the primitive Church. If the average pagan convert could not be expected to give up the pleasant and beautiful things with which he surrounded himself in his everyday life, still less could he be expected to exclude the arts from his religious observance: accustomed to an array of marble statuary representing the gods he worshipped, he would be difficult to attract to a religion which had no more tangible object of veneration to offer him than the written word.

Early Christian art betrays this origin in its entire character. The earliest Christian works of art were produced in a completely pagan environment; in the third and fourth centuries there were probably painters and sculptors who worked for both a Christian and a pagan clientele, and it is small wonder that Christian art borrowed from contemporary pagan art its style and sometimes even its subject-matter. There are many instances of Classical figures being taken over unchanged by Christian artists. We find Cupids, personifications of the seasons and other pagan allegorical subjects in the wall-decorations of Roman catacombs belonging to this period; Tritons and Nereids were frequently represented on Christian sarcophagi. All these figures were regarded as compatible with the new religion; they were general symbols of the next world and eternal happiness—matters of no less importance to Christians than to the heathen. . . .

. . . Cases of actual copying, however, although the most obvious examples of pagan survival, are not perhaps those which had the greatest bearing on the subsequent development of Christian art. As early as the third century attempts were made to give traditional figures a new and specifically Christian meaning. We find pictures of Christ modelled on figures of Apollo, Helios, or some other youthful god or hero; no more suitable way could be found of expressing his divine mission than by giving him features universally associated with the gods. Even more frequently he was represented as a shepherd with his flock; while this theme was of course inspired by Gospel texts, Classical models were followed in rendering it. During the fourth century these youthful and idyllic representations of Christ began to be replaced by a more austere and majestic bearded type, but the inspiration again came from pagan art, the models being older Olympian gods, such as Zeus or Asklepios, or portraits of great philosophers, who symbolised supreme wisdom. Angels were easily derived from the Victories so frequent in Greek and Roman art, and the insignia of imperial power and military triumph became symbols of the victorious Church. . . .

The writers of Gospel manuscripts conformed to the pagan custom of inserting at the beginning of the book a portrait of the author, in this case the evangelist, who was represented exactly as the Classical writers and philosophers had been; this was the origin of the evangelist portraits which played such a conspicuous part in Medieval book-illumination. Nor was the process of adaptation confined to figural art: the Early Christian church had the form of the basilica of the Roman market-place, adapted to the requirements of the divine service.

These few examples show that Early Christian art was developed from pagan prototypes. It may even be assumed that the Christians, having begun to use art for their own purposes, made a point of adapting well-known Classical subjects so as to render the change in inner meaning all the more apparent. There were, however, many themes for which no models were available, notably New Testament stories; these had to be conceived afresh, and it is in these free inventions that the full force of the Classical tradition is apparent. There was certainly no prototype in pagan art for the Raising of Lazarus, but the artist naturally set the scene in front of a Classical tomb; the Entry into Jerusalem was modelled on an emperor's triumphal arrival at the gates of one of his cities. Such instances can easily be multiplied.

In company with Classical iconography, Classical style naturally penetrated Christian art. There is no stylistic difference between Christian painting and sculpture of the third and fourth centuries and contemporary pagan work. Catacomb paintings were executed in the manner familiar from the wall-decorations of Roman houses; the style in both cases is a debased version of the impressionistic manner evolved in the early days of

the Roman Empire and seen to best advantage in the frescoes of Pompeii. The paintings of the Early Christian period were all executed in this versatile technique, capable of sketching with light brush-strokes a figure in lively action with a recognisable "glance" in the eyes, surrounded by a landscape full of light and air. . . .

Neither pagan nor Christian works of art of this period lived up to the highest standards of Classical art, however. The Graeco-Roman style had completely degenerated by the time it was taken over by the Christians; even the outstanding works of Early Christian times . . . cannot really be compared with the highest achievements of Roman art, to say nothing of the masterpieces of the Hellenistic period. In the best examples the figures recall earlier work, but usually a certain stiffness and awkwardness in the poses, a lack of proportion in the bodies and an absence of expression in the faces are all too evident. The artists imitated the traditional forms without entering into the spirit; the beauty of the best Classical art had disappeared altogether.

These works can be described in other than purely negative terms, though, if they are judged by the standards not of the Classical age which lay behind them, but of the Medieval period which they foreshadowed. The very features which from the Classical point of view appear as shortcomings acquire a new and positive value when seen in the light of the development which was to follow. For even the earliest Christian works are not merely instances of the survival of Classical features: they also illustrate the other aspect of our transition period which makes it important from the point of view of Medieval art—the transformation of the Classical into a transcendental, abstract style. To trace the origins of these abstract tendencies we must again go back beyond the beginnings of Christian art, since they appeared in Roman art as early as the second century and their foundations lie in an even remoter past.

While the Greeks achieved the ideal representation of the human body and the Romans perfected individual portraiture and greatly advanced the representation of landscape and three-dimensional space, there were at the same time people with different tastes and different traditions who did not share the Classical artist's concern with the naturalistic representation of the outside world. In the East, in Mesopotamia and Persia, the ancient heritage of a rigid and hieratic official art had never entirely died out. In the north-east, beyond the shores of the Black Sea, were the people of the Steppes, the most prominent among them the Scythians, who had no monumental art at all but only portable objects decorated with fantastic designs. This was also true of the barbarian peoples in the north and north-west, notably the Celts with their richly decorated bronze objects.

These self-contained cultures, with artistic ideals differing widely from the Classical, had little direct influence on the development of style in the Late Antique period; what is more important from our point of view

was the existence of border regions between the Classical world and the eastern and barbarian lands. Classical art was as widespread as the empires with which it was associated. In Hellenistic times it was carried all over the Mediterranean by Alexander the Great; countries like Egypt were thoroughly hellenised at that time, and Classical influence was felt as far away as India. The same thing happened in Roman times, when the imperial legions carried Roman civilisation, and with it Classical art, to the Rhine, the Danube, the Thames, and all over North Africa and the Near East. Wherever it appeared, Graeco-Roman art was accepted as the standard, if only because it introduced to peoples previously unfamiliar with it the means of depicting lifelike human figures in stone, metal or paint. But Classical models followed by artists with quite different traditions naturally took on a local colour: the features of a figure were superficially the same as in Rome or Greece, but we often feel that the free pose, the lifelike and individualised expression of the face, the natural and easy relationship between figures—in short, all the essential qualities which the Greeks had discovered—have not been quite faithfully reproduced.

In many of these border regions we therefore find an art which is Classical in origin and general concept but not in spirit. Typical examples of such pseudo-Classical art are provided by lands in the Near East which had a strong artistic tradition of their own but sooner or later fell under Greek or Roman domination, among them North Africa, the Nile valley, Syria, Parthian and Sassanian Mesopotamia and Persia, inland Asia Minor and the island of Cyprus. . . . Common to all these different examples of "sub-Antique" art was the attempt to impose some abstract principle on the natural forms of Graeco-Roman art. In various ways, differing from place to place, the border regions of the Roman world cultivated deliberate stylisation in opposition to the naturalism of Classical art.

These "sub-Antique" traditions would probably not have been so important had they been confined to the outer regions of the Classical world. The decisive factor was the increasingly strong influence exerted by provincial styles on the art of the great cities, beginning as early as the second century but becoming much more marked during the third and fourth. This was a development pointing to sweeping changes in the artistic ideals of those centres; in fact it has often been said that internal changes taking place in Rome and the other great cities at the time were far more important than any influence from outside, and that the evolution of Late Antique art was largely the result of a complete transformation within the Roman Empire. It is, however, impossible to disregard the strong ties between Late Antique style and the "sub-Antique" art of the previous centuries which undoubtedly influenced its development. On the other hand, it would be hard to maintain that provincial styles were imposed upon the metropolitan cities against their will; the change was certainly not caused by provincial artists forcing their way into the big cities. On the contrary, the

abstract style was adopted readily, and, since in the course of the third and fourth centuries it began to appear on the most important imperial monuments, it was clearly no longer regarded as provincial, inferior or connected only with the lower strata of the population but was spontaneously recognised as the official art of Rome.

This points to profound changes in Roman life and taste, involving the abandonment of everything achieved by Classical art since the period of archaic Greek sculpture. It marks the end of almost a thousand years of striving after a "humanised" art, in which the Mediterranean cultures had outshone all their more easterly predecessors. The most obvious way of explaining this important change is to ascribe it to a general decline in artistic skill, a result of the increasingly unstable political and economic conditions in the decadent Roman Empire. According to this theory, the growing resemblance between official Roman art and provincial art showed that official art was itself becoming provincial. Artists no longer trained to paint or carve a lifelike human figure, to study the characteristics of an individual face or to create the illusion of three-dimensional space in a painting or relief would inevitably produce the flat abstract compositions and stiff impersonal figures which had all along marked the less pretentious works in the provinces.

There is undoubtedly some truth in this assertion. The average Late Roman work of art betrays considerable carelessness; a decline in technique and craftsmanship resulted in simplification amounting to crudity. On the other hand it is quite clear that there were some who found new possibilities and positive merits in this 'provincial' style. If Classical ideals were abandoned, it was not just because they ceased to hold interest: artists began to pursue new objectives for which "sub-Antique" art offered more adequate forms of expression. . . .

[A good] example of the new and positive tendencies in Late Roman art . . . [is] an ivory panel with the apotheosis of an emperor [Figure 6], also probably a Roman work of the later fourth century. Both in style and spirit, this carving marks the dawn of the Middle Ages in the late pagan art of Rome. There are Medieval elements even in its subject-matter. In the lower half of the panel we see an emperor, whose identity has never been definitely established, seated in a carriage drawn by four elephants. In the upper half, the same person is being carried to heaven—represented by signs of the Zodiac, the sun-god and a number of busts of uncertain significance—by two naked winged genii. In the centre is a veiled pyre, from which a naked deity drives heavenwards in a chariot, escorted by two eagles. Not all the details of this panel have been adequately explained, but it is clearly an elaborate representation of the emperor's progress to the next world. It illustrates the belief in a life after death which, although in existence throughout the Classical period, had never taken such definite shape and had never been the subject of so much interest and speculation as in

Figure 6 *Apotheosis of an emperor. Ivory panel, The British Museum, London.*

Reproduced by courtesy of the Trustees of The British Museum.

this late period. The neoplatonic and Mithraic beliefs which dominated philosophy and religion in Late Roman times were centred in the hereafter, and the panel exemplifies the interest in the supernatural and transcendental which had taken possession of the Classical world and was one of the signs heralding the end of Classical Antiquity.

The style of this carving, although at first sight totally decadent, contains novel elements. There is a complete and significant neglect of the third dimension: the figures, although meant to be at varying distances from the spectator, all appear in one plane, and, while an attempt was made to render in perspective the canopy surrounding the emperor, the illusion of depth is destroyed by the alignment of the elephants' feet with the wheel of the carriage in the foreground. Equally significant are the loss of individual characteristics in the faces, the staring eyes and the awkward poses of the figures. All these features are familiar from "sub-Antique" art; if they now begin to occur on works clearly of an official character, it is not—or not just—because they require less skill. There is a positive intention behind their use. For one thing, the absence of perspective and the simplified composition and figures focus attention on essentials: the artist's main interest was in his story, he was anxious to convey a particular message, and he has invited us to concentrate on this rather than on details of form. In Classical works of art we always find a perfect balance between content and form; the loss of this balance marked a new stage in art history, a stage in which art had become a vehicle for the propagation of certain doctrines.

Yet it would be wrong to say that our artist simply neglected formal values: there is in this carving an almost deliberate protest against realism. The sculptor has made it clear that he had no confidence in formal beauty or naturalism. He has disregarded the laws of nature; he shows that he was not interested in such things as three-dimensional space and the anatomy of the human body. For these he has substituted other values. His concern was the abstract relationship between things rather than the things themselves. Instead of a naturalistic scene he has given us a solemn assemblage of persons, with the emperor as the central power. A composition arranged like a geometric pattern on a single plane with a blank background of infinite depth is removed from the sphere of actual life and has a spiritual significance, a symbolic and transcendental character. There are, therefore, new and positive qualities in this so-called decadence which are closely bound up with the moral and religious changes the subject-matter of our panel reflects. The tendency of the age was to seek an escape from the material world, and men found refuge and consolation in the spiritual.

The scene is not merely a statement of such values, however. Perhaps its most significant aspect is its strong and direct appeal to the spectator. A Classical work of art is entirely self-contained: figures on a Greek relief

turn to each other, unaware of our presence and independent of it. The scene on the ivory, on the other hand, is presented to us ceremonially: all the principal figures are conscious of our presence, and the whole composition is spread before us and is meaningless without a spectator. Not only had the outlook of the artist changed, then, but also his function. He was making a direct appeal to his public, he had a definite message to convey, and he was also aiming at a definite psychological effect, as the solemn and awe-inspiring figures clearly show. An entirely new art was in the making here, differing from Classical art both in its approach to the outside world and in its relationship to the spectator. The style of "sub-Antique" art was adopted because it offered these new aims more adequate expression; it was adapted to serve a new purpose.

The full result of this revolutionary tendency did not become apparent until much later: its ultimate outcome was the art of the high Middle Ages. It was left to the painters and sculptors of the twelfth and thirteenth centuries to discover the consummate form for the spiritual and transcendental, and it was the Medieval Church which perfected the use of art as a didactic instrument and as a vehicle for the propagation of the faith. The rigid solemnity to which our sculptor aspired eventually materialised in the figures of Christ in Majesty enthroned over the porches of Medieval cathedrals. The motionless impersonal faces monotonously arrayed in the upper zone of our carving had as their successors the rows of saints in Medieval paintings and reliefs. Roman art of the third and fourth centuries initiated this movement, and therein lies its greatest significance. It should be noted that the decisive turn took place at a time when there was still very little Christian art. Classical art became "medieval" before it became Christian: the new creed was not a primary cause of the change. The art which the Christians took over from their pagan contemporaries was already on its way towards the Middle Ages.

8

Marilyn Stokstad

THE ROAD TO SANTIAGO DE COMPOSTELA AND THE MEDIEVAL PILGRIMAGE

A GLANCE AT THE MAP OF Europe is enough to raise curiosity about Santiago de Compostela. The town is named after Saint James (Santiago in Spanish). Situated in the Spanish province of Galicia, about as far West as Europe extends, Santiago seems an unlikely place to have attracted travelers in an age when a horse was a luxury and ones feet the commonest means of transport. But Santiago had been the site of a Roman settlement. It may be that Medieval discoveries of the remains of Roman soldiers led to the belief that Saint James's bones had been miraculously transported to distant Spain. Moved by devotion, repentance, or thankfulness, the Medieval pilgrim undertook the arduous journey to this holy site.

Perhaps precisely because of the distance and difficulty of the journey, the pilgrimage to Santiago led to the development of an elaborate religious tourist industry. By the twelfth century pilgrims from France could travel along well-marked roads from city to city, finding hostels, inns, and churches at convenient distances along the route. The finish of the journey was not the only attraction. Pilgrams stopped to see relics and holy shrines along the way. In this way each city on the route contributed to the pilgrims' holy purpose—and benefited from the tourist trade they brought. Under the influence of the Monastery at Cluny in eastern France (about halfway between the modern cities of Dijon and Lyon), a type of Romanesque church called the "Pilgrimage Church" was built in numerous cities along the routes to Santiago de Compostela: St. Sernin, in Toulouse, is one of the many outstanding examples that survive in something like their original form.

But how was a prospective traveler to know the route, its important sites and attractions, its hazards and its rules? The work known as the *Pilgrims' Guide* helped to fill this need, just as a guidebook helps the modern traveler find the best restaurants and hotels, entertainment and instruction, available in each place he visits.

Guidebooks tell us about more than the country to be visited; they also tell us a great deal about the travelers for whom they are intended. What was important to the Medieval pilgrim? Safety, good food, a knowledge of the historical and religious events that had happened in the places he visited. For example, the *Pilgrims' Guide* tells its readers where Charlemagne fought a great battle, and the "Song of Roland," about Charlemagne's unfortunate commander at the tragic battle of Roncesvalles, was one of the most popular Medieval tales; modern guidebooks point out the location of Gettysburg or Waterloo. The Medieval guide warned about safe and unsafe food and the danger of bandits, reminding us of warnings about muggers in guides to modern large cities. Like many a later writer, the author of the *Guide* betrays his own prejudices as he contrasts the peoples living near his home to people of other provinces. What did he think of strangers, like the people of Navarre?

Marilyn Stokstad's fine translation of the *Pilgrims' Guide* and her explanation of its meaning form part of a comprehensive study of Santiago de Compostela's church and city, art and history. This excerpt should help to bring to life the people who visited the great Romanesque churches and looked at the vigorous Romanesque sculpture we admire today.

From

Santiago de Compostela in the Age of the Great Pilgrimages

According to tradition the stars themselves marked the way to St. James, for the Milky Way is a heavenly representation of the road to Santiago de Compostela. Other shrines might rival that of St. James in splendor and renown, but no other pilgrimage had mystique develop around the road itself, making the journey almost rival the importance of the shrine in the mind of the pilgrim. Not only were other important relics located in monasteries and cities along the way, not only did the road pass the sites of Christian heroism fabled in history and legend, but the very road and its bridges were built by such men as Santo Domingo de la Culzada, who were canonized for their pious engineering feats.

Today it seems impossible that Santiago de Compostela could ever have been one of the centers of civilization; however, the spiritual force of the cult of relics drew the thousands of pilgrims to this desolate and isolated spot near the Atlantic coast. The region, called "Finistera," resembles other "land's ends" like Brittany and Cornwall more than the rest of Spain. Yet so great were the throngs of visitors that the word *peregrino* came to refer to pilgrims to the shrine of St. James. The pilgrims to Rome were called *romeros* and those to the Holy Land *palmeros* (Palmers), after the palms which they carried as their symbols, just as the scallop shell was the badge of the *peregrino*.

Around the pilgrimage to St. James grew a body of literature—legends, miracles, folklore, and history—and of music that enriched the cultural life of the entire Western world. Along the road moved masons, carpenters, painters, sculptors, artists, and artisans who created a coherent style which Kingsley Porter called the "pilgrimage style." . . . Along the road moved merchants and traders; and the pilgrims themselves carried goods and money to Santiago de Compostela. Towns and monasteries were founded or expanded to provide for the material needs of the travelers. . . . Down the road came knights, adventurers, and soldiers of fortune ready to fight for a price or an ideal. After completing their pil-

Marilyn Stokstad, *Santiago de Compostela in the Age of the Great Pilgrimages* (Norman: University of Oklahoma Press, 1978). Excerpts from Chapter II, "The Road to Santiago de Compostela and the Medieval Pilgrimage."

grimage, they remained to continue the crusade and the reconquest of Spain. . . . Along the road moved the sick in body and spirit. Beside the road were built some of the great charitable foundations of the Middle Ages, within whose walls medicine, pharmacy, and the biological sciences were being developed to care for the body, in case St. James should not see fit to intervene in the pilgrim's behalf.

The pilgrimage to the shrine of St. James was not simply a peculiar phenomenon of the eleventh and twelfth centuries. . . . To be sure, the pilgrimage reached the height of its international fame and importance during the twelfth century when throngs of pilgrims made the arduous journey, but the pilgrimage itself was of much earlier foundation and longer duration. As we have seen, in Compostela the pilgrimage was considered to have begun immediately after the identification of the relics of St. James by Bishop Teodomiro and King Alfonso II [*c.* 759–842].

The pilgrimages to Rome and Jerusalem were, of course, of much greater antiquity than the pilgrimage to Santiago. The tomb of St. Peter and the Sepulchre of Christ were venerated from the earliest Christian period, and the churches were under imperial patronage from the time of the donations of Constantine in the fourth century. That emperor had basilicas erected over the shrines which rivaled in size and splendor the pagan Roman buildings. In contrast to the venerable shrines in Jerusalem and Rome, the tomb and church of St. James at first would have appeared very humble indeed if it were not for the talent of the monastic propagandists. The large numbers of pilgrims to Spain did not arise out of spontaneous piety alone but from very skillful organization on the part of the church. Even the archbishop of Santiago, Gelmírez, traveled through France and Italy in the early twelfth century preaching the pilgrimage to his cathedral.

To a large extent the monks of the Congregation of Cluny stimulated and organized the pilgrimage. Cluny was founded in 910 in Burgundy as a reform movement within the Benedictine order. Favored by a secure geographical location in the age of Islamic and Viking invasions and led by the brilliant and dynamic abbots, the Cluniacs flourished and soon became one of the leading intellectual and spiritual forces in the early Middle Ages. This spiritual leadership evolved into political and economic power as well, until by the twelfth century the Congregation had become a religious, political, and economic empire of international scope.

The Pilgrimage Road (or the "French Road" as it was often called) described by Aymery Picaud in his *Pilgrims' Guide* did not become popular until the end of the eleventh century. The earliest routes followed the northern coast of the peninsula, but as soon as the crusade against the Moors made such a change feasible, the pilgrims followed inland roads to avoid the constant threat of attacks by pirates, not the least of whom were the Vikings who harried the north coast of Spain throughout the ninth and tenth centuries.

By the twelfth century the land route of the pilgrims across northern Spain was well established. The pilgrims traveled through France on one of four major roads, three of which joined to cross the Pyrenees at Roncesvalles. . . .

In spite of . . . these variations the phrase "pilgrimage road" conjures up the image of the route described in the *Pilgrims' Guide*. The guide, properly called the *Liber Sancti Jacobi*, was probably compiled under the direction of Aymery Picaud of Parthenay, the chancellor of Pope Calixtus. It is found in *Codex Calixtinus* which is composed of five books: *The Offices of the Church of Santiago de Compostela, The Miracles of St. James, The Life and Translation of St. James, The Expedition of Charlemagne to Spain,* and *The Pilgrims' Guide.* The Codex was attributed to Pope Calixtus II, but it was neither written nor compiled by him. . . .

Although Aymery Picaud may not have actually written the *Guide,* someone from Poitou or Saintonge composed it in the second quarter of the twelfth century. Unlike most accounts of pilgrimages which are simple itineraries, the *Guide* provided valuable information for the trip, a description of the route and cities, the character of countries and people, religious highlights and relics to be visited, and such practical matters as hospitals, the quality of food and water, and a brief vocabulary guide to the Basque language. It also has a detailed description of the city and Cathedral of Santiago de Compostela. In short, it is one of the most interesting documents to survive from the twelfth century.

The first six chapters of the *Guide* are concerned with the route. Naturally for the successful completion of an international journey, the lives and fortunes of the travelers had to be relatively secure. A regular chain of monastic houses was established throughout France and northern Spain: thus the pilgrims not only were urged to travel but also were guided and cared for along the way. The road was kept in repair, bridges were built, and when necessary ferries were operated. At key spots stood hospitals. The trip from the Pyrenees to Compostela was planned in thirteen stages with hostels spaced at intervals of a day's journey and more extensive facilities available at large cities and major shrines.

"There are four roads leading to Santiago which unite in a single road at Puente la Reina, in Spanish territory. One goes through St. Gilles, Montpellier, Toulouse, and Somport: another passes Notre Dame du Puy, Ste. Foy de Conques and St. Pierre de Moissac: another passes Ste. Marie Madeleine de Vézelay, St. Léonard in the Limousin, and the city of Perigueux: still another passes through St. Martin de Tours, St. Hilarie de Poitiers, St. Jean d'Angély, St. Eutrope de Saintes, and the city of Bordeaux.

"The roads by way of Ste. Foy, St. Léonard, and St. Martin meet at Ostabat, and after having crossed the pass at Cize, join the road

which went by way of Somport at Puente la Reina: from there only one road leads to Santiago."

Chapter six includes both practical advice and travelers' tales along with geographical notes beginning with the rivers.

"Here are the rivers that one encounters between the passes of Cize and Somport and Santiago: from Somport there descends a healthful river by the name of Aragón which irrigates Spain: from the port of Cize flows a healthy river which many call the Runa and which passes Pamplona. At Puente la Reina the Arga and the Runa meet; in a place called Lorce towards the east flows a river called the salty stream; there be careful not to water your horse for this river is deadly. On its banks when we were going to Santiago we found two Navarrese seated sharpening their knives: they made a practice of skinning the mounts of the pilgrims who drank this water and died. To our question they replied with a lie saying that this water was good and drinkable; we watered our horses, and at once two of them died and these people flayed them on the field. . . .

At Logroño a large river named the Ebro passes. In it the water is good, and it abounds with fish. All the rivers one finds from Estella to Logroño have water dangerous for men and horses to drink, and the fish are poisonous to those who eat them. There is a fish which is commonly called *barbo* or which the Poitevins call *alosam* and the Italian *clipiam* or *ealor*. Do not eat fish in Spain, or in Galicia, for undoubtedly you will die shortly afterwards, or at least you will become ill. If someone should by chance eat it and not fall sick, he is simply much healthier than others or, more likely, he has become acclimated by a long stay in the country. All the fish, beef and pork in all of Spain and Galicia make foreigners sick. . . ."

[The next section discusses roads, road building, and the importance of road maintenance.]

Closely linked to the problem of public transportation was (then as now) the problem of public safety. The traveler to Santiago de Compostela, from the poorest penitent to the richest lord, required protection from the human hazards of an already arduous journey. The pilgrim to Santiago de Compostela was accorded special privileges of free passage through territories and, in effect, a safe conduct. The treatment to be accorded the pilgrim is set forth in the last book of the *Pilgrims' Guide.*

"The pilgrims, be they poor or rich, who come to Santiago or who want to go there ought to be received with charity and regard by

all: for whosoever receives them and gives them shelter has given shelter not only to St. James but to our Lord himself as it was said in the Gospel, *"Qui vos recipit me recipit."* Many are those who have incurred the wrath of God because they have not taken in the pilgrims of St. James or the beggars.

At Nantua, which is a town situated between Geneva and Lyon, a cloth merchant refused bread to a pilgrim of Santiago who asked him for it; suddenly he saw his linen fall down torn apart through the middle. At Vilanova a poor pilgrim to Compostela asked alms for the love of God and the blessed James from a woman who had placed bread under hot ashes. She told him she had no bread, to which the pilgrim responded. "I hope to heaven your bread changes to stone." The pilgrim left the house and continued his journey, and when that woman went to the ashes to get her bread, she found in its place only a round stone. With a contrite heart she went out to look for the pilgrim, but she did not find him. . . .

This is why everyone ought to know that, rich or poor, the pilgrims to Santiago are entitled to hospitality and a kind reception." (Book V. chapter XI)

In spite of such strictures the pilgrim was often robbed or mistreated by bandits or unscrupulous local residents. . . .

Informally at first, a few knights took up the duty of protecting travelers through their lands. By the twelfth century this sporadic protection was extended along the entire road, and a group of knights were organized into the Order of Santiago. (The order became one of the most important noble orders in Europe.) . . .

The Knights of Santiago could not protect the traveler from the evils of the innkeepers. The pilgrim had to rely on his wits and his patron saint. The tales of the intervention of St. James on behalf of a pilgrim were popular during the twelfth century and appear in painting and sculpture as well as in literature.

The road to Compostela was filled with hazards, and St. James could not be relied on to provide an endless succession of miracles. Today we are accustomed to travel with ease and with our English literary heritage, we think of pilgrimages in terms of Chaucer's *Canterbury Tales.* We must remember that the trip from London to Canterbury in the fourteenth century was a pleasure outing compared with the trip from Vézelay or St. Gilles to Santiago de Compostela in the twelfth. The most vivid impression of the trip may be gained from chapter seven of the *Pilgrims' Guide,* that is, the description of the countries and people to be encountered by the pilgrim traveling from southwestern France to Compostela. The author of

this chapter must have written from personal experience, for he brings the journey to Santiago and some of the people of Spain alive to us.

"Going to Santiago by way of Toulouse, after having first crossed the Garonne, one arrives in Gascony, and thereafter having climbed the peak of Somport, Aragón, the Navarre, and so on. But if one takes the route by way of the pass of Cize, after Tours one finds oneself in Poitou, which is a fertile, excellent, happy land. The Poitevins are vigorous people and good warriors, skillful in the use of the bows, arrows, and lances, courageous in the front of battle, very fast in races, elegant in their manner of dress, beautiful, spiritual, very generous and hospitable. [Chauvinism is clearly not a modern development.] Then one enters Saintonge; from there after having crossed an arm of the sea and the Garonne one arrives in the Bordelais where the wine is excellent, the fish abundant but the language crude. . . . Then three tiring days are needed to cross the region of Landes. This is a desolate country lacking everything. . . . If by chance you cross Landes in summer take something to protect your face from the enormous flies that fly around everywhere. . . . And if you don't watch your feet carefully you will sink rapidly up to the knees in the encroaching sea sand.

After having crossed this country, one comes to Gascony, rich in white bread and excellent red wine; it is covered with woods, meadows, streams, and pure springs. The Gascons are frivolous, braggards, mockers, debauchers, drunkards, gluttons, badly dressed, and careless with money; however, they are well-trained warriors and remarkable for their hospitality to the poor. Seated around a fire, they usually eat without a table and all drink from the same goblet. They eat a lot, drink to the dregs, and are badly dressed: they think nothing of all sleeping together on a thin pallet of straw, the servants along with the master and mistress.

On leaving that country the road to St. James crosses two rivers. . . . It is impossible to cross them except in a boat. Curses on Ferrymen. Actually each of the streams is narrow. The people are, however, accustomed to take a coin from each man that must cross to the other side whether he be poor or rich, and for a horse they forcibly extort four coins. Their boat is small, made from a single tree trunk, making it difficult to carry horses. Also when one gets on, one must be very careful not to get on with many passengers, for if the boat is too loaded it will sink.

More than once after having received their money, the ferrymen have loaded on such a large troop of pilgrims that the boat capsized, and the pilgrims drowned: and then the evil boatmen rejoiced and robbed the dead.

Surrounding the pass of Cize is the Basque territory. . . . This country has a barbarous language, and is wooded, mountainous, and lacks bread, wine, and food of all kinds; however, one finds some compensation in the apples, cider, and milk.

This country is inhabited by evil people . . . the people frankly should be sent to the Devil. They actually surround the pilgrims with two or three sticks to extort by force an unjust tribute. And if some traveler refuses to yield to their demands and to give them money, they beat him with the sticks, take the tax from him, injure him, and strip him. . . . The ferocity of their faces and appearance and their barbarous speech terrifies everyone who sees them. . . .

[*Here follows a demand for excommunication.*]

In the Basque country, the route of Santiago climbs a remarkable mountain called the pass of Cize . . . this mountain is so high that it seems to touch the sky; he who climbs it could believe he would be able to touch the sky with his own hand. . . . On the summit of this mountain is a place named the Cross of Charles (*Crux Karoli*) because it was here that Charlemagne and his army . . . cleared a passage on the way to Spain and that he first erected a cross and knelt before it, and turning towards Galicia he addressed a prayer to God and St. James. Thus, when they arrive here, the pilgrims usually kneel and pray, turning toward the country of St. James, and each places his cross like a standard. One can find almost a thousand crosses there. . . . It is on this mountain, before Christianity was spread widely in Spain, that the impious Navarrese and the Basques were accustomed not only to strip the pilgrims going to Santiago but also to ride them like asses and to kill some of them. Near this mountain toward the north is a valley called Charles's Valley (*Vallis Karoli*) in which Charlemagne took refuge with his army after the warriors had been killed at Roncesvalles. It is through this valley that the pilgrims pass when they do not want to climb the mountain.

On the descending slope one finds the hospice and the church with the rock which that superhuman hero, Roland, split from the top to bottom through the middle with a triple blow of his sword. Next one comes to Roncesvalles, the site of the great battle in which King Marsile, Roland, Oliver, and 40,000 other Christian and Moorish warriors died. After this valley, one enters Navarre. . . .

The Navarrese wear short black tunics which come only to their knees like the Scots: they wear shoes which they call *lavarcas* made of raw leather still covered with hair, which they attach around their feet with cords but which cover only the bottom of the foot, leaving the top bare. They wear elbow-length cloaks of dark-colored fringed wool, like a hood, which they call *saias*. These people are poorly dressed and eat and drink badly. At home the Navarrese family—servants and

master, maids and mistress—all eat food mixed together in a single dish. They eat with their hands without spoons, and they drink from the same goblet. Watching them eat reminds one of dogs or pigs feeding gluttonously. Hearing them speak reminds one of barking dogs. Their language is completely barbarous. . . . [Here follow examples of words.]

This is a barbarous people, different from all people, and both through custom and race, filled with trickery, black in color, heavy in face, debauched, perverse, perfidious, disloyal, corrupt, voluptuous, drunken, expert in all violences, ferocious and savage, dishonest and false, impious and crude, cruel and quarrelsome, incapable of all good feeling, inclined to every vice and iniquity. These people resemble the Getes and the Moors in their malice and in every sort of enmity to our people of France. For only a sou the Navarrese or the Basques would kill a Frenchman, if they could. . . .

[The Basque and Navarrese are further maligned by the writer before he continues his description of the country.]

After this country one travels through the forest of Oca toward Burgos, and the land of Spain that is the country of Castile. This country is filled with riches, gold and silver, fodder and vigorous horses; and bread, wine, meat, fish, milk, and honey abound: however, it lacks wood, and is inhabited by tricky, vicious people.

Then one comes to Galicia, after crossing León and the mountains Irago and Cebrero. Here the countryside is wooded, crossed by rivers, well provided with meadows and excellent grassy plots. The fruits are good and the springs are clear, but cities, villages, and cultivated fields are rare. Wheat bread and wine are scarce, but one finds lots of rye bread and cider, cattle and horses, milk and honey, enormous ocean fish and small fish. Also gold, silver, fine fabrics, wild animal furs, and other riches abound there, as well as sumptuous Moorish treasures.

Among all the civilized people of Spain the people of Galicia are most like our race, the French, in their habits, but they are, it is said, inclined to be hot-tempered and litigious." (Book, V, chapter VII)

Thus the author of the *Guide* assures the traveler of an easier journey and better treatment as he approaches his destination. After all, the pilgrim needed to be warned of the hazards but not discouraged from making his trip.

9

Robert Branner

CHARTRES CATHEDRAL

BRANNER'S *Chartres Cathedral* is an anthology entirely devoted to one build-
ing. It brings together both medieval sources and recent scholarship to
foster understanding of one of the most beautiful French Gothic cathe-
drals. Professor Branner's introduction demonstrates his own knowledge
of Chartres as an aesthetic monument, as an illustration of the history of
Gothic style, and as a part of the social fabric of the Middle Ages. Many
readers will want to follow this introduction to Chartres by reading other
sections of his book.

Branner's essay covers many aspects of the work of historians of Me-
dieval art. One of the subjects that medievalists address is the function of
the work. What was the purpose of the Gothic cathedral? What are some of
the different activities that it sheltered? Some of them seem obvious, but
others—its use as a kind of hiring hall for casual labor, for example—are
unexpected.

The financing of Chartres' construction is in itself a fascinating story.
Branner makes it clear that the economic system of the thirteenth century
was not well-prepared for large-scale building projects. Therefore special
means were taken to pay for the large labor force and for the raw materials
needed to build a new cathedral.

The history of the building of Chartres is a microcosm of Medieval
architectural history. After a brief description of early structures at the site
(mostly omitted from this excerpt), Branner introduces us to the Roman-
esque cathedral begun by Bishop Fulbert. A disastrous fire destroyed most
of that building, as is documented by the excerpt from a Medieval text that

follows Branner's introduction. It is interesting to see how the modern writer has made use of a primary source like the "Miracle" text to establish the chronology of the building's construction. However, one part of the church, the West facade or "Royal Portal," [Figure 7] survived the fire. Built in the middle of the twelfth century, it constitutes one of the most fascinating sculptural complexes of the Medieval world. The reason for this fascination is the curious character of its style, poised between Romanesque and Gothic—almost as if we could see a new style at the moment of its birth.

The "Royal Portal" is also an iconographic puzzle. What is the meaning of the doorway? Who are the figures its statues represent? Branner's summary of recent opinions in interpreting the "Royal Portal" introduces us to the complexity of Medieval theology. Perhaps most important is Branner's multileveled view of iconography; the subject of the cathedral sculpture doesn't have to be "either–or," but can be understood as conveying two meanings at once.

Branner's description of the major features of Gothic Chartres, begun after 1194, helps us visualize the beauty of the building and understand its place in the historical development of Gothic style. In a final section omitted from this excerpt, Branner also describes some late Gothic additions to the church that make it virtually an anthology of Gothic styles from the early to late periods. But even without those additions, Chartres is clearly an extraordinary building—at once one of the earliest Gothic cathedrals, and an outstanding example of High Gothic style.

Figure 7 *Chartres Cathedral, West Facade: Royal Portal.*
Photo: Lauros-Giraudon. Art Resource, New York.

From
Chartres Cathedral

To the modern tourist and historian alike, the Cathedral of Chartres is the monument most representative of the Gothic style. It is the only French cathedral to have survived in nearly complete form from the early thirteenth-century, with sculpture decorating every portal, with a full array of stained glass giving the interior a deep, vibrant color, and with architecture which is surprisingly uniform for a medieval church. How fortunate that Chartres also stood at a critical moment in the development of Gothic art! Architecturally and sculpturally, Chartres was not only a culmination of the early Gothic experiments of the twelfth century, but was also the pacesetter for the century that was to follow. It is much more than a mere example of a type, an anonymous member of a class of objects used by the present-day teacher to illustrate historical movements. Chartres was itself a motivating force, a powerful agent of change in the thirteenth century, the first of the so-called High Gothic cathedrals that fixed the future of the Gothic style. Together, these two sides of Chartres—the aesthetic and the historical—give it a unique place in the modern world.

The Cathedral of Our Lady at Chartres rises at the edge of the plain of Beauce, a gently rolling country in the wheat-producing region of France. Its spires, like beacons, can be seen for miles across the yellow fields, drawing the traveler on, promising him comfort and sanctuary. In the city, the towering cathedral was the medieval forerunner of the skyscraper, but, unlike its modern counterpart, it subsumed a number of different functions. It was generally the one building that could hold all the townspeople at once, and therefore sometimes acted as a meeting hall for semireligious events. Moreover, the medieval cathedral was physically integrated into the town. Houses crowded up to its very walls and lean-to's were built right against them. Stalls and stores often abounded here and sometimes the local fair would be held on the *parvis*, the open space lying in front of the façade. At Chartres, the local labor force shaped up in one of the side aisles of the nave. At one moment or another, therefore, the

Robert Branner, ed., *Chartres Cathedral*, A Norton Critical Study in Art History (New York: W. W. Norton & Company, 1969). Excerpts from introductory essay, pp. 69–87. Copyright © 1969 by Robert Branner. Reprinted by permission of W. W. Norton & Company, Inc.

medieval church could serve civic, communal, and commercial purposes. But it was first and foremost a religious building, the seat of the bishop and of the canons of the chapter, his assistants in pastoral mission. At Chartres, the bishop's palace lay on the north side of the Cathedral, while, on the other side, the houses of the canons were grouped around an irregularly shaped courtyard called the cloister. The Cathedral dominated the town, not only by its physical form but as the center of spiritual authority as well.

Medieval art was essentially a religious art, not because it was at the service of the Church, but because the age was a profoundly religious one. The salvation of the soul after death was an event hoped for and looked forward to and the spiritual life was considered the highest calling in this world. It was an age of miracles and one in which men such as St. Bernard and Dante had personally experienced the revelation of God. It is small wonder, then, that medieval art is visionary and intense in character, or that a small town like Chartres should have built an astonishingly large cathedral.

In the Middle Ages, the Church was the greatest patron of the arts, incessantly calling upon the best artistic talent and providing it with the wherewithall as well as the incentive to produce one masterpiece after another. Kings might also commission important and costly works of art, and, in later times, the bourgeois towns put art into the service of government and commerce by building townhalls and guildhalls. But the Church was the only institution that consistently patronized the arts throughout the Middle Ages and, in the twelfth and thirteenth centuries, it was the only institution capable of concentrating the diverse energies of all the people—noble, burgher, and peasant alike—on a single project. Without this concentration, the Gothic cathedrals could not have been created.

Medieval Chartres considered itself the chief sanctuary of the Virgin in Western Europe. The source of this eminence was the "tunic of the Virgin," a piece of cloth thought to have been worn by the Virgin and given to the Cathedral in the ninth century. . . . With this prestigious relic, Chartres became a famous pilgrimage center and the pilgrimage, in turn, was the chief source of the town's prosperity. . . .

The present Cathedral of Chartres is largely the work of the late twelfth and early thirteenth centuries, but here and there—notably in the crypt and on the west façade—substantial remains of older monuments are to be found. The history of these early Cathedrals is very imperfectly known, but they are nonetheless important because, in addition to showing that the site had been devoted to religious purposes for centuries, they also serve to explain certain aspects of the Gothic cathedral. A brief résumé is therefore in order.

As far as the oldest Christian building on the site is concerned, only a very general remark can be made. The church probably lay snug up against the late Roman city wall that ran across the area. . . .

From the time of the Romans to the time of the Carolingians in the ninth century, the architectural history of Chartres Cathedral is a virtual void, punctuated here and there by a text, always frustratingly brief and usually referring to a fire. In 743, for instance, the Cathedral was burned by Hunald, Duke of Aquitania; but it is not known if the church had to be rebuilt from its foundations and, if so, what it may have looked like. In 858, the church was again burned, this time by the Danes, and a new building was begun soon after by Bishop Gislebert. Fragments of this Cathedral have tentatively been identified in the substructures of the present one. It was probably larger than its predecessors, for the apse projected beyond the emplacement of the Roman wall. This indicates that the town of Chartres was beginning to expand outside the fixed Roman perimeter and the larger population, of course, required a larger sanctuary. There was still another fire in 962. The texts tell us that a new façade was then put on the monument, but its design and even its location are unknown. It is only with the Cathedral created by Bishop Fulbert after 1020 that we reach something tangible.

Fulbert had been a brilliant teacher at Chartres before he became bishop in 1007 and it was he, more than any other individual, who laid the foundations of the famous school that was to flourish at Chartres in the twelfth century. When the Cathedral was destroyed by fire in 1020, he took considerable pains to raise construction funds himself. . . . The crypt was completed in 1024, but Fulbert died in 1029, before the church above it was finished. The dedication took place under his successor, Thierry, in 1037.

Fulbert's church was nearly as long as the later Gothic Cathedral, and fully as wide. . . . To the east were three large chapels projecting from an ambulatory; the latter joined two side aisles flanking the long nave, which were, in turn, flanked by two towers; and at the west there was a tower. The aisles, ambulatory, and radiating chapels were repeated at the crypt level, indicating that the plan was intended to accommodate large numbers of pilgrims: one could enter the crypt at the western end of one corridor, walk down to the grotto of the Virgin, and come out through the other corridor without disturbing services that were taking place in the church upstairs. Similar patterns of circulation, on two levels or even on one alone, charac-terized the great pilgrimage churches of the Loire Valley, not far from Chartres, in the late tenth and early eleventh centuries, and Fulbert's basil-ica clearly was a member of that group. . . .

Fulbert's basilica lasted until 1194, but the late eleventh-century tower was affected by another fire that swept the city in 1134. The Cathedral is famous for the work carried out over the next two decades, for the new west façade is one of the great monuments of early Gothic art. The façade is also evidence that the cult of the Virgin was still strong, because the

elaborate sculptural decoration and the large stained glass windows must have been very expensive (the rose window and the north spire were created at a later date). The pilgrimage had continued to attract large numbers of people to Chartres and their donations certainly helped repair and reface the damaged building. But even more than that, in 1144, on the tenth anniversary of the fire, the Cathedral suddenly became the object of a mass exercise in piety and devotion. People of all ranks began to band together to supply the physical labor required to bring the building materials to the site, pulling wagons loaded with wood and stone in what has been called the "cult of carts."

The materials themselves cost virtually nothing and were often donated by their owners, the great landlords. But in the late eleventh and early twelfth centuries, as the new economy based on money continued to supplant the older one based on goods and barter, the old, fixed labor corvées that the peasants owed to the bishop and chapter were replaced by payments in coin. In consequence, labor now had to be purchased. The people, therefore, made a real contribution to the work of the Cathedral. But this must not be confused with the professional talent of the artists and craftsmen who designed the façade and converted the raw materials into what we see today. As a spiritual force, the pilgrims helped call the new work into being and they made it possible financially; but their physical contribution was never more than that of temporary, unskilled laborers. The "cult of carts" was a symbol of the will to adorn the sanctuary of the Virgin with the new and beautiful façade.

The early Gothic portions of the west façade, as we see them today, were not created in one fell swoop, however, and since they have been the subject of intense investigation, this cannot be passed over in total silence. There was one fundamental change of plan in the course of construction. In the original plan, two towers were to be set out in front of Fulbert's church, one opposite each side aisle, and both were to be connected to the long, subterranean corridors leading to the crypt and grotto. Between the towers, there was to be a sort of covered courtyard or portico, open on the west, from which one could either enter the nave of the church or go into one of the towers and from there go down directly to the crypt. The portico was to support a chapel above it, continuing the tradition of the late eleventh-century tower and of Fulbert's building, and the chapel was to have three great stained-glass windows. The entrance from the three-aisled portico into the nave was to be decorated with three sculpted portals, perhaps laid right up against the west wall of Fulbert's church or perhaps on an extension of the latter reaching almost to the eastern side of the towers.

Before the south tower had been carried very high, however, the plan was altered. The sculpture which had been prepared for the east side of the

portico was put up at the west side, where we see it today, and the portico was closed off from the elements, becoming a sort of narthex instead. Since there was less space between the towers than on Fulbert's façade, it was necessary to reduce the width of the portals and a number of stones in the lateral tympana, lintels, and archivolts had to be recut in order to make them fit the new emplacement. . . . But the results were spectacular; for the tall, narrow portals were now visually associated with the lancet windows of the chapel to produce a single, harmonious design of great beauty.

The Both towers at Chartres were meant to have spires, although the north one was completed only in the sixteenth century. . . .

The west portals of Chartres are also close to the fountainhead of Gothic sculpture [Figure 7]. Here, the key to the new style is the statue-column decorating the jambs of the portals. The statue-column, a new form in medieval art, consists of a figure on a shaft that is set into the architecture. In many ways, the sculpture of the west façade of Chartres is still cast in the older Romanesque mode, as is only natural in an early work of a new and emergent style. The statue-column is still fundamentally a part of the monument, one that cannot easily be removed. And the statutes themselves are somewhat rigid and frontal, with strong overtones of Romanesque iconicism But the position of the statue *in front of* the column had important consequences, for it would shortly begin to move and turn, to activate the jamb as well as the space before it, and to develop the lyricism and the sense of being accessible to us that is latent throughout the decoration of the west façade of Chartres. The exact source of the statue-column is still unknown, although it is now generally agreed that the columns at Chartres, begun about 1145, must be later than those at St.-Denis, where the façade was dedicated in 1140 But there may well have been more than one source, just as the decoration of Chartres has itself been shown to be varied and to have been carved by a number of different artists: each man may have brought traditions of his own to bear on the designs of the workshop.

The meaning of the portals at Chartres is complex. Judging from a thirteenth-century text in which they are named the *porta regia* (royal portal), it has sometimes been thought they might have had some direct connection with Louis VII, King of France. This is erroneous in the literal sense because the Latin phrase was widely used in the Middle Ages, to such an extent, indeed, that either word (*porta* or simply *regia*) was often employed alone to signify "portal." Some relation to kingship in general is clear, however, for many of the statue-columns represent kings and queens. In the eighteenth century, it was suggested that they stood for the early medieval dynasties that had ruled France. It seems more likely now that they were meant to be kings and queens of the Old Testament. But the iconography could also have had more than one level of meaning. According to the medieval "science" of hermeneutics, allegorical and moral

meanings could underlie the historical or literal one. Thus just as the columns support the tympana and archivolts, so the kings and queens (including such ancestors of Christ as David and Solomon) support and prefigure the persons and events of the New Testament that are represented above. This kind of alliance or reconciliation fascinated the twelfth century. And in this world of multiple levels, yet another modern interpretation of the statues can be found. According to it, the presence of some priests among the royalty indicates the conjunction of secular and spiritual authority, known as *regnum et sacerdotium*—kingship and priesthood. As the study of Chartres and of medieval iconography continues, however, still other interpretations will undoubtedly be made.

It is the tympana of Chartres that bear the main message of the sculptural program. On the left tympanum, Christ ascends to Heaven while angels announce the event to the seated Apostles; the surrounding archivolts represent the signs of the Zodiac and the Labors of the Months, both cosmic cycles that had been associated with the Ascension before Chartres. In the central portal, Christ is shown surrounded by the symbols of the Evangelists; the twelve Apostles (flanked by Elijah and Enoch, the two Old Testament prophets who also ascended to Heaven) stand below, and the archivolts show the twenty-four Elders of the Apocalypse.

The Apostles are usually associated with the Last Judgment and even though the Resurrection of the Dead is not shown here, the tympanum can be said to combine into one the two great themes of early twelfth-century portals—the Second Coming of Christ and the Last Judgment.

The right portal is probably the most significant one of all, for here, as Professor Adolf Katzenellenbogen has shown, dogmatic themes are expounded and the Virgin takes a leading role. The lowest zone of the tympanum shows (from left to right) the Annunciation, the Visitation, the Nativity, and the Annunciation to the Shepherds. But the Nativity has been put in the center of the lintel (and the Annunciation to the Shepherds has been stretched, so to speak, to fill up the right side), in order to emphasize it and make it the bottom of a vertical axis running through the tympanum. The Nativity is also designed in such a way that the swaddled Infant lies on top of the manger as if it were an altar; a reference to the Host in the mass is unmistakable. In the next zone, which is the Presentation in the Temple, the Child actually stands on the altar, facing outward rather than turning to either the high priest (left) or the Virgin (right), either of which would be more normal. And finally, at the top, the Virgin holds the Child on her lap and the pair face outward in a stiff pose that suggests an icon. This is the *Sedes Sapientiae*, the Seat of Wisdom. The surrounding archivolts represent the Several Liberal Arts, the curriculum of the medieval school, and corresponding classical Greek and Roman authors. Thus, the theme of the Incarnation—God-become-man—is presented with great visual clarity in a

program that, because of its intricacy and finesse, must have been devised by the theologians of Chartres. The presence of the Liberal Arts on the portal even suggests that these men thought dogma should be taught and defended in a school and it is not irrelevant to recall that, at that very time, the school of Chartres was nearing the height of its fame.

The last—but by no means the least important—Gothic feature of the twelfth-century work at Chartres is the stained glass. In addition to the three great lancets that light the chapel behind the west façade, one other window has been preserved from that time which, significantly enough, represents the Virgin and Child. Notre-Dame de la Belle Verrière, as it is called, must have been made for a place of honor in the old church, for after the latter was destroyed by fire in 1194, fragments of the window were rescued and reinstalled with thirteenth-century additions in the side aisle of the choir.

It is the west windows, however, that best reveal the new impulse of Gothic. At St.-Denis, the stained-glass maker and the architect collaborated to explore a new and stimulating direction and their success was immediately repeated at Chartres. What the architect wanted was to illuminate the vast open spaces that he took pains to create and his solution was to enlarge the windows. The dim, dungeonlike interior of the Romanesque style was now illuminated by moving, flickering rectangles of warm color. But larger windows not only provided more light, they also reduced the amount of masonry flanking the volumes and replaced it with a translucent screen that literally gave an impression of weightlessness. The window was thus suddenly liberated from the captivity of the wall to become an active force in the complex of architecture while the architecture itself was lightened by the new window. The paintings that had decorated the walls of Romanesque monuments were henceforth banished since stained glass now provided a field for the representation of holy figures and scenes and the stained-glass maker could now, for the first time, design his compositions on a monumental scale. At Chartres, this can be seen in two forms. On the one hand, the central and northern lancets are filled with series of square and round panels, each containing a scene from the cycle of the Infancy of Christ and from that of the Passion; although the individual panels preserve the quality of fine, almost miniature, work, the overall effect is prodigious. On the other hand, the third window is a Tree of Jesse, a single, grand composition showing a schematized vine growing from the body of the prophet and holding the ancestors of the Virgin and of Christ in its branches.

The new western complex created at Chartres in the two decades following 1134, therefore, holds an important place in the history of Gothic art. Although it is not a whole church, but merely a "fragment" added to the body of an older building, it contains all the elements fundamental to the development of the style; ribbed vaults, statue-columns, and stained

glass. The very combination, in such an early phase of the new style, is proof of the vision of the designers and of their ability to assimilate new ideas rapidly and develop them. It is indeed fortunate that the larger part of this ensemble has been preserved to the present day.

Fulbert's Cathedral burned on June 10, 1194 and a new church—the present one—was begun immediately. The body of the monument was completed by 1221, when the canons first entered the new stalls in the choir, and it was dedicated in 1260, by which time most of the accessory works of sculpture and glass had been completed.

The holocaust of 1194 had a profound effect on everyone. At first, it was thought that the tunic of the Virgin had also perished in the fire, but a cleric found it intact in the crypt and brought it out just as the stunned townspeople were gathering around the smoking ruins. Mourning became jubilation. The people were fired with the desire to rebuild the sanctuary and the spirit soon pervaded the pilgrimage routes. This undoubtedly explains why the monument was finished in the record time of twenty-seven years.

The methods of financing the Gothic Cathedral were traditional but not very efficient. As before, gifts of labor and small sums of cash were made, but these were scarcely enough for the reconstruction. In addition, in an excess of generosity, the bishop and chapter, who were responsible for the enterprise, turned over part of their income to the work for a period of three years; but at the expiration of that time, the funds simply ran out and other sources had to be found. Three years might have been enough to clear away the wreckage and raise the new work above ground in the expectation that once the project was under way the money to complete it would be forthcoming. This is, in fact, what occurred, although it does not seem to have been planned that way. As the author of the *Miracles of the Virgin* tells us, the Virgin herself had to exhibit a miracle in order to start things up again. Some people made gifts for general purposes, while others preferred to specify what their gifts were to be used for. Later on, when the Cathedral was ready for glazing, individuals, families, and even the guilds of the town contributed particular windows, which generally include their "signatures" at the bottom. On the whole, however, it is astonishing to see the bishop and chapter undertake what was surely the largest church then within memory, without any sensible appreciation of the difficulties involved and without any budget, however rudimentary. Chartres is vivid testimony of the depth and endurance of faith in an age of great construction.

The chapter of Chartres took its obligations to the Virgin and to the pilgrimage very seriously. It would have been all but impossible to design a church smaller in plan than Fulbert's had been, especially since the crypt of his Cathedral was still largely intact: it was well arranged for mass circulation and could easily be adapted to serve as a foundation for the Gothic

church. But there was no physical or programmatic need to make the new Cathedral as tall as it is. That aspect of the design must be attributed to two different factors: one is prestige; and the other is the particular stage of development that Gothic architecture had reached at the end of the twelfth century.

Prestige is the most difficult factor for us to deal with because the Middle Ages does not seem to have discussed the matter except to condemn it—that is, to condemn bishops and abbots who built at a scale far beyond the simple requirements of numbers of people and frequency of services. But Chartres was never condemned for being big, perhaps partly because of its active role in the secular life of the community. On the contrary, it was praised for being imposing and for having "elegant vaults." It is not too much to infer that the bishop and chapter were pleased with such descriptions, which, they felt, showed that they were not wrong in wanting a cathedral that would impress the ever more sophisticated taste of their contemporaries. Indeed, they succeeded only too well, for Chartres has continued to inspire awe down to our own day. . . .

The interior of Chartres is composed of three stories—the main arcade, the triforium passage, and the clearstory windows. They form the walls of the monument while ribbed vaults form the ceiling. The architect's chief structural concern was how to keep the vaults up and to that end he made use of a new device—the flying buttress. The flying buttress provided lateral support from the outside. Another device was the heavy arch at the top of the clearstory windows which also appeared on the outside; this arch linked the tops of the supports together down the length of the nave and helped stabilize the wall against the pressure of the roof, just as did the uppermost arch of the flying buttress. . . .

The extraordinary quality of Chartres results from its regularity and uniformity. Each bay is a unit, a cell covered by a four-part vault, to which there corresponds a similar but smaller cell in each aisle. The nave, the transept, and the choir are composed of a number of such groups placed side by side, varied only in the hemicycle, where the succession of spaces comes to a grandiose, rhythmic conclusion. The identity of the bay as a cell and as a design on the wall is reinforced by the sharp responds which protrude into the space of the nave and which rise from the pavement to the vaults. The horizontal string courses weave in and out across them forming a pattern on the wall surface and giving it texture. The surface itself is broken into zones of solid and void as well as into zones of light and dark by the triforium passage and clearstory. Repetition and agreement are the keys here, for Chartres is possibly the most magnificent example of balance and unity that Gothic was to produce.

The pivotal position of Chartres must be seen in relation to its past and its future. With respect to the twelfth century, it was a conclusion—a culminating point—but not simply a summation. The first aim of early

Gothic architects—to create vast spaces surrounded by thin membranes—was pursued and developed throughout the sixty years between 1134 and 1194. Once in command of the ribbed vault, the masters sought ways to increase the size of the monument so as to give greater reality to their vision. Size meant both breadth and height. The first could be had by increasing the number of aisles to five and second by increasing the stories to four, with vaulted tribunes and other devices providing support in the second and third zones. Both aims were achieved in the decades following 1160; at Notre-Dame in Paris and at Laon Cathedral, for example. Laon, which looks forward to Chartres in its rich plastic treatment of the wall, also introduced the triforium passage to Gothic; Paris, where the effect is rather of an extremely thin closure, invented the flying buttress. And in both, an effort was made to "capture" large chunks of space by using six-part vaults, each embracing two bays of the nave.

The architect of Chartres was impelled by some inner urge to create an even bigger structure; not only to conquer more space but also to create a sense of scale that is nothing short of colossal. The triforium passage and the flying buttress were essential to this, for they meant that tribunes were no longer needed: the vaults could now be abutted at exactly the proper place from the outside without encumbering the interior of the edifice. Structurally, therefore, Chartres represented a major simplification, a purgation of those elements which had become unnecessary in the light of new devices. . . . The simplicity of the scheme was matched by its flexibility, for the whole edifice could be made larger or smaller and parts could be altered without affecting stability. At Chartres itself, this explains the great height of the monument and is one of the reasons for the astonishing success of the Chartrain formula in succeeding years.

Most important of all, however, is the fact that the Master of Chartres matched his gigantic spaces with enormous piers and shafts and with gigantic bases and capitals. The bases of such buildings as Notre-Dame in Paris or of Laon Cathedral are positively minuscule when compared to those of Chartres; throughout the work, wherever one turns, one is faced with elements of an entirely new, monumental order. This accounts for the often noted "will to heaviness" of Chartres. But in reality, heaviness is more fundamental than the mere desire to overbuild a new design so as to avoid the risk of structural failure. In early Gothic art, we have the impression that the monument seems larger than it really is and, in turn, that our own stature has somehow been reduced. This is the visionary nature of the Gothic which was stated quite clearly by the suggestion of vastness in the earliest examples of the style. At Chartres, this is affirmed a hundredfold. And its "reality" is brought home to us by the size of its elements—by the size of the bases we can touch with our hands, by the diameter of the colonnettes on the piers, by many details both near and far. If it is still effective today in an era of unheard-of colossism, how much more im-

pressive it must have been in 1200 to men accustomed to the small scale of the twelfth century! . . .

Medieval Text:
The Miracles of the Virgin*

Therefore, in the year 1194 after the Incarnation of the Lord, since the church at Chartres had been devastated on the third of the Ides of June [June 10] by an extraordinary and lamentable fire making it necessary later, after the walls had been broken up and demolished and leveled to the ground, to repair the foundations and then erect a new church.

. . . The inhabitants of Chartres, clerics as well as laymen, whose homes and practically all their furnishings the aforementioned fire had consumed, all deplored the destruction of the church to such an extent that they made absolutely no mention of their own losses; they considered as their chief misfortune, or rather the totality of their misfortune, the fact that they, unhappy wretches, in justice for their own sins, had lost the palace of the Blessed Virgin, the special glory of the city, the showpiece of the entire region, the incomparable house of prayer. . . .

Indeed, when for several days they had not seen the most sacred reliquary of the Blessed Mary, transferred to a more hidden place out of fear of the fire, the population of Chartres was seized with incredible anguish and grief, concluding that it was unworthy to restore the structures of the city or the church, if it had lost such a precious treasure, [which was] indeed the glory of the whole city. At last, on a particular holy day, when the entire populace had assembled by order of the clergy at the spot where the church had stood, the above-mentioned reliquary was brought forth from the crypt. . . . The fact must not be passed over that when, at the time of the fire, the reliquary frequently referred to had been moved by certain persons into the lower crypt (whose entrance the laudable foresight of the ancients had cut near the altar of the Blessed Mary), and they had been shut up there, not daring to go back out because of the fire now raging, they were so preserved from mortal danger under the protection of the Blessed Mary that neither did the rain of burning timbers falling from above shatter the iron door covering the face of the crypt, nor did the drops of melted lead penetrate it, nor the heap of burning coals overhead injure it. . . . And after such a fierce conflagration, when men who were considered already dead from smoke or excessive heat had come back unharmed, all present were filled with such

*A. Thomas, ed., *Miracles of the Virgin* (*Miracula B. Marie Virginis in Carnotensi ecclesia facta. . .*, pp. 95–96), in *Bibliothèque de l'école des chartes*, vol. 42, 1881, pp. 508ff. Excerpts.

gladness that they rejoiced together, weeping affectionately with them.

. . . When, following the ruin of the walls mentioned above, necessity demanded that a new church be built and the wagons were at last ready to fetch the stone, all beckoned as well as exhorted each other to obey instantly and do without delay whatever they thought necessary for this construction or [whatever] the master workers prescribed. But the gifts or assistance of the laymen would never have been adequate to raise such a structure had not the bishop and the canons contributed so much money, as stated above, for three years from their own revenues. For this became evidence to everyone at the end of the three-year period when all finances suddenly gave out, so that the supervisors had no wages for the workmen, nor did they have in view anything that could be given otherwise. But I recall that at that moment someone said—I know not by what spirit of prophecy—that the purses would fail before the coins needed for the work on the church of Chartres [were obtained]. What is there to add? Since, in view of the utter failure of human resources, it was necessary for the divine to appear, the blessed Mother of God, desiring that a new and incomparable church be erected in which she could perform her miracles, stirred up the power of this son of hers by her merits and prayers. When there was a large gathering of people there, she openly and clearly exhibited a certain new miracle, one unheard of for a long time past, seen by all for the first time. As a result, news of the miracle spread far and wide through the whole of Gaul and made it easier to give credence to succeeding miracles.

10

Millard Meiss

JAN VAN EYCK
AND MASACCIO

THERE ARE MANY WAYS OF ASKING "What is the Renaissance?"; and there are even more ways of answering that question. For some authors, only those works of art or literature that revive a Classical style based on ancient Roman precedents belong to the Renaissance. If that standard is applied to art, then in the fifteenth century only Italy produced Renaissance art, while the countries of Northern Europe belonged to a "Late Medieval" culture. So questions about the nature of the Renaissance and questions about the time and place that it began are related; the "when" and "where" depend upon our understanding of what the Renaissance is.

Undoubtedly some cultural traits that we would associate with the Renaissance appeared before the generation of Masaccio and van Eyck, and many Medieval modes of thought survive well into modern times. For this reason the debate will certainly continue. In this essay comparing two great artists, Meiss indirectly addresses two questions about the nature of the Renaissance. The first asks whether van Eyck is a Medieval or a Renaissance painter. Since van Eyck does not revive Classical forms, some other definition of Renaissance will be needed if we decide to classify him among artists of the Renaissance. The second question is whether the art of van Eyck (and his contemporaries in Flanders)—even if classified as Renaissance—is completely separate in its principles and in its goals from Italian paintings of the same time. But if we see van Eyck largely as different, then it seems hard to defend the idea that he is a Renaissance artist. If we see similarities to Italian works, then his place in the Renaissance becomes surer and more logical.

Meiss's lifelong goal, as a scholar and art historian, was to find unifying elements that deepen our understanding of the relations between Italian and other European art. In numerous essays and books Meiss explored the diffusion of styles and mutually influential currents in Northern and Italian art. His monumental four-volume work on French manuscripts[1] is perhaps the best-known example of his methods, but he also wrote about many subjects ranging from the late thirteenth century to the end of the fifteenth, in Italy, France, Flanders, and even Spain.

The reading "Jan van Eyck and Masaccio" compares two artists of almost the same generation. Although the differences between them had been emphasized by many writers, Meiss instead explores ideas that relate the achievement of one to the other. The key ideas that he uses to convince us that Masaccio and van Eyck share certain "Renaissance" qualities include the artists' use of *light,* their use of *space* and *perspective,* and their inclusion of *similarly posed figures.* It is a rare privilege to read an essay like this one, because Meiss has revealed not only his conclusions, but also his *method* of thinking. We are made aware of common qualities in the works of two artists that we had not seen before, and can follow his conclusions to learn how both van Eyck and Masaccio "present us with a new order of mentality, far more subtle and complex than anything visible in earlier painting."

[1]*French Painting in the Time of Jean de Berry* (New York and London: Phaidon Press, 1967, 1968, 1974)—(National Gallery of Art. Kress Foundation Studies in the History of European Art, vols. 2, 3, 4).

From
Jan Van Eyck
and the Italian Renaissance

It is generally recognized that many Italian painters of the last quarter of the fifteenth century were deeply impressed by the art of the Netherlands.[1] When Giovanni Bellini began the fateful transformation of his style in the early seventies, he was undoubtedly instructed by Netherlandish panels as well as by those of Piero della Francesca. Even in Florence, the great stronghold of *disegno*, Ghirlandaio, Filippino and Piero di Cosimo were much affected by the glowing panels of Hugo van der Goes. In 1481 Ghirlandaio modeled his *St. Jerome* upon a specific work by Jan van Eyck— very probably the panel that is partly his, now in the Museum at Detroit. But the main Italian tradition in the earlier Quattrocento is usually referred to contemporary painting in the Netherlands, and above all to Jan van Eyck, only to prove utter and irreconcilable differences. For this there is much reason and impressive ancient sanction. In a well-known passage that formulated a prevalent Italian conception Michelangelo is reported to have remarked that "In Flanders they paint with a view to external exactness. . . . They paint stuffs and masonry, the green grass of the fields, the shadows of trees, and rivers and bridges . . . all this is done without reason or art, without symmetry or proportion."[2] Earlier, in 1449, the widely-travelled antiquarian Ciriaco d'Ancona made similar though more enthusiastic comments, writing of "gold really resembling gold; pearls, precious stones, and everything else you would think to have been produced, not by

Millard Meiss, *The Painter's Choice, Problems in the Interpretation of Renaissance Art* (New York: Harper and Row, 1976). Excerpts from "Jan van Eyck and the Italian Renaissance," pp. 19–35. (Originally published in *Venezia e l'Europa: Atti del XVIII congresso internazionale di storia dell'arte, 1955* [Venice 1956] pp. 58–69.) Reprinted by permission of Margaret L. Meiss, Executor for the Estate of Millard Meiss.
 [1]The footnotes added to this lecture have been limited to essential information, such as the identification of quotations. The writer intends to publish elsewhere extended and more fully documented versions of several sections of the lecture.
 [2]Francisco de Hollanda, *Four Dialogues on Painting*, tr. A. Bell (Westport, Conn.: Hyperion Press, 1979); originally published in London, 1928. See E. Holt, *Literary Sources of Art History* (Princeton: Princeton University Press, 1974) p. 208.

the artifice of human hands but by all-bearing nature herself."[3] This re-
corded Italian view of Netherlandish painting, employing the critical con-
cepts of antiquity, was unchallenged by any early local tradition in the
North, and it has echoed down the centuries. . . .

Now it is of course characteristic of the pictorial tradition of the Ital-
ian Renaissance, even in its moments of closest approximation to visual
reality . . . , that objects in the world lose many qualities when becoming
elements in a work of art. They yield part of their character to what
Michelangelo and his Florentine predecessors called symmetry and pro-
portion—in other words to an overlying image of relation and order. The
long-established notion that Netherlandish painting, on the other hand,
tends to preserve or duplicate the visible qualities of objects, while convey-
ing part of the truth, does not of course attain it. If Italian painters may be
said to abstract from visible reality, Jan van Eyck does not so much mirror it
as enhance it, raising it to a higher power. Ciriaco d'Ancona was wrong to
say that in Jan's painting or that of his followers gold really resembles gold
and trees trees. The truth is that Jan gave to gold a splendor that we can all
see in his panels but only he could "see" in the world. It is in *his painting*
rather than in *our experience* that bronze has the more palpable hammered
density, glass beads the more scintillating translucency, a mirror the cooler
smoothness and the greater brilliance.

It is furthermore not right to suppose that Jan van Eyck's fascination
with single objects precluded a prominent larger order in his work. While it
is true that Jan brings his eye near each of the many objects in a painting as
he shapes them with his brush, his picture is not constructed from these
innumerable close points of sight alone. There is a more distant viewpoint,
implied by the perspective and the larger order of color, light and shape.
In Erwin Panofsky's recent telling formula: "The great secret of Eyckian
painting [is] the simultaneous realization, and, in a sense, reconciliation, of
the two infinites, the infinitesimally small and the infinitely large."[4]

If this is true, then Jan van Eyck's actual distance from his contempo-
raries in Italy may not be quite so great as conventional criticism has taught
us. He emerged, after all, from a tradition of painting that for nearly a
hundred years had been enriched by the study of Italian art. . . . The art of
Jan van Eyck, heir to the Northern tradition, inevitably resembled in some
respects Italian painting, so that the significant question is whether he
struck out in a direction wholly divergent from that of his equally revolu-
tionary Italian contemporary, Masaccio. . . .

Jan van Eyck's figures, like those of Masaccio, present to us a new

[3]This passage is quoted by Erwin Panofsky, *Early Netherlandish Painting* (Cambridge,
Mass.: Harvard University Press 1953) p. 2.

[4]Op. cit., p. 181.

order of mentality, far more subtle and complex than anything visible in earlier painting. Nothing in any of the arts of the time bespeaks so decisively the beginning of a new era The new depth of consciousness in the figures of Jan and Masaccio is bound up with the unprecedented visualization of light. Light permits an infinitely subtle, vivid, yet imprecise variation of plane. Mobile and intangible, it has always been associated with the spirit, especially during the Christian centuries. Present in medieval art only as a symbol, light, even more than linear perspective, was the great conquest of fifteenth-century painting, a conquest in which Masaccio and Van Eyck shared equally. In the work of both light reveals a new reality *inside* man as well as around him.

Although Jan van Eyck's light is devoted more to the enhancement of color and texture and Masaccio's to the intensification of substance and space, the luminary patterns created by the two painters are often fundamentally similar. In both the Arnolfini portrait of 1434 and the *Crucifixion of St. Peter* in Berlin, light strikes into the pyramidal space from the upper left, spreading across the immediate foreground. Behind this luminous area, through which, so to speak, we enter the picture, a band of shade extends across the space, giving way in turn to a brighter zone, so that the extension of the space is made vivid by an alternation of light and dark zones, all parallel to the picture plane. The figures, likewise more or less parallel to the same plane, are grounded, as it were, in the middle dark zone but they tend to rise into light. The space is closed behind them by a wall that is responsive to their variations in luminosity, becoming bright where they darken, and vice versa.

These two paintings by Jan van Eyck and Masaccio, with their succession of parallel planes, share other compositional qualities—a highly developed axiality, symmetry, rectangularity. In Jan's Paele Altarpiece of 1436, the figures, more massive and rounded than in the Arnolfini panel of 1434, conform to a semi-circular space defined by the arcade of a church [Figure 8]. Now a circular arrangement of cylindrical figures may be found also in the painting of Masaccio—in the *Tribute Money*, for instance [Figure 9]. It is a form of composition that was novel in both Italy and the Netherlands. Prior to Masaccio and Van Eyck, compositions were commonly rectilinear, the forms parallel to the picture plane The concave plan introduced by our two painters effects a slow, regular movement *into* space and out again. It permits both plastic compactness and spatial extension, and it imparts a grave serenity to the design. In both the Paele *Madonna* and the *Tribute Money*, the architectural members are rounded also: arches and windows, and in Jan's panel, stout columns. Now the taste for circular forms, for hemispherical plans, and for domical spaces, is widespread in Italy in the second quarter of the fifteenth century. Alberti justifies it as a natural phenomenon. "It is evident," he says, "that Nature takes delight in round things," and he refers for proof to trees and birds' nests.

Figure 8 *Jan van Eyck*, Madonna of Canon George van der Paele with Sts. Donation and George. *Bruges, Groeningemuseum.*
Reproduced by permission of the Groeningemuseum, Bruges.
Photo: **Copyright Hugo Maertens Fotograaf.**

The occasion for these comments was his consideration of the shapes of churches and their chapels.[5] During this period symbolic values were attached to circular buildings, as Wittkower has recently shown.[6] . . .

In addition to these broad similarities of taste and of style, the paintings of Masaccio and Jan van Eyck are related with respect to perspective, linear as well as aerial, despite the fact that Jan did not attain to a one-point system. The two masters shared a conception of an objectified perspective image seen through a frame from one or two fixed points of sight, and sometimes they drew very similar consequences from this conception. Jan's *Madonna of the Fountain*, for instance, resembles the mother receiving alms from St. Peter in the damaged fresco in the Brancacci Chapel. Both women stand majestically and hold an infant who turns his back upon the beholder as he clings to his mother's body. The reversed figure, introduced by Giotto and occasionally employed before 1425 even for the Christ Child,[7] is here given a similar form, expressiveness and importance. . . .

Masaccio and Jan van Eyck . . . are related historically, as well as stylistically; they hold similar positions in the development of Western painting. After the initial impact of their radically new styles had been felt, the influence of each tended to decline until the late fifteenth century. Then just when Michelangelo and other painters were looking more intently at the frescoes in the Brancacci Chapel, Memling, Massys and others inaugurated a sort of Eyck revival in the Netherlands. And it is especially illuminating that this reversion to Van Eyck coincided with the first introduction of Italian Renaissance forms, as in Memling's *Madonnas* in Vienna or the Uffizi. These painters themselves, then, sensed a certain kinship between Jan van Eyck and the Italian Quattrocento.

The art of Jan van Eyck defies classification in terms of our established historical concepts. Too remote from antiquity to be considered a true Renaissance art, it nevertheless must be judged to have a near or para-Renaissance character. Like Masaccio and his followers in Italy, Jan opened a new era in the North. All references to modern painting in the Netherlands, from Vasari, Guicciardini and VanMander on, rightly begin with him. In Italy the great pictorial divide between the Middle Ages and what follows had two peaks—Giotto and Masaccio—but in the North there was really only one. . . .

[5]Leon Battista Alberti, *X Libri de architectura*, Book VII, Chapter 4. (*Ten books on Architecture.* Translated into Italian by Cosimo Bartoli and into English by James Leoni, ed. Joseph Rykwert [New York: Transatlantic Arts, 1966].)

[6]R. Wittkower, *Architectural Principles in the Age of Humanism* (London: Warburg Institute, 1949) pp. 1–28.

[7]As Northern forerunners of Jan's averted Child, compare the Madonna in an *Horae* of 1415 (Berlin: Staatsbibliothek, Germ. 42, 4⁰, fol. 284v); or, still earlier, the Madonna in the *Belles Heures*, fol. 26v, reproduced in J. Porcher, *Les Belles Heures de Jean de France, duc de Berry* (Paris: Bibliothèque Nationale, 1953) plate XXIX.

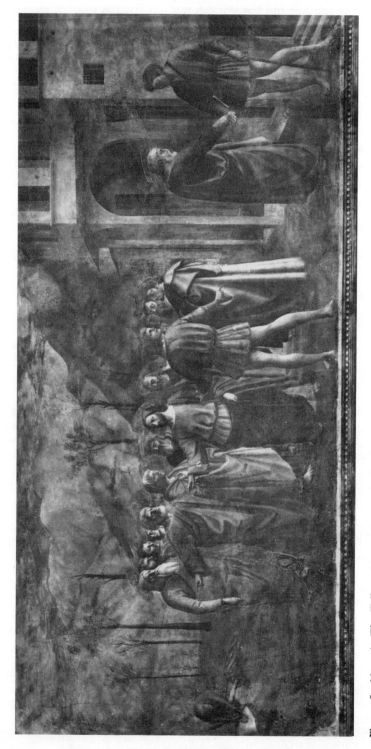

Figure 9 *Masaccio,* The Tribute Money. *Brancacci Chapel, Sta. Maria del Carmine, Florence.*
Photo: Alinari. Art Resource, New York.

11

Giorgio Vasari

THE LIFE
OF MICHELANGELO

GIORGIO VASARI, (1511–1574), PAINTER, architect, and close friend of Michelangelo, can rightly be considered the founder of the discipline of art history. Vasari was born in Arezzo, the oldest son of a merchant. His ability to draw was apparent from childhood, and in his teens he was brought to Michelangelo in Florence to study drawing. Michelangelo soon left for Rome. Vasari continued his studies with Andrea del Sarto; but the meeting with Michelangelo was the beginning of a friendship that grew in importance and meaning and lasted until Michelangelo's death (1564).

As a Renaissance artist, Vasari considered himself a scholar and art collector, not a mere artisan. It is not surprising that, as he painted commissions for various patrons in the 1540s, Vasari also collected drawings and made notes on the painting and sculpture that he saw on his travels. Gradually the project of writing the *Lives of the Most Excellent Painters, Sculptors, and Architects* took shape. The first edition appeared in 1550; a second, enlarged and revised, in 1568.

Vasari's *Lives* are short biographies of painters, sculptors, and architects of almost three centuries with critical descriptions of their works. Both the artists he chose and the qualities that he praised in their works illustrate Vasari's view of art. His first principle is, simply, that an historical or chronological approach is a meaningful way to study art. Vasari began with the earliest artists and discussed each artist according to his place in time. We take this for granted in art history books today, just as we take for granted the fact that an author selects the best artists to discuss. Vasari wrote about only the "most excellent" artists, and modern readers are

sometimes surprised at the amount of praise Vasari gives his subjects. However, he was writing not just a history, but also a guide to what the reader ought to see and admire.

Explanations of technical methods and evaluations of the way each artist used his technique were also important parts of Vasari's approach. From technique he moved to critical appraisals of the artist's works. Vasari tried to see and describe as many works by each artist as possible and to explain why those works were to be admired. The way he judged art amounted to a summary of sixteenth-century taste.

Like his contemporaries among the humanists and art collectors, Vasari had little interest in the art of the Medieval world. For him, the Middle Ages was a long gap between the achievements of ancient Rome, and the coming of Giotto who had "rescued and restored" the art of painting.

Vasari believed that art had improved steadily from Giotto's time until it reached its highest state in the work of Michelangelo. This implies that Vasari saw a kind of development in art similar to the growth of a living creature. We call such a scheme an "organic" model for the history of art. According to this model, art has an infancy (Giotto, the "rebirth"), a period of growth and development (largely the fifteenth-century masters, such as Donatello), and a climax (Michelangelo and the High Renaissance). Vasari does not consider what comes next. Must we conclude that there is an inevitable decline—a kind of senile old age—after a period of greatness? Or a new beginning? Furthermore, in the organic model even the individual artist's works should conform to a developmental scheme. Vasari expected that mature works should improve upon early efforts.

Vasari embodied the aesthetic judgment of his time in the criteria he used to evaluate works of art. Some of the qualities he applauded are technical proficiency, especially in drawing; good composition; fidelity to nature; variety and invention; and similarity to the Classical art of ancient Rome. Finally he felt that all these qualities must be accomplished with grace, which means that the work must appear to have been done with masterful ease. He emphasized that a magical, god-like quality—which we would call *genius*—is the essential quality of great art.

The *Lives* is not only a source of facts (and stories) about the Renaissance; it is the story of a great epoch, told with love and wit. In the words of the translator George Bull, "Vasari painted a harmonious and glowing composition which sustains with ease the task of conveying the revolutionary nature of what happened in Italian art between the fourteenth and sixteenth centuries. He lifted the story of Tuscan art . . . to the plane of the heroic, stretching back to the quasi-legendary figures of Cimabue and Giotto, and forward to the inspired Michelangelo Buonarroti, genius and saint."

The selection that follows is a very short version of the life of Michelangelo. The whole of Vasari's great work prepares the way for the coming of Michelangelo, almost as if the fourteenth and fifteenth centuries were a kind of artistic "Old Testament" and Michelangelo the divine hero of a "New Testament." It is not difficult to understand why Vasari gave Michelangelo this special status: the first page of his biography indicates

that Michelangelo reached what no other artist had been, or would be, able to achieve: that is, *perfection.*

Vasari's life of Giotto (1267?–1337) had been based on traditions that were little better than legends, for Giotto died more than two centuries before Vasari began to write. However, Vasari attributed to Giotto the first steps toward Renaissance art. In a famous sentence he wrote, "For after the many years during which the methods and outlines of good painting had been buried under the ruins caused by war it was Giotto alone who, by God's favour, rescued and restored the art. . . ." Giotto had rescued art by turning to nature as his model. By emphasizing Giotto's debt to nature, Vasari named one of the qualities he most admired in the art of his contemporary, Michelangelo. Vasari also retold a fable about Giotto's "discovery." It seems the boy was sketching one of the sheep he tended when a passing artist saw him and recognized his talent. Reminiscent of modern tales of actresses discovered behind the soda fountain counter, Giotto's miraculous discovery can be compared to the many miraculous auguries surrounding Michelangelo; both demonstrate Vasari's belief in the divine nature of genius.

Vasari's principal theses were established early in the *Lives,* beginning with the "Life of Giotto." In contrast, in the "Life of Michelangelo," Vasari applied his principles to an artist he knew and loved. Michelangelo's biography is the longest in Vasari's work, more than twice as long as its nearest competitor, occupying over a hundred pages in most editions. But it is not only Vasari's personal admiration that his work reflects. The views he presented were commonly held and can be found in the writings of other authors. At the end of the "Life of Michelangelo," in a section omitted from this excerpt, Vasari described Michelangelo's funeral. Its elaborate ceremonies give ample evidence that all of Florence's leading artists and humanists held Michelangelo in the same reverential esteem. It was universally acknowledged that God, the astrological influences of the planets, and the beneficial atmosphere of the city of Florence had combined to produce such a genius. Michelangelo's divinity is stressed again in his precocity. His genius, tested by frustrations and threatened by the conspiring of the jealous, nevertheless overcomes every difficulty set in its way. Works like the statue of *David* and the figure of *Moses* demonstrate his divine genius.

Michelangelo's works and the dates of their commissioning are generally accurate in Vasari's account. Since he knew the artist and had written the first (1550) edition of the *Lives* during Michelangelo's own lifetime, any errors were relatively easily corrected.[1] Furthermore, Vasari's appreciation of Michelangelo's works surpasses mere description. Vasari's language is vivid; he does not merely list subjects (in fact, he often assumes the reader knows pretty well what the subject is) but draws the reader's attention to detail, to effect, to the love with which Michelangelo imbued stone.

Yet Michelangelo does not remain a remote and god-like figure in

[1]Condivi's biography of 1553, written in close collaboration with Michelangelo, also provided information on which Vasari drew freely.

these pages. Intermixed with descriptions of his triumphant artistic achievements are anecdotes, often quoted from Michelangelo's own words—the story of Michelangelo's love of carving sucked in with his wet-nurse's milk, or Michelangelo's saving enough rope from the Sistine ceiling scaffolding to dower a workman's daughter. Quotations, and references to his making copies of earlier art works, prove that Michelangelo understood and loved the artists who preceded him. This raises an interesting question. How can we reconcile Michelangelo's use of ancient models and imitations of Renaissance art with the disdain for copies that he expressed on several occasions (see pages 127–128)?

Vasari's accounts of the difficulties that resulted in Michelangelo's never finishing the Tomb of Julius II (his favorite project)—nor, in fact, bringing to completion most of his other later sculptures—are suspect in one important way: to Vasari (and possibly, at least in part, to Michelangelo himself) all difficulties were the result of plots, jealousy, and human distractions. Only occasionally is there a hint that Michelangelo himself may have found difficulty in completing works—that something within him as well as something outside could bring a project to a halt.

Vasari's own painting falls into the period, or style, known as *Mannerism*. Several parts of the descriptions of Michelangelo's works show that Vasari writes from a Mannerist perspective. This is particularly clear in the description of the New Sacristy of San Lorenzo, in Florence, and in the description of the *Last Judgment* (Sistine Chapel, Rome). Both of these works depart from High Renaissance style. Vasari is alert to these departures and praises them; other contemporaries were critical, particularly of the *Last Judgment*. Vasari responded to some of these criticisms. The rather sour, prudish, tone of the Counter-Reformation critics is answered by a joke (the story of Biagio da Cesena). Questions of style—Michelangelo's indifference to the "charm" of colors, his concentration on the human figure, his neglect of "delicate refinements"—are answered by a defense of the idea that art's highest goal is the reproduction of the human form. Vasari convinces us that Michelangelo's way has led to an even greater achievement: the revelation of God's mind to man.

From
The Lives of the Artists

Life of Michelangelo Buonarroti:
Florentine painter, sculptor,
and architect, 1475–1564

Enlightened by what had been achieved by the renowned Giotto and his school, all artists of energy and distinction were striving to give the world proof of the talents with which fortune and their own happy temperaments had endowed them. They were all anxious (though their efforts were in vain) to reflect in their work the glories of nature and to attain, as far as possible, perfect artistic discernment or understanding. Meanwhile, the benign ruler of heaven graciously looked down to earth, saw the worthlessness of what was being done, the intense but utterly fruitless studies, and the presumption of men who were farther from true art than night is from day, and resolved to save us from our errors. So he decided to send into the world an artist who would be skilled in each and every craft, whose work alone would teach us how to attain perfection in design (by correct drawing and by the use of contour and light and shadows, so as to obtain relief in painting) and how to use right judgement in sculpture and, in architecture, create buildings which would be comfortable and secure, healthy, pleasant to look at, well-proportioned and richly ornamented. Moreover, he determined to give this artist the knowledge of true moral philosophy and the gift of poetic expression, so that everyone might admire and follow him as their perfect exemplar in life, work, and behaviour and in every endeavour, and he would be acclaimed as divine. He also saw that in the practice of these exalted disciplines and arts, namely, painting, sculpture, and architecture, the Tuscan genius has always been pre-eminent, for the Tuscans have devoted to all the various branches of art more labour and study than all the other Italian peoples. And therefore he chose to have Michelangelo born a Florentine, so that one of her own citizens might bring to absolute perfection the achievements for which Florence was already justly renowned.

So in the year 1474 in the Casenino, under a fateful and lucky star,

Giorgio Vasari, *The Lives of the Artists (The Lives of the Most Excellent Painters, Sculptors, and Architects, written by Giorgio Vasari, Painter and Architect of Arezzo, revised and extended by the same, with their portraits* [woodcuts B.W.] *and with the addition of the Lives of living artists and those who died between the years 1550 up to 1567,* second edition, published 1568), modern translation by George Bull (Harmondsworth, England: Penguin Books, 1965, rev. ed. 1971). Excerpts. Copyright © George Bull, 1965. Reprinted by permission of Penguin Books Ltd.

the virtuous and noble wife of Lodovico di Leonardo Buonarroti gave birth to a baby son. That year Lodovico (who was said to be related to the most noble and ancient family of the counts of Canossa) was visiting magistrate at the township of Chiusi and Caprese near the Sasso della Vernia (where St. Francis received the stigmata) in the diocese of Arezzo. The boy was born on Sunday, 6 March, about the eighth hour of the night; and without further thought his father decided to call him Michelangelo, being inspired by heaven and convinced that he saw in him something supernatural and beyond human experience. This was evident in the child's horoscope which showed Mercury and Venus in the house of Jupiter, peaceably disposed; in other words, his mind and hands were destined to fashion sublime and magnificent works of art. Now when he had served his term of office Lodovico returned to Florence and settled in the village of Settignano, three miles from the city, where he had a family farm. That part of the country is very rich in stone, especially in quarries of grey-stone which are continuously worked by stone-cutters and sculptors, mostly local people; and Michelangelo was put out to nurse with the wife of one of the stone-cutters. That is why once, when he was talking to Vasari, he said jokingly: "Giorgio, if my brains are any good at all it's because I was born in the pure air of your Arezzo countryside, just as with my mother's milk I sucked in the hammer and chisels I use for my statues."

[Michelangelo showed a talent for drawing and was apprenticed to Domenico Ghirlandaio (1449–1494), Florentine painter.]

The way Michelangelo's talents and character developed astonished Domenico, who saw him doing things quite out of the ordinary for boys of his age and not only surpassing his many other pupils but also very often rivalling the achievements of the master himself. On one occasion it happened that one of the young men studying with Domenico copied in ink some draped figures of women from Domenico's own work. Michelangelo took what he had drawn and, using a thicker pen, he went over the contours of one of the figures and brought it to perfection; and it is marvellous to see the difference between the two styles and the superior skill and judgement of a young man so spirited and confident that he had the courage to correct what his teacher had done. This drawing is now kept by me among my treasured possessions. . . .

At that time the custodian or keeper of all the fine antiques that Lorenzo the Magnificent had collected at great expense and kept in his garden on the Piazza di San Marco was the sculptor Bertoldo.[1] He had been a pupil of Donatello's, and the chief reason why Lorenzo kept him in his service was because he had set his heart on establishing a school of first-rate painters and sculptors and wanted Bertoldo to teach and look after

[1]Giovanni di Bertoldo (*c.* 1420–1491).

them. Bertoldo was now too old to work; neverthless, he was very experienced and very famous. . . . So Lorenzo, who was an enthusiastic lover of painting and sculpture, regretting that he could find no great and noble sculptors to compare with the many contemporary painters of ability and repute, determined, as I said, to found a school himself. For this reason he told Domenico Ghirlandaio that if he had in his workshop any young men who were drawn to sculpture he should send them along to his garden, where they would be trained and formed in a manner that would do honour to himself, to Domenico, and to the whole city. So Domenico gave him some of the best among his young men, including Michelangelo and Francesco Granacci. And when they arrived at the garden they found Torrigiano (a young man of the Torrigiani family) working there on some clay figures in the round that Bertoldo had given him to do.[2] After he had seen these figures, Michelangelo was prompted to make some himself; and when he saw the boy's ambitious nature Lorenzo started to have very high hopes of what he would do. Michelangelo was so encouraged that some days later he set himself to copy in marble an antique faun's head which he found in the garden; it was very old and wrinkled, with the nose damaged and a laughing mouth. Although this was the first time he had ever touched a chisel or worked in marble, Michelangelo succeeded in copying it so well that Lorenzo was flabbergasted. Then, when he saw that Michelangelo had departed a little from the model and followed his own fancy in hollowing out a mouth for the faun and giving it a tongue and all its teeth, Lorenzo laughed in his usual charming way and said:

"But you should have known that old folk never have all their teeth and there are always some missing."

In his simplicity Michelangelo, who loved and feared that lord, reflected that this was true, and as soon as Lorenzo had gone he broke one of the faun's teeth and dug into the gum so that it looked as if the tooth had fallen out; then he waited anxiously for Lorenzo to come back. And after he had seen the result of Michelangelo's simplicity and skill, Lorenzo laughed at the incident more than once and used to tell it for a marvel to his friends. He resolved that he would help and favour the young Michelangelo; and first he sent for his father, Lodovico, and asked whether he could have the boy, adding that he wanted to keep him as one of his own sons. Lodovico willingly agreed, and then Lorenzo arranged to have Michelangelo given a room of his own and looked after as one of the Medici household. Michelangelo always ate at Lorenzo's table with the sons of the family and other distinguished and noble persons who lived with that lord, and Lorenzo always treated him with great respect. All this hap-

[2]Pietro Torrigiano (1472–1528), a Florentine sculptor who worked in England, notably on the tomb of Henry VII.

pened the year after Michelangelo had been placed with Domenico, when he was fifteen or sixteen years old; and he lived in the Medici house for four years, until the death of Lorenzo the Magnificent in 1492. . . .

To return to the garden of Lorenzo the Magnificent: this place was full of antiques and richly furnished with excellent pictures collected for their beauty, and for study and pleasure. Michelangelo always held the keys to the garden as he was far more earnest than the others and always alert, bold, and resolute in everything he did. For example, he spent many months in the church of the Carmine making drawings from the pictures by Masaccio;[3] he copied these with such judgement that the craftsmen and all the others who saw his work were astonished, and he then started to experience envy as well as fame.

It is said that Torrigiano, who had struck up a friendship with Michelangelo, then became jealous on seeing him more honoured than himself and more able in his work. At length Torrigiano started to mock him, and then he hit him on the nose so hard that he broke and crushed it and marked Michelangelo for life. Because of this, Torrigiano, as I describe elsewhere, was banished from Florence. . . .

[Michelangelo's fake "antique"]

. . . For Lorenzo di Pierfrancesco de'Medici, he [Michelangelo] made a little St. John in marble, and then immediately started work on another marble figure, a sleeping Cupid, life-size. When this was finished, Baldassare del Milanese showed it as a beautiful piece of work to Lorenzo di Pierfrancesco, who agreed with his judgement and said to Michelangelo:

"If you were to bury it and treat it to make it seem old and then send it to Rome, I'm sure that it would pass as an antique and you would get far more for it than you would here."

Michelangelo is supposed to have then treated the statue so that it looked like an antique; and this is not to be marvelled at seeing that he was ingenious enough to do anything. Others insist that Milanese took it to Rome and buried it in a vineyard he owned and then sold it as an antique for two hundred ducats to Cardinal San Giorgio. Others again say that Milanese sold the cardinal the statue that Michelangelo had made for him, and then wrote to Pierfrancesco saying that he should pay Michelangelo thirty crowns since that was all he had got for the Cupid; and in this way he deceived the cardinal, Lorenzo di Pierfrancesco, and Michelangelo himself. But then afterwards, the cardinal learned from an eye-witness that the Cupid had been made in Florence, discovered the truth of the matter through a messenger, and compelled Milanese's agent to restore his money and take back the Cupid. . . .

[3]That is, the Brancacci Chapel frescoes, c. 1427, in Santa Maria della Carmine, Florence. [BW]

All the same this work did so much for Michelangelo's reputation that he was immediately summoned to Rome [in 1496]

[The Pietà of 1498–99]

All the other works then being created were regarded as trivial compared with what Michelangelo was producing. As a result the French cardinal of Saint-Denis, called Cardinal Rouen,[4] became anxious to employ his rare talents to leave some suitable memorial of himself in the great city of Rome; and so he commissioned Michelangelo to make a Pietà of marble in the round, and this was placed, after it was finished, in the chapel of the Madonna della Febbre in St. Peter's, where the temple of Mars once stood. It would be impossible for any crafstman or sculptor no matter how brilliant ever to surpass the grace or design of this work or try to cut and polish the marble with the skill that Michelangelo displayed. For the Pietà was a revelation of all the potentialities and force of the art of sculpture. Among the many beautiful features (including the inspired draperies) this is notably demonstrated by the body of Christ itself. It would be impossible to find a body showing greater mastery of art and possessing more beautiful members, or a nude with more detail in the muscles, veins, and nerves stretched over their framework of bones, or a more deathly corpse. The lovely expression of the head, the harmony in the joints and attachments of the arms, legs, and trunk, and the fine tracery of pulses and veins are all so wonderful that it staggers belief that the hand of an artist could have executed this inspired and admirable work so perfectly and in so short a time. It is certainly a miracle that a formless block of stone could ever have been reduced to a perfection that nature is scarcely able to create in the flesh. Michelangelo put into this work so much love and effort that (something he never did again) he left his name written across the sash over Our Lady's breast. The reason for this was that one day he went along to where the statue was and found a crowd of strangers from Lombardy singing its praises; then one of them asked another who had made it, only to be told: "Our Gobbo from Milan."[5] . . .

This work did wonders for Michelangelo's reputation. To be sure, there are some critics, more or less fools, who say that he made Our Lady look too young. They fail to see that those who keep their virginity unspotted stay for a long time fresh and youthful, just as those afflicted as Christ was do the opposite. Anyhow, this work added more glory and lustre to Michelangelo's genius than anything he had done before.

Then some of his friends wrote to him from Florence urging him to return there as it seemed very probable that he would be able to obtain the

[4]This was Jean Villier de la Grolaie, abbot of St. Denis and cardinal of Santa Sabina.
[5]Cristoforo Solari.

block of marble that was standing in the Office of Works. Piero Soderini, who about that time was elected Gonfalonier for life,[6] had often talked of handing it over to Leonardo da Vinci, but he was then arranging to give it to Andrea Contucci of Monte Sansovino, an accomplished sculptor who was very keen to have it. Now, although it seemed impossible to carve from the block a complete figure (and only Michelangelo was bold enough to try this without adding fresh pieces) Buonarroti had felt the desire to work on it many years before; and he tried to obtain it when he came back to Florence. The marble was eighteen feet high, but unfortunately an artist called Simone de Fiesole had started to carve a giant figure, and had bungled the work so badly that he had hacked a hole between the legs and left the block completely botched and misshapen. So the wardens of Santa Maria del Fiore (who were in charge of the undertaking) threw the block aside and it stayed abandoned for many years and seemed likely to remain so indefinitely. However, Michelangelo measured it again and calculated whether he could carve a satisfactory figure from the block by accommodating its attitude to the shape of the stone. Then he made up his mind to ask for it. Soderini and the wardens decided that they would let him have it, as being something of little value, and telling themselves that since the stone was of no use to their building, either botched as it was or broken up, whatever Michelangelo made would be worthwhile. So Michelangelo made a wax model of the young David with a sling in his hand; this was intended as a symbol of liberty for the Palace, signifying that just as David had protected his people and governed them justly, so whoever ruled Florence should vigorously defend the city and govern it with justice. He began work on the statue in the Office of Works of Santa Maria del Fiore, erecting a partition of planks and trestles around the marble; and working on it continuously he brought it to perfect completion, without letting anyone see it.

As I said, the marble had been flawed and distorted by Simone, and in some places Michelangelo could not work it as he wanted; so he allowed some of the original chisel marks made by Simone to remain on the edges of the marble, and these can still be seen today. And all things considered, Michelangelo worked a miracle in restoring to life something that had been left for dead. . . . Without any doubt this figure has put in the shade every other statue, ancient or modern, Greek or Roman . . . such were the satisfying proportions and beauty of the finished work. The legs are skilfully outlined, the slender flanks are beautifully shaped and the limbs are joined faultlessly to the trunk. The grace of this figure and the serenity of its pose have never been surpassed, nor have the feet, the hands, and the head,

[6]Soderini was elected *Gonfaloniere di Justizia* for life (in effect, head of the Florentine Republic) in 1502.

whose harmonious proportions and loveliness are in keeping with the rest. To be sure, anyone who has seen Michelangelo's David has no need to see anything else by any other sculptor, living or dead.

The David (for which Piero Soderini paid Michelangelo four hundred crowns) was put in position in the year 1504

[Michelangelo's Moses (Figure 10), carved for the Tomb of Pope Julius II, begun 1503–1504. The statue is now in S. Pietro in Vincoli, Rome.]

. . . Michelangelo also finished the Moses, a beautiful statue in marble ten feet high. With this no other modern work will ever bear comparison (nor, indeed, do the statues of the ancient world). For, seated in an attitude of great dignity, Moses rests one arm on the tablets that he is grasping in one hand, while with the other he is holding his beard, which falls in long ringlets and is carved in the marble so finely that the hairs (extremely difficult for the sculptor to represent) are downy and soft and so detailed that it seems that Michelangelo must have exchanged his chisel for a brush. Moreover, the face of Moses is strikingly handsome, and he wears a saintly and regal expression; indeed, one cries out for his countenance to be veiled, so dazzling and resplendent does it appear and so perfectly has Michelangelo expressed in the marble the divinity that God first infused in Moses' most holy form. In addition, the draperies worn by Moses are carved and finished with beautiful folds in the skirt; and the arms with their muscles and the hands with their bones and tendons are so supremely beautiful, the legs, knees, and feet are covered with such carefully fashioned hose and sandals, and every part of the work is finished so expertly, that today more than ever Moses can truly be called the friend of God. For, through the skill of Michelangelo, God has wanted to restore and prepare the body of Moses for the Resurrection before that of anyone else. And well may the Jews continue to go there (as they do every Sabbath, both men and women, like flocks of starlings) to visit and adore the statue, since they will be adoring something that is divine rather than human. . . .

[Michelangelo paints the Sistine Chapel, 1508–1512.]

. . . The Pope had returned to Rome, while Michelangelo remained in Bologna to finish the statue.[7] In his absence Bramante was constantly plotting with Raphael of Urbino to remove from the Pope's mind the idea of having Michelangelo finish the tomb on his return. Bramante did this (being a friend and relation of Raphael and therefore no friend of Michelangelo's) when he saw the way his holiness kept praising and glorifying Michelangelo's work as a sculptor. He and Raphael suggested to Pope Julius that if the tomb were finished it would bring nearer the day of his death, and they said that it was bad luck to have one's tomb built while one was still alive. Eventually they

[7]A bronze statue of Pope Julius II for the church of San Petronio, Bologna. [BW]

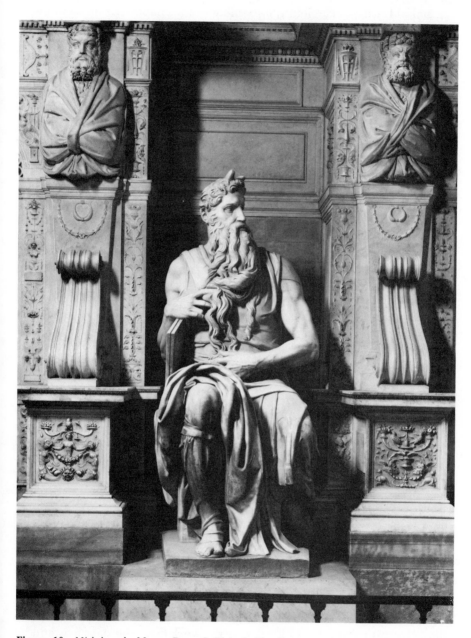

Figure 10 *Michelangelo,* Moses. *Rome, S. Pietro in Vincoli.*
Photo: Alinari. Art Resource, New York.

persuaded his holiness to get Michelangelo on his return to paint, as a memorial for his uncle Sixtus, the ceiling of the chapel that he had built in the Vatican. In this way Bramante and Michelangelo's other rivals thought they would divert his energies from sculpture, in which they realized he was supreme. This, they argued, would make things hopeless for him, since as he had no experience of colouring in fresco he would certainly, they believed, do less creditable work as a painter. Without doubt, they thought, he would be compared unfavorably with Raphael, and even if the work were a success being forced to do it would make him angry with the Pope; and thus one way or another they would succeed in their purpose of getting rid of him. So when Michelangelo returned to Rome he found the Pope resolved to leave the tomb as it was for the time being, and he was told to paint the ceiling of the chapel. Michelangelo, being anxious to finish the tomb, and considering the magnitude and difficulty of the task of painting the chapel, and his lack of experience, tried in every possible way to shake the burden off his shoulders. But the more he refused, the more determined he made the Pope, who was a wilful man by nature and who in any case was again being prompted by Michelangelo's rivals, and especially Bramante. And finally, being the hot-tempered man he was, his holiness was all ready to fly into a rage.

However, seeing that his holiness was persevering, Michelangelo resigned himself to doing what he was asked. Then the Pope ordered Bramante to make the ceiling ready for painting, and he did so by piercing the surface and supporting the scaffolding by ropes. When Michelangelo saw this he asked Bramante what he should do, when the painting was finished, to fill up the holes. Bramante said: "We'll think of it when it's time." And he added that there was no other way. Michelangelo realized that Bramante either knew nothing about the matter or else was no friend of his, and he went to the Pope and told him that the scaffolding was unsatisfactory and that Bramante had not known how to make it; and the Pope replied, in the presence of Bramante, that Michelangelo should do it himself in his own way. So he arranged to have the scaffolding erected on props which kept clear of the wall, a method for use with vaults (by which many fine works have been executed) which he subsequently taught to various people, including Bramante. In this instance he enabled a poor carpenter, who rebuilt the scaffolding, to dispense with so many of the ropes that when Michelangelo gave him what was over he sold them and made enough for a dowry for his daughter.

. . . Being forced reluctantly, by the magnitude of the task, to take on some assistants, Michelangelo sent for help to Florence. He was anxious to show that his paintings would surpass the work done there earlier, and he was determined to show modern artists how to draw and paint. Indeed, the circumstances of this undertaking encouraged Michelangelo to aim very high, for the sake both of his own reputation and the art of painting; and in this mood he started and finished the cartoons. He was then ready to begin

the frescoes, but he lacked the necessary experience. Meanwhile, some of his friends, who were painters, came to Rome from Florence in order to assist him and let him see their technique. . . . Having started the work, Michelangelo asked them to produce some examples of what they could do. But when he saw that these were nothing like what he wanted he grew dissatisfied, and then one morning he made up his mind to scrap everything they had done. He shut himself up in the chapel, refused to let them in again, and would never let them see him even when he was at home. . . .

Thereupon, having arranged to do all the work by himself, Michelangelo carried it well on the way to completion; working with the utmost solicitude, labour, and study he refused to let anyone see him in case he would have to show what he was painting. As a result every day the people became more impatient.

Pope Julius himself was always keen to see whatever Michelangelo was doing, and so naturally he was more anxious than ever to see what was being hidden from him. So one day he resolved to go and see the work, but he was not allowed in, as Michelangelo would never have consented. . . . Then, when the work was half finished, the Pope who had subsequently gone to inspect it several times (being helped up the ladders by Michelangelo) wanted it to be thrown open to the public. Being hasty and impatient by nature, he simply could not bear to wait until it was perfect and had, so to say, received the final touch.

As soon as it was thrown open, the whole of Rome flocked to see it; and the Pope was the first, not having the patience to wait till the dust had settled after the dismantling of the scaffolds. Raphael da Urbino (who had great powers of imitation) changed his style as soon as he had seen Michelangelo's work and straight away, to show his skill, painted the prophets and sibyls of Santa Maria della Pace; and Bramante subsequently tried to persuade the Pope to let Raphael paint the other half of the chapel However, the Pope recognized Michelangelo's genius more clearly every day and wanted him to carry on the work himself; and after he had seen it displayed he was of the opinion that Michelangelo would do the other half even better. And so in twenty months Michelangelo brought the project to perfect completion without the assistance even of someone to grind his colours. . . . There is no other work to compare with this for excellence, nor could there be; and it is scarcely possible even to imitate what Michelangelo accomplished. The ceiling has proved a veritable beacon to our art, of inestimable benefit to all painters, restoring light to a world that for centuries had been plunged into darkness. Indeed, painters no longer need to seek new inventions, novel attitudes, clothed figures, fresh ways of expression, different arrangements, or sublime subjects, for this work contains every perfection possible under those headings. In the nudes, Michelangelo displayed complete mastery: they are truly astonishing in their perfect foreshortenings, their wonderfully rotund contours, their grace, slenderness, and proportion. And to show the vast scope of his

art he made them of all ages, some slim and some full-bodied, with varied expressions and attitudes, sitting, turning, holding festoons of oak-leaves and acorns (to represent the emblem of Pope Julius and the fact that his reign marked the golden age of Italy, before the travail and misery of the present time) . . . Moreover, to show the perfection of art and the greatness of God, in the histories Michelangelo depicted God dividing Light from Darkness, showing him in all his majesty as he rests self-sustained with arms outstretched, in a revelation of love and creative power. . . .

[Michelangelo designs the New Sacristy, San Lorenzo, Florence, in the 1520s.]

The death of Leo was a fearful blow to the arts and those who prac- tised them, both in Florence and Rome; and while Adrian VI was Pope, Michelangelo stayed in Florence giving his attention to the tomb of Julius. Then Adrian died and was succeeded by Clement VII, who was no less anxious than Leo and his other predecessors to leave a name glorified by the arts of architecture, sculpture, and painting. It was at that time, in 1525, that Giorgio Vasari was taken as a young boy to Florence by the cardinal of Cortona and placed with Michelangelo as an apprentice. How- ever, Michelangelo was called to Rome by Pope Clement, who was ready to have a start made on the library of San Lorenzo and the new sacristy. . . . After the Pope and Michelangelo had discussed many things together, they resolved to finish completely the sacristy and the new library of San Lorenzo at Florence.

So Michelangelo again left Rome and raised the cupola of the sacristy as we see it today. . . .

Michelangelo made in the sacristy four tombs to hold the bodies of the fathers of the two Popes: namely, the elder Lorenzo and his brother Giuliano, and those of Giuliano, the brother of Leo, and of Duke Lorenzo, Leo's nephew. He wanted to execute the work in imitation of the old sacristy made by Filippo Brunelleschi but with different decorative fea- tures; and so he did the ornamentation in a composite order, in a style more varied and more original than any other master, ancient or modern, has ever been able to achieve. For the beautiful cornices, capitals, bases, doors, tabernacles, and tombs were extremely novel, and in them he de- parted a great deal from the kind of architecture regulated by proportion, order, and rule which other artists did according to common usage and following Vitruvius and the works of antiquity but from which Michelangelo wanted to break away.[8]

The licence he allowed himself has served as a great encouragement to others to follow his example; and subsequently we have seen the creation

[8]Cf. the Preface to Part Three of the *Lives* where Vasari discusses the meaning of these terms. Vitruvius was a Roman architect (Marcus Vitruvius Pollio) whose *De Architectura,—* rediscovered in the fifteenth century—exercised a profound influence on Renaissance archi- tectural theory.

of new kinds of fantastic ornamentation containing more of the grotesque than of rule or reason. Thus all artists are under a great and permanent obligation to Michelangelo, seeing that he broke the bonds and chains that had previously confined them to the creation of traditional forms. . . . Michelangelo's ideas for the tombs of Duke Giuliano and Duke Lorenzo de' Medici caused even more astonished admiration. For here he decided that Earth alone did not suffice to give them an honourable burial worthy of their greatness but that they should be accompanied by all the parts of the world; and he resolved that their sepulchres should have around and above them four statues. So to one tomb he gave Night and Day, and to the other Dawn and Evening; and these statues are so beautifully formed, their attitudes so lovely, and their muscles treated so skilfully, that if the art of sculpture were lost they would serve to restore to it its original lustre.

Then among the other statues there are the two captains in armour: one, the pensive Duke Lorenzo, the embodiment of wisdom, with legs so finely wrought that nothing could be better: the other, Duke Giuliano, a proud figure, with the head, the throat, the setting of the eyes, the profile of the nose, the opening of the mouth, and the hair made with such inspired craftsmanship, as are the hands, the arms, the knees, the feet, and indeed every detail, that one's eyes can never be tired of gazing at it. One has only to study the beauty of the buskins and the cuirass to believe that the statue was made by other than human hands. But what shall I say of the Dawn, a nude woman who is such as to arouse melancholy in one's soul and throw sculpture into confusion? In her attitude may be seen the anxiety with which, drowsy with sleep, she rises up from her downy bed; for on awakening she has found the eyes of the great duke closed in death, and her eternal beauty is contorted with bitter sorrow as she weeps in token of her desperate grief. And what can I say of the Night, a statue not only rare but unique? Who has ever seen a work of sculpture of any period, ancient or modern, to compare with this? For in her may be seen not only the stillness of one who is sleeping but also the grief and melancholy of one who has lost something great and noble. And she may well represent the Night that covers in darkness all those who for some time thought, I will not say to surpass, but even to equal Michelangelo in sculpture and design. In this statue Michelangelo expressed the very essence of sleep. . . . In 1529, while Michelangelo was labouring with intense love and solicitude on these works, Florence was besieged, and this decisively frustrated their completion. Because of the siege Michelangelo did little or no more work on the statues, because he had been given by the Florentines the task of fortifying both the hill of San Miniato and, in addition, as I said, the city itself. . . .

[Michelangelo's Last Judgment, *painted 1533–1541 during the papacy of Paul III]*

. . . I shall not dwell on the details of the inventions and composition of the Last Judgement, since so many copies of all sizes have been printed

that there is no call to waste time describing it. It is enough for us to understand that this extraordinary man chose always to refuse to paint anything save the human body in its most beautifully proportioned and perfect forms and in the greatest variety of attitudes, and thereby to express the wide range of the soul's emotions and joys. He was content to prove himself in the field in which he was superior to all his fellow craftsmen, painting his nudes in the grand manner and displaying his great understanding of the problems of design. Thus he has demonstrated how painting can achieve facility in its chief province: namely, the reproduction of the human form. And concentrating on this subject he left to one side the charm of colouring and the caprices and novel fantasies of certain minute and delicate refinements that many other artists, and not without reason, have not entirely neglected. For some artists, lacking Michelangelo's profound knowledge of design, have tried by using a variety of tints and shades of colour, by including in their work various novel and bizarre inventions (in brief, by following the other method of painting) to win themselves a place among the most distinguished masters. But Michelangelo, standing always firmly rooted in his profound understanding of the art, has shown those who can understand how they should achieve perfection.

To return to the Last Judgement: Michelangelo had already finished more than three-fourths of the work when Pope Paul went to see it. On this occasion Biagio da Cesena, the master of ceremonies and a very high-minded person, happened to be with the Pope in the chapel and was asked what he thought of the painting. He answered that it was most disgraceful that in so sacred a place there should have been depicted all those nude figures, exposing themselves so shamefully, and that it was no work for a papal chapel but rather for the public baths and taverns. Angered by this comment, Michelangelo determined he would have his revenge; and as soon as Biagio had left he drew his portrait from memory in the figure of Minos, shown with a great serpent curled round his legs, among a heap of devils in hell; nor for all his pleading with the Pope and Michelangelo could Biagio have the figure removed, and it was left, to record the incident, as it is today. . . .

When the Last Judgement was revealed it was seen that Michelangelo had not only excelled the masters who had worked there previously but had also striven to excel even the vaulting that he had made so famous; for the Last Judgement was finer by far, and in it Michelangelo outstripped himself. He imagined to himself all the terror of those days and he represented, for the greater punishment of those who have not lived well, the entire Passion of Jesus Christ, depicting in the air various naked figures carrying the cross, the column, the lance, the sponge, the nails, and the crown of thorns. These were shown in diverse attitudes and were perfectly executed with consummate facility. We see the seated figure of Christ

turning towards the damned his stern and terrible countenance in order
to curse them; and in great fear Our Lady draws her mantle around her as
she hears and sees such tremendous desolation. In a circle around the
figure of Christ are innumerable prophets and apostles; and most remark-
able are the figures of Adam and St. Peter, included, it is believed, as being
respectively the original parent of the human race that is now brought to
Judgement and the first foundation of the Christian Church. At the feet of
Christ is a most beautiful St. Bartholomew, who is displaying his flayed
skin . . .

The Last Judgement must be recognized as the great exemplar of the
grand manner of painting, directly inspired by God and enabling mankind
to see the fateful results when an artist of sublime intellect infused with
divine grace and knowledge appears on earth. Behind this work, bound in
chains, follow all those who believe they have mastered the art of painting;
the strokes with which Michelangelo outlined his figures make every intel-
ligent and sensitive artist wonder and tremble, no matter how strong a
draughtsman he may be. When other artists study the fruits of
Michelangelo's labours, they are thrown into confusion by the mere
thought of what manner of things all other pictures, past or future, would
look like if placed side by side with this masterpiece. How fortunate they
are, and what happy memories they have stored up, who have seen this
truly stupendous marvel of our times! And we can count Pope Paul III as
doubly fortunate and happy, seeing that, by allowing this work to come into
existence under his protection, God ensured future renown for his holiness
and for Michelangelo. How greatly are the merits of the Pope enhanced by
the genius of the artist! The birth of Michelangelo was indeed a stroke of
fortune for all artists of the present age, for his work as a painter, a sculp-
tor, and an architect has with its brilliance illuminated every problem and
difficulty.

Michelangelo laboured for eight years on the Last Judgement, and he
threw it open to view, I believe, on Christmas Day in the year 1541, to the
wonder and astonishment of the whole of Rome, or rather the whole
world. That year, I went to Rome myself, travelling from Venice, in order
to see it; and I along with the rest was stupefied by what I saw. . . .

*[Following the description of Michelangelo's death (1564), Vasari recounts several
anecdotes in which Michelangelo comments on art and artists.]*

A friend asked Michelangelo his opinion of someone who had imi-
tated in marble several of the most famous antique statues and boasted that
his copies were far better than the originals. Michelangelo answered:

"No one who follows others can ever get in front of them, and those
who can't do good work on their own account can hardly make good use of
what others have done."

* * *

As he was passing by San Giovanni in Florence, Michelangelo was asked what he thought of Ghiberti's doors; he replied: "They are so beautiful that they could stand at the entrance to Paradise."

* * *

Another time, a painter had executed a scene in which many of the details were copied from other pictures and drawings, and indeed there was nothing original in it. The painting was shown to Michelangelo, and after he had looked at it a close friend of his asked for his opinion.

"He has done well," Michelangelo commented, "but at the Day of Judgement when every body takes back its own members, I don't know what this picture will do, because it will have nothing left."

And this was a warning to artists to practise doing original work.

12

William M. Ivins, Jr.

ON THE RATIONALIZATION
OF SIGHT

"The Rationalization of Sight" is an essay about the history of ideas, about changes in the way men think about the universe they inhabit. One significant milestone in intellectual history was the development of rational thought: the ability to describe and analyse what we perceive by means of mathematical demonstration. Ivins's essay examines the relationship between visual art and the rational, scientific approach to understanding our world.

William Ivins was trained as a lawyer and practiced law successfully for some years before accepting a position as the first curator of prints at New York's Metropolitan Museum. In 1916, when he arrived, the Metropolitan (founded in 1870) had very few prints for him to care for; when Ivins retired in 1948, he had built the collection to an estimated 150,000 items. Ivins served as Acting Director of the Metropolitan for several years in the late 1930s, and it was while he held that very taxing office that he wrote the essay reprinted here.[1]

This essay is devoted to demonstrating the importance of perspective to the history of mathematical thought and to the history of ideas. According to Ivins, mathematical perspective (as described by Leon Battista Alberti, 1404–1472, and other authors cited) is not just an amusing device that

[1]Ivins was the author of a number of works on prints that demonstrate his ability to communicate with many kinds of readers, from beginners to scholars. His pictorial introduction to historical print techniques, *How Prints Look* (New York: Beacon Paperback, 1943) is still one of the best ways to start learning about the subject.

enables artists to startle us by the apparent creation of open space on a flat surface. Although the sensation is certainly delightful [see Figure 11]—and must have been even more so to a fifteenth century viewer who had never seen anything like it—its importance goes far beyond the magic-show that it provides. Perspective is one aspect of a scientific field, the science of optics.[2] Its use in painting is an example of the interrelationship of science and art.

We know the "real," three-dimensional, world by touch (by using our bodies) as well as by sight; but it is with our eyes alone that we experience space in the two-dimensional representation of the world that an artist puts on a flat surface. Perspective enables artists to depict the visual world convincingly on a single plane by establishing a mathematical relationship between the tactile and the visual realms of experience.

Once perspective was discovered, the sense of sight acquired a dimension that other sensory experiences, such as smell or touch, lack. There is still no mathematical equivalent for taste, for example. This means that although many people may agree that something tastes like a strawberry, we cannot prove that they all mean the same thing by that opinion. (In fact, by the simple experiment of presenting an unfamiliar taste or smell to a group of people, one can readily demonstrate that we do *not* all mean the same thing by such expressions as "It tastes [or smells] like a strawberry.") However, our sensory impression of *space* (sight), is no longer confined to a subjective individual sensation. The discovery of geometric perspective allows us to translate our sensory impressions into precise mathematical descriptions.

According to Ivins, Renaissance perspective construction anticipated the mathematical definition of parallel lines as "lines that meet at infinity." It provided a way to explain mathematically why objects appear to change in shape and size depending on their distance from us ("exterior relations of objects"), while their actual position and size ("interior relations") remain unchanged. It explains the apparent contradiction between our knowledge that railroad tracks are five feet apart here in front of us and still five feet apart a mile down the road, and the illusion they present to our eyes of meeting at a point on the horizon.

Ivins's essay was written decades before a concern with systems of symbols became one of the major approaches of scholars to many fields of study. In the last quarter of the twentieth century, linguists, anthropologists, and literary as well as art historians have gained new insights by studying their subjects as systems of symbols, borrowing some of their terminology and methods from mathematics. Since we, as modern scholars, must acknowledge this debt to the mathematician, it is fitting to recall that mathematics in turn owes important ideas to the artists of the Renaissance.

Is it an accident that an expert on the history and technique of printmaking wrote an essay on perspective? Ivins tells us that, on the con-

[2]When the Latin word *perspectiva* appears in medieval writings modern scholars often translate it as "optics."

Figure 11 *Central Italian, fifteenth century: Ideal View of a City. Baltimore. Walters Art Gallery.*
Reproduced by courtesy of the Walters Art Gallery.

131

trary, the origin of prints and the discovery of perspective were closely related. Prints produced identical images without the inevitable variation introduced by hand copying; this made it possible for many people to see exactly the same picture. Therefore when people talked to one another about a particular picture, they *knew* they were discussing the same thing— unlike the people trying to discuss the taste of strawberries. The print, "a technique which made possible the exact duplication of pictorial symbols for visual awareness," was introduced only a short time before Alberti's explanation of a precise, reproducible, logic for representing space on the plane.

A secondary purpose of Ivins's essay is his outline of the subsequent story of perspective and its mathematical implications from the fifteenth to the nineteenth centuries. This part of the work should be particularly interesting to students of math and science. Titles of the scientific works to which Ivins refers have been paraphrased (not translated literally) in brackets: the footnotes, however, retain the language of the original for the use of the serious student of the history of science.

From

On the Rationalization of Sight

For some time past the present writer has been pursued by the notion that the most important thing that happened during the Renaissance was the emergence of the ideas that led to the rationalization of sight. This is a matter so different from the fall of Constantinople, the invention of printing from movable types, the discovery of America, the Reformation or the Counter Reformation, or any of the other traditional great events of that period, that a hasty account of it seems excusable before embarking upon a detailed examination of the mechanics of the perspective schemes of Alberti, Pelerin (known as the Viator), and Dürer, in which the effort towards that rationalization received its first expression in Italy, France, and Germany.

In order to have ideas about the returns given us about nature by our five senses, it is necessary to have some system of symbols by which to represent those returns and some grammar or rule by which those symbols are given logical relationships. Lacking such symbols, or a grammar for their use, the task of thinking becomes too onerous to be carried very far. A symbol that cannot be exactly duplicated, or, what comes to the same thing, a symbol that of necessity undergoes fortuitous changes of meaning in the course of repetition or duplication, is of very limited usefulness. A system of symbols without logical schemes, both for its interrelations and combinations within itself and, if it symbolize external fact, for its two-way, or reciprocal, correspondence with that external fact, is also of very limited usefulness. However interesting or important such symbols or series of symbols may be for personal intuition they obviously have little or no value for rationalization.

Words as symbols have no meanings except such as they get from general convention or specific agreement as coupled with recognitions arising through concrete experience, and thus are incapable of conveying information about unique characteristics to people who are not acquainted with those characteristics at first hand. It is doubtful whether a recognizable portrait has ever been painted from a verbal description. As yet no symbolization except a very poor verbal tautology has ever been worked

William M. Ivins, Jr., *On the Rationalization of Sight* (New York: Da Capo Press, 1973). Excerpts from pp. 7–13. Originally published as *Metropolitan Museum of Art Papers*, no. 8 (1938). Reprinted by permission of Da Capo Press, Inc.

out for the returns given us by the senses of taste and smell. At most we can say that strawberries taste like strawberries and that roses smell like roses. The symbolization for the returns given us by the sense of hearing is extremely limited and as yet has proved incompetent to deal with sounds that lie outside the conventional restrictions of the notation of words and music. There is no symbolism that has been able to record or deal with such things as the personal timbre or characteristics of a human voice. The phonograph and the sound cinema, which after all are very recent inventions, while providing a method for the duplication of sounds, provide no symbols for them and no grammar or rules for the combination of such symbols.

The ancient Greeks worked out a highly abstract symbolism for certain very elementary and limited space intuitions and provided it with a most remarkable grammar. The two together are known to us as Euclidean geometry, the origin of which in tactile-muscular intuition is shown by its nearly complete preoccupation with metrical problems and its essential dependence upon congruence. The dominance of tactile-muscular intuition in Greek geometry and the failure of that geometry to take account of visual intuition is exemplified by the fact pointed out by L. Cremona that "most of the propositions in Euclid's Elements are metrical, and it is not easy to find among them an example of a purely descriptive theorem."[1] Although the Greeks worked all around the problem of perspective, as is shown, for example, by their interest in conics, their knowledge of the anharmonic ratio, and their discovery of such theorems as that about the inscribed hexagon to which Pappus's name is attached,[2] they seem never to have realized that there was such a thing as a mathematical problem of perspective. The underlying tactile assumptions of Euclidean geometry are excellently exhibited in its basic postulate about parallel lines. If we get our awareness of parallelism through touch, as by running our fingers along a simple molding, there is no question of the sensuous return that parallel lines do not meet. If, however, we get our awareness of parallelism through sight, as when we look down a long colonnade, there is no doubt about the sensuous return that parallel lines do converge and will meet if they are far enough extended. Although Euclid was well aware of this (see his *Optics*, Theorem VI) and was explicit about the fact that his famous fifth postulate[3] was a postulate, it was not until the seventeenth century that for the first time a mathematician adopted convergence at infinity as the basis of a definition of parallel lines.[4]

[1]*Elements of Projective Geometry*, Oxford, third edition, p. 50.

[2]For these and other similar instances, see Sir Thomas Heath's *A History of Greek Mathematics*, Oxford, 1921, vol. II, pp. 270, 381, 397, 419, 521, etc.

[3]Euclid's fifth postulate is today perhaps best known through Playfair's eighteenth-century equivalent, that only one line may be drawn through a given point parallel to a given line.

[4]If one remembers correctly, it was Ernst Mach who picturesquely pointed out that if men were fastened immovably to rocks like mollusks in the sea they could have no sensory

At the very beginning of human history men discovered in their ability to make pictures a method for symbolization of their visual awarenesses which differs in important respects from any other symbolic method that is known. As distinguished from purely conventional symbols, pictorial symbols can be used to make precise and accurate statements even while themselves transcending definition.[5] In spite of this, picturemaking long remained a most inefficient sort of symbolization. There were two great reasons for this inefficiency: one, that no picture could be exactly duplicated, and the other, that there was no rule or grammatical scheme for securing either logical relations within the system of pictorial symbols or a logical two-way, or reciprocal, correspondence between the pictorial representations of the shapes of objects and the locations of those objects in space.[6]

Until the end of the fourteenth century this was the condition of man's ability to symbolize his sensuous awareness of nature. To it may be attributed much of the failure of classical and mediaeval natural science.

At the end of the fourteenth century or the beginning of the fifteenth century someone somewhere in Europe began to make woodcuts. Original-

intuition of Euclidean space. F. Enriques, who has discussed the spatial intuitions that come from visual and from tactile-muscular sensations, has said: "F. Klein a le premier remarqué cette difference entre les propriétés descriptives et les propriétés métriques." (*Encyclopédie des sciences mathématiques* . . . , tome III, vol. 1, p. 63, and see also Enriques's *Leçons de géométrie projective*, Paris, 1930, p. 3.) The way in which the tactile-muscular habit of thought inhibited the ancient geometers is very remarkably shown by Heath's account (*op. cit.*, vol. II, p. 521) of Peithon and Serenus (fourth century A.D.). This account is so interesting that I quote it in extenso. "In the propositions (29–33) from this point to the end of the book Serenus deals with what is really an optical problem. It is introduced by a remark about a certain geometer, Peithon by name, who wrote a tract on the subject of parallels. Peithon, not being satisfied with Euclid's treatment of parallels, thought to define parallels by means of an illustration, observing that parallels are such lines as are shown on a wall or a roof by the shadow of a pillar with a light behind it. This definition, it appears, was generally ridiculed; and Serenus seeks to rehabilitate Peithon, who was his friend, by showing that his statement is after all mathematically sound. He therefore proves, with regard to the cylinder, that, if any number of rays from a point outside the cylinder are drawn touching it on both sides, all the rays pass through the sides of a parallelogram (a section of the cylinder parallel to the axis)—Prop. 29—and if they are produced farther to meet any other plane parallel to that of the parallelogram the points in which they meet the plane will lie on two parallel lines (Prop. 30); he adds that the lines will not *seem* parallel (*vide* Euclid's *Optics*, Prop. 6)."

[5]In thinking about symbols it is necessary to remember that while some symbols are defined by their references, other references are defined by their symbols. The more closely a highly organized and purely conceptual subject, such as mathematics, defines its symbols, the wider is the range of variation that may be introduced into the physical forms of the symbols without effecting change in their significance. The more closely symbols (e.g. pictures) define unorganized and concrete subjects, such as the materials of visual sense awarenesses, the narrower is the range of variation that may be introduced into the physical forms of the symbols without effecting change in their significance. Thanks to the pictorial symbol's sensuously immediate definition of its reference, it is basic for many of the recognitions of similarity which must be made before practical knowledge or science is possible.

[6]The only pre-Renaissance statement I have found to show that people were ever specifically aware of the difficulties of a pictorial symbolism that was not accurately repeatable is contained in chapters 4, 5, and 10 of Book XXV of Pliny's *Natural History*. Little more interesting or directly to the point can be desired than this account of why some Greek botanists gave up the attempt to illustrate their books.

ly the woodcut was a mere laborsaving device for the quantity production of sacred images. It was the earliest form of the printed picture. By the end of the fifteenth century men were printing pictures from engraved and etched metal plates as well as from wooden blocks. The printing of pictures provided for the first time a technique which made possible the exact duplication of pictorial symbols for visual awareness.[7]

The invention of the printed picture was thus not improbably an event unique in the history of European thought. Very shortly after it happened there was another unprecedented event which, coming in similar fashion to a society that was not prepared for it, took a long time before its mechanics were understood or its implications were recognized. This was Leone Battista Alberti's discovery of a simple but logical scheme for pictorial perspective.

Perspective may be regarded as a practical means for securing a rigorous two-way, or reciprocal, metrical relationship between the shapes of objects as definitely located in space and their pictorial representations [see Figure 11]. Important as this is to picturemaking in the narrowest sense, it is doubtless even more important to general thought, because the premises on which it is based are implicit in every statement made with its aid. Either the exterior relations of objects, such as their forms for visual awareness, change with their shifts in location, or else their interior relations do. If the latter were the case there could be neither homogeneity of space nor uniformity of nature, and science and technology as now conceived would necessarily cease to exist. Thus perspective, because of its logical recognition of internal invariances through all the transformations produced by changes in spatial location, may be regarded as the application to pictorial purposes of the two basic assumptions underlying all the great scientific generalizations, or laws of nature.[8]

Alberti's perspective scheme of 1435–1436 marked the effectual beginning of the substitution of visual for tactile space awareness, because its novel procedure of central projection and section[9] not only automatically brought parallel lines together in logically determinable vanishing points, but provided a basis for the hitherto missing grammar or rules for securing

[7]The history of the graphic techniques is neither more nor less than the history (1) of the extension of the ability exactly to duplicate the symbols of visual awareness and (2) of the extension of the power of those symbols sensuously to define unique personal characteristics that transcend purely formal or conventional notation. The historians of "fine prints," because of their limited technical approach and also because of their preoccupation with primitive rarities and the very occasional artistic masterpieces, have with remarkable unanimity disregarded both the expansion of the social utility of the graphic media and their functional growth and intellectual importance as tools of knowledge and thought.

[8]Cf. B. A. W. Russell, *An Essay on the Foundations of Geometry*, Cambridge, 1897, *passim*.

[9]The late Greek geometers on rare occasion utilized this procedure, as for example in propositions 28 and 29 of the fourth book of Pappus's *Synagoge* (see Heath, *op. cit.*, vol. II, p. 380), but would seem never to have realized its possibilities or to have developed it.

both logical relations within the system of symbols employed and a reciprocal, or two-way, metrical correspondence between the pictorial representations of objects and the shapes of those objects as located in space.

Ever since Alberti made his statement, men have been busy, some misunderstanding and some developing it. Leonardo da Vinci and others who understood it reduced it to a form, known as the "costruzione legittima," that was practical for artists.[10] Viator published the variant which is now known in the studios as three-point perspective in his *De artificiali perspectiva* [*On Constructed Perspective*] of 1505. Dürer, whose *Unterweysung der Messung* [*Course in the Art of Measurement*, a treatise on geometry for artists] was published in 1525, was acquainted with the method of projection and section, but failed to understand it, as apparently did his immediate German successors. Vignola, in the first half of the sixteenth century, taught both the costruzione legittima and the three-point method, but the substance of his teaching was not published until Egnatio Danti's *Le due regole della prospettiva pratica* [*The Two Rules of Practical Perspective*] appeared at Rome in 1583. Guidobaldo del Monte in his prolix *Montis perspectivae libri sex* [*Monte's Six Books on Perspective*] of 1600 summed up the perspective knowledge of the sixteenth century and worked out a number of elaborate variations but seemingly added little to the basic theory. He is said to have been the first to use the phrase vanishing point (*punctum concursus*).

Kepler's postulation, in his *Ad vitellionem paralipomena* of 1604 [*Additions to Witelo* (the reference is to Witelo's *Perspectiva*, written about 1270)], that parallel lines meet at a point at infinity[11] was the independent mathematical recognition of an operational fact implicit in Alberti's construction and indirectly stated by him in his text It has been said that Kepler's postulation marks off modern from classical geometry.

It was not, however, until the 1630's that for the first time a mathematician of genius attacked the specific problem of perspective. This man, Girard Desargues of Lyons, the greatly admired friend of Descartes and Fermat, opened the way to both the perspective and the descriptive geometries. That Alberti preceded Kepler by one hundred and seventy years, and Desargues by two hundred years, throws much light upon the mathematical knowledge and ability of the fifteenth and sixteenth centuries. Among many other things, Desargues discovered the theorem about perspective triangles now known by his name, and, from purely perspective considerations, he postulated in so many words that parallel lines in a plane

[10]The text of leaf 42 recto of Leonardo's Manuscript A proves conclusively that Leonardo was fully aware of the strict two-way metrical correspondence between a correctly made perspective drawing of an object in space and the object itself.

[11]See Charles Taylor's article "Geometrical Continuity" in *Encyclopedia Britannica*, eleventh edition. The essential passage from Kepler's text is reprinted in H. F. Baker's *Principles of Geometry*, Cambridge, 1929, vol. I, p. 178.

meet at a point at infinity.[12] In 1640, the year after Desargues's *Brouillon proiect d'une atteinte*, [untranslatable title of Desargue's treatise, usually referred to as the *Brouillon Project*] his pupil, Blaise Pascal, by the use of its methods, worked out the theorem about the hexagon inscribed in a conic. Thus Desargues and Pascal, between them, developed the two basic theorems of the modern geometry of perspective.[13] Those who think of perspective only as a more or less unimportant subject in the curriculum of an art school should find food for thought in the facts that Desargues is reputed to have been the first to design an epicycloidal gearing,[14] and that every engineering and architectural school now requires that its students have a knowledge of descriptive geometry.

Because of the scattered way in which Desargues published his results—his very important *Brouillon proiect d'une atteinte* was lost from the end of the seventeenth century until the middle of the nineteenth century—and especially, it would seem, because of the fascination of the field of endeavor opened up by Descartes's almost simultaneous publication (1637) of analytical geometry, the discoveries of Desargues and Pascal were in general ignored until after they had been more or less independently worked out by other men in the late eighteenth and early ninteenth centuries.

In 1798–1799 Monge published his *Géométrie descriptive*, [*Descriptive Geometry*] in which, as the result of a remarkable analysis of previous practice and the discovery of its generalized theoretical basis, he may be said to

[12]Desargues, writing in 1636, said: "Quand les lignes suiet sont paralelles entr'elles, & que la ligne de l'oeil menée paralelle à icelles, n'est pas paralelle au tableau; les aparences de ces lignes suiet, sont des lignes qui tendent toutes au poinct auquel cette ligne de l'oeil rencontre le tableau, d'autant que chacune de ces lignes suiet est en un mesme plan avec cette ligne de l'oeil, en laquelle tous ces plans s'entre-coupent ainsi qu'en leur commun essieu, & que tous ces plans sont coupez d'un autre mesme plan le tableau." (See A. Bosse, *Manière universelle de Mr Desargues pour pratiquer la perspective*, 1648, p. 333.) If this be compared with Alberti's construction, it will be seen to be a verbal statement of what happens in the operation of that construction. In 1639 Desargues, in his *Brouillon proiect d'une atteinte* . . . , said: "Pour donner à entendre l'espece de position d'entre plusieurs droites en laquelle elles sont toutes paralelles entr'elles, il est icy dit que toutes ces droites sont entr'elles d'une mesme ordonnance, dont le but est à distance infinie, en chacune d'une part et d'autre." (See Poudra's *Oeuvres de Desargues*, Paris, 1864, vol. I, p. 104.) Desargues's 1636 demonstration of his theorem about perspective triangles will be found at p. 340 of the book by Bosse cited above, as well as in Poudra's edition of Desargues's *Oeuvres*.

[13]H. Wiener, in his "Ueber Grundlagen und Aufbau der Geometrie" (*Jahresber. d. deutsch. Math. Verein*, vol. I, 1892, p. 47) says: "Diese beiden Schliessungssätze [i.e. the theorem of Desargues about perspective triangles and that of Pascal about the particular case in which the hexagon is inscribed within a conic degraded to two straight intersecting lines] aber genügen, um ohne weitere Stetigkeitsbetrachtungen oder unendliche Processe den Grundsatz der projectiven Geometrie zu beweisen, und damit die ganze lineare projective Geometrie der Ebene zu entwickeln."

[14]See Chasles's *Aperçu historique sur l'origine et le développement des méthodes en géométrie*, Paris, third edition, p. 86.

have created modern descriptive geometry.[15] In 1822 J. V. Poncelet, one of Monge's old pupils, published his great classical *Traité des propriétés projectives des figures: Ouvrage utile à ceux qui s'occupent des applications de la géométrie descriptive et d'operations géométriques sur le terrain,* [*Treatise on the projective properties of figures, for the use of those concerned with applications of descriptive geometry and land surveying*] in which projective geometry was finally developed into a full-fledged mathematical discipline.[16] In 1847 von Staudt freed perspective geometry of metrical notions.[17] The development at the hands of subsequent workers has been most remarkable, especially as leading up to the study of the foundations of geometry. Methods have been discovered by which Euclidean geometry and the various non-Euclidean geometries have been so related to projective geometry that Cayley felt justified in his enthusiastic statement that "projective geometry is all geometry."[18]

On the immediately practical side it is hardly too much to say that without the development of perspective into descriptive geometry by Monge and into perspective geometry by Poncelet and his successors modern engineering and especially modern machinery could not exist. Many reasons are assigned for the mechanization of life and industry during the nineteenth century, but the mathematical development of perspective was

[15]"Monge en conçut les idées fondamentales vers 1775, il élabora lentement et les exposa pour la première fois d'une façon systématique à l'École Normale, an III de la République. Mais il ne fut autorisé à publier ses importantes découvertes que l'an VII, à cause de la crainte éprouvée par le Gouvernement que les étrangers n'en tirent profit pour leurs ouvrages de défense militaires." (M. Solovine, at p. x of the Notice biographique prefacing his edition of Monge's *Géométrie descriptive,* Paris, 1922.) The following sentences from the short "Programme" which Monge himself prefixed to his book are not without interest: "Cet art a deux objets principaux. Le premier est de représenter avec exactitude, sur des dessins qui n'ont que deux dimensions, les objets qui en ont trois, et qui sont susceptibles de définition rigoureuse. Sous ce point de vue, c'est une langue nécessaire à l'homme de génie qui conçoit un projet, à ceux qui doivent en diriger l'exécution, et enfin aux artistes qui doivent eux-mêmes en exécuter les différentes parties. Le second objet de la Géométrie descriptive est de déduire de la description exacte des corps tout ce qui suit nécessairement de leurs formes et de leurs positions respectives. . . . On contribuera donc à donner à l'éducation nationale une direction avantageuse, en familiarisant nos jeunes artists avec l'application de la Géométrie descriptive aux constructions graphiques qui sont nécessaires au plus grand nombre des arts, et en faisant usage de cette Géométrie pour la représentation et la détermination des éléments des machines. . . ."

[16]There are few stories more romantically interesting or intellectually suggestive than those of the early lives of Monge and Poncelet. Poncelet, captured by the Russians during Napoleon's retreat from Moscow, and languishing in prison for several years without books or papers, preserved his sanity during his enforced idleness by making some of the greatest of all mathematical discoveries.

[17]In the preface to his *Geometrie der Lage* of 1847, he said: "Ich habe in dieser Schrift versucht, die Geometrie der Lage zu einer selbständigen Wissenschaft zu machen, welche des Messens nicht bedarf."

[18]Compare the remark made by Jean Nicod, *Foundations of Geometry & Induction,* London, 1930, p. 182: "The order of views thus becomes the only fundamental space of nature."

absolutely prerequisite to it. Professor A. N. Whitehead has somewhere remarked that the great invention of the nineteenth century was that of the technique of making inventions. The inventions of Monge and Poncelet were among the most important of the intellectual tools which made that great invention possible.

It is interesting to notice that, just as the earliest datable European prints were made during the lifetime of Alberti (1404–1472), so Monge (1746–1818) and Poncelet (1788–1867) were contemporaries of Nièpce (1765–1833) and Fox Talbot (1800–1877), to whose ingenuity we owe the first photography, a form of picturemaking that is not only precisely duplicable but one in which geometrical perspective is so inherent that today the camera is used as a surveying and measuring instrument[19] as well as a tool for the making of precisely duplicable pictures of unique characteristics that transcend notation in terms of convention, for instance, in its use in the attributions of connoisseurship. Photographic pictures have entered so deeply into the consciousness of Western Europe and America that now there are few people who are not unhappy with a modern picture that is too obviously out of photographic perspective.

The most marked characteristics of European pictorial representation since the fourteenth cenury have been on the one hand its steadily increasing naturalism and on the other its purely schematic and logical extensions. It is submitted that both are due in largest part to the development and pervasion of methods which have provided symbols, repeatable in invariant form, for representation of visual awarenesses, and a grammar of perspective which made it possible to establish logical relations not only within the system of symbols but between that system and the forms and locations of the objects that it symbolizes.

In the middle sixteenth century Brunfels and Fuchs issued the first botanies provided with printed illustrations adequate to the symbolization of the unique characteristics of the various plants and flowers. In 1543 Vesalius and John of Calcar produced the first fully illustrated anatomy, that is, the first grammar of the human figure which, naming the various bones, muscles, etc., defined them by exact reference to pictures, which, being printed from unchanging wooden blocks, remained invariant throughout the entire edition. Since that time, thanks in important measure to the availability of methods for the exact duplication of logically arranged pictorial symbols for visual awareness, scientific description has proceeded at a constantly accelerating rate. Scientific classification, which was practically impossible for many things so long as such methods were not available, has now because of them made enormous strides. Those methods have perhaps reached some of their most popularly acclaimed

[19]See, e.g., H. Deneux, *La Métrophotographie* . . . , Paris, 1930.

achievements in classification in the fields of archaeology, artistic connoisseurship, medical diagnosis, and criminal detection, knowledges and practices that have been completely refashioned since the development of photography and its related processes. Today there are few sciences or technologies that are not predicated in one way or another upon this power of invariant pictorial symbolization.

The constant extensions of the fields of usefulness of the pictorial symbol that is precisely duplicable and of the grammars of its use have had a most astonishing effect not only upon knowledge but upon thought and its basic assumptions or intuitions. Where the dominant Greek and mediaeval idea of "matter" seems to have been based on tactile and muscular intuitions, the modern one to a very great extent is based upon visual habits and intuitions. Relativity, which now in one form or another runs throughout contemporary thought and practice, is in large measure a development of ideas that were evolved through the study and use of projective transformations.

From being an avenue of sensuous awareness for what people, lacking adequate symbols and adequate grammars and techniques for their use, regarded as "secondary qualities," sight has today become the principal avenue of the sensuous awarenesses upon which systematic thought about nature is based. Science and technology have advanced in more than direct ratio to the ability of men to contrive methods by which phenomena which otherwise could be known only through the senses of touch, hearing, taste, and smell, have been brought within the range of visual recognition and measurement and thus become subject to that logical symbolization without which rational thought and analysis are impossible.[20] The discovery of the early forms of these grammars and techniques constitutes that beginning of the rationalization of sight which, it is submitted, was the most important event of the Renaissance.

[20]Nicod, *op. cit.*, p. 172, speaks of "our so-called visual distance which alone is correct enough for science."

13

Paolo Veronese

PAOLO VERONESE APPEARS BEFORE THE INQUISITION IN VENICE

WHEN PAOLO VERONESE WAS CALLED before the Inquisition to answer questions about one of his paintings, it could not have occurred to him that his testimony would be preserved and read centuries later as an unconditional defense of artistic freedom. The inquisitors asked Veronese about a painting called *Last Supper in the House of Simon*, (now called *Feast at the House of Levi*) [Figure 12], which seemed to them to include sacrilegious figures. The artist defended his work and its content with the words, "I paint as I see fit . . .". To a modern artist, that goes without saying. Subtle internalized values substitute for external prescriptions. The Medieval and the Renaissance artist, however, was expected to follow directions given to him by his patron. Often the church was the patron, and theological scholars determined the iconographic content of a work of art.

Veronese attempted to defend his painting by insisting that in all basic ways his work conformed to the church's guidelines. The offending "Germans," dogs, and people picking their teeth were mere ornament, said Veronese. Like the picture frame, they served only to enrich the work's appearance or to fill up space. Such things need not concern a commission of inquiry. Perhaps that is what Veronese really thought, and we are imposing our modern point of view on a sixteenth-century artist when we read more into his words. But it is also possible that Veronese was merely playing dumb, that when goaded into defending himself, he intentionally did exactly what it sounds like he did: defended the right of the artist to design his work according to his own views and talents.

Veronese was born Paolo Caliari in Verona (not far from Venice) in

Figure 12 *Paolo Veronese*, Feast at the House of Levi. *Venice, R. Accademia.*
Photo: Alinari. Art Resource, New York.

143

1528. He began his career in his native city, arriving in Venice in 1551. His first Venetian commission (an altarpiece for the Giustiniani Chapel, San Francesco della Vigna), shows that Titian was a major influence in the formation of his style. Veronese was a very successful artist, known for allegorical and historical paintings in the Ducal Palace and elsewhere and for his wonderful decorative scenes in Palladio's Villa Barbaro at Maser (about 1560). He died in Venice in 1588. *The Feast in the House of Levi* was painted in 1573.

The Inquisition that summoned Veronese was an arm of the church that had first appeared in the thirteenth century. It was an ecclesiastical court that sought out and tried heretics, Christians whose religious beliefs or practices differed from official church doctrine. The actual function of the Inquisition changed in the sixteenth century. Revived under the authority of the Holy Office, it now concentrated on the threat that the Protestant Reformation presented to the Roman Catholic Church. The German-speaking lands were, of course, one of the centers of the Reformation: Martin Luther's Protestant movement was centered in Germany. Veronese's inquisitors were most concerned with the possibility that somehow Protestant ideas might be behind the puzzling aspects of Veronese's painting. That is why they particularly asked about the Germans (identifiable by their clothes) among the spectators at the Last Supper.

Veronese's calling his picture "Last Supper . . . at the House of Simon" is already confusing. According to the Bible,[1] Jesus ate at the house of Simon two days before the beginning of Passover (the occasion of the Last Supper). Was Veronese trying to confuse the whole affair by pretending he understood very little of the subject of his paintings? In addition to the defense of his work that Veronese made in the excerpt from the trial included here, the artist also presented another defense. He compared himself to Michelangelo, whose *Last Judgment* (Sistine Chapel, Rome, 1536–1541) had been criticized because it contained so many nude figures. This distracted the examiners; they felt obliged to defend Michelangelo, who was regarded with enormous reverence (*see* Chapter 11 [Vasari]).

In the end, the Inquisition ruled that Veronese had three months to "improve and change" his painting. He never carried out their order; he did change the name of the painting. Apparently the *Feast at the House of Levi*[2] is a less important subject and therefore the "frivolities" Veronese had included were less offensive.

[1]Slightly varied accounts of this event are found in all four Gospels: Matthew XXVI, 6–7; Mark XIV, 1–3; Luke VII, 36–38; John XII, 1–8.

[2]Luke V, 27–32, similar accounts in Matthew IX, 9–13, and Mark II, 13–17.

From
Veronese's Trial Before The Holy Tribunal

Venice, July 18, 1573. The minutes of the session of the Inquisition Tribunal of Saturday, the 18th of July, 1573. Today, Saturday, the 18th of the month of July, 1573, having been asked by the Holy Office to appear before the Holy Tribunal, Paolo Caliari of Verona, domiciled in the Parish Saint Samuel, being questioned about his name and surname, answered as above.[1]

Questioned about his profession:

ANSWER: I paint and compose figures.

QUESTION: Do you know the reason why you have been summoned?

A: No, sir.

Q: Can you imagine it?

A: I can well imagine.

Q: Say what you think the reason is.

A: According to what the Reverend Father, the Prior of the Convent of SS. Giovanni e Paolo, whose name I do not know, told me he had been here and Your Lordships had ordered him to have painted [in the picture] a Magdalen in place of a dog. I answered him by saying I would gladly do everything necessary for my honor and for that of my painting, but that I did not understand how a figure of Magdalen would be suitable there for many reasons which I will give at any time, provided I am given an opportunity.[2]

Elizabeth Gilmore Holt, "Trial Before the Holy Tribunal," *Literary Sources of Art History* (Princeton, N.J.: Princeton University Press, 1947) pp. 245–248. Reprinted in Elizabeth Gilmore Holt, *A Documentary History of Art*, Volume II: *Michelangelo and the Mannerists: The Baroque and the Eighteenth Century* (Princeton, N.J.: Princeton University Press 1982), excerpt pp. 65–69. Copyright 1947, © 1958, 1982 by Princeton University Press. Reprinted by permission of Princeton University Press.

[1]The account of the trial is translated from the text as given in Pietro Caliari, *Paolo Veronese*, Rome, 1888, pp. 102 ff. A French translation showing slight variations in the text is given in A. Baschet, "Paolo Veronese," *Gazette des Beaux-Arts*, XXIII, 1867, pp. 378–382. See also: Blunt, *Theory*, p. 116; Percy H. Osmond, *Paolo Veronese*, London, 1927, pp. 68–70.

[2]Osmond, op. cit., p. 68, calls attention to the fact that the report is merely notes, not a verbatim report. Paolo seems to be feigning ignorance and to have little interest in the doctrinal significance of his pictures, as is shown by his mention of omitting Magdalen and then naming the picture "The Last Supper that Jesus took with His Apostles in the house of Simon."

Q: What picture is this of which you have spoken?
A: This is a picture of the Last Supper that Jesus Christ took with His Apostles in the house of Simon. [Figure 12]
Q: Where is this picture?
A: In the Refectory of the Convent of SS. Giovanni e Paolo.
Q: Is it on the wall, on a panel, or on canvas?
A: On canvas.
Q: What is its height?
A: It is about seventeen feet.
Q: How wide?
A: About thirty-nine feet.
Q: At this Supper of Our Lord have you painted other figures?
A: Yes, milords.
Q: Tell us how many people and describe the gestures of each.
A: There is the owner of the inn, Simon; besides this figure I have made a steward, who, I imagined, had come there for his own pleasure to see how the things were going at the table. There are many figures there which I cannot recall, as I painted the picture some time ago . . .
Q: In this Supper which you made for SS. Giovanni e Paolo, what is the significance of the man whose nose is bleeding?
A: I intended to represent a servant whose nose was bleeding because of some accident.
Q: What is the significance of those armed men dressed as Germans, each with a halberd in his hand?
A: This requires that I say twenty words!
Q: Say them.
A: We painters take the same license the poets and the jesters take and I have represented these two halberdiers, one drinking and the other eating nearby on the stairs. They are placed here so that they might be of service because it seemed to me fitting, according to what I have been told, that the master of the house, who was great and rich, should have such servants.
Q: And that man dressed as a buffoon with a parrot on his wrist, for what purpose did you paint him on that canvas?
A: For ornament, as is customary.
Q: Who are at the table of Our Lord?
A: The Twelve Apostles.
Q: What is St. Peter, the first one, doing?
A: Carving the lamb in order to pass it to the other end of the table.
Q: What is the Apostle next to him doing?
A: He is holding a dish in order to receive what St. Peter will give him.
Q: Tell us what the one next to this one is doing.
A: He has a toothpick and cleans his teeth.

Q: Who do you really believe was present at that Supper?

A: I believe one would find Christ with His Apostles. But if in a picture there is some space to spare I enrich it with figures according to the stories.

Q: Did any one commission you to paint Germans, buffoons, and similar things in that picture?

A: No, milords, but I received the commission to decorate the picture as I saw fit. It is large and, seemed to me, it could hold many figures.

Q: Are not the decorations which you painters are accustomed to add to paintings or pictures supposed to be suitable and proper to the subject and the principal figures or are they for pleasure—simply what comes to your imagination without any discretion or judiciousness?

A: I paint pictures as I see fit and as well as my talent permits. . . .

14

Heinrich Wölfflin

PRINCIPLES OF ART HISTORY

A TOOL INVENTED FOR ONE PURPOSE can prove useful for purposes its inventor never envisaged. In *Principles of Art History*, Heinrich Wölfflin designed such a set of tools. His paired stylistic terms like "linear" and "painterly" were invented to distinguish between the artistic style of the Renaissance and the style of the Baroque. We still use them for this purpose. They help us see basic similarities which lead us to classify such different painters as Dürer and Raphael together as High Renaissance artists, Caravaggio and Rembrandt as Baroque. However, Wölfflin's tools proved useful in describing art of many times and places and even for distinguishing between artists who are contemporaries. For the real subject of Wölfflin's work is the study of *modes of perception*—ways of seeing—that determine what an artist does. These modes of perception differ for each individual; but all individuals from a single culture are conditioned by their culture. Therefore there are also similarities among them that set them off from artists of other times.

Heinrich Wölfflin was born in Zurich in 1864. Educated in Germany and Switzerland late in the nineteenth century, Wölfflin too was influenced by the culture in which he lived. During his lifetime, physical science had made enormous advances in understanding the workings of the material world. Nineteenth-century biologists had discovered evolution and the germ theory of disease. All of knowledge seemed susceptible to scientific organization and classification. This encouraged art historians to pursue goals similar to those of the scientists. It is unfortunately also characteristic of German scholarship in Wölfflin's time that a complicated, difficult lan-

guage was employed. The translator, M. D. Hottinger, has succeeded in capturing the flavor of Wölfflin's style in English without making the selection totally incomprehensible.

One of Wölfflin's assumptions that might seem surprising today is the idea that the art of the High Renaissance (sixteenth century) is better in *quality* than the art of the Early Renaissance (fifteenth century). This idea would not have surprised Vasari. It is indeed implied by Vasari's model of artistic development. And it was a long-lived idea, lasting until late-nineteenth- and twentieth-century art challenged the values that supported it. (*See* Chapters 7 [Kitzinger] and 19 [Schapiro].)

Wölfflin's purpose is to establish a method for defining the artistic styles of different times. Included here are his definitions of five pairs of descriptive terms he used to distinguish High Renaissance art from Baroque art, and some examples of his applications of the terms to specific works in various media.[1] These pairs of terms are: *linear* and *painterly; plane* and *recession; closed form* and *open form; multiplicity* and *unity;* and *absolute clarity* and *relative clarity.* In each case, Wölfflin suggests a development from works better described by the first term of the pair to works better described by the second. The terms and their uses need careful reading in order for us to grasp the special meaning Wölfflin has given them.

Wölfflin begins with two words that seem simple: *linear* and *painterly.* These slightly awkward translations from German have become familiar to generations of art history students. We should be careful to remember that "linear" does not necessarily mean that there is a sharp line around every form in a painting. (Wölfflin calls such a style "primitive.") Perhaps the word "boundary" more nearly approximates Wölfflin's intentions. In a linear work, "stress is laid on the limits of things" and we can always tell whether we are looking at the object or at its surroundings. The term "painterly" nicely suggests a messier idea, for we are all familiar with housepaint and its ability to spread beyond the boundaries for which it is intended. The painterly quality of Baroque art is made obvious when we bring our eyes close to a seventeenth-century painting and find that the form of an object has dissolved into shapeless splotches.

The second pair of terms concerns the use of space within a painting, or in the volume of space occupied by sculpture or architecture. The first of these terms, *plane,* does not mean that the work is flat and lies on a single surface like, say, Early Christian catacomb paintings or certain minimalist paintings of the 1960s and 1970s. The word specifically describes art that uses the knowledge of perspective acquired during the Renaissance. It means that space is organized in a series of planes: that we can say confidently that one object is in front of another, and that we experience the work in an orderly progression from front to back. *Recession,* in contrast, implies that in-and-out motion seems to our eyes continuous. The viewer is

[1]A serious problem in Wölfflin's scheme is the absence of any discussion of *Mannerism.* However, an analysis of this question is outside the scope of this book. The bibliography in any survey of art history may be consulted for sources dealing with this topic.

forced to experience front-to-back movement, rather than easily dividing the image into foreground and background.

It rapidly becomes clear that Wölfflin's paired terms are interrelated. Linear works are usually planar, and painterly works tend to show recession. The first term of each pair will apply to Renaissance art, the second to Baroque. This close relationship among Wölfflin's criteria will help us to understand each term, for each reinforces the previous description. Although only examples of the use of Wölfflin's first two paired terms are given in this excerpt, the reader should observe Wölfflin's method and generalize its application to the three equally important principles that are not illustrated. *Closed* and *open* form can, for example, be easily understood when they are considered as part of a set of ideas we have already begun to use.

Although at first glance Wölfflin's terms seem to apply to the painted image, they prove remarkably helpful in describing sculpture and architecture. One example of the latter, the idea of plane and recession in architecture, easily convinces us of the power of Wölfflin's method. Mastering the ideas Wölfflin set forth will amply repay the reader, for they will at once prove useful in remembering and describing the painting, sculpture, and architecture of almost any period.

From

Principles of Art History

The Double Root of Style

Ludwig Richter[1] relates in his reminiscences how once, when he was in Tivoli as a young man, he and three friends set out to paint part of the landscape, all four firmly resolved not to deviate from nature by a hair's-breadth; and although the subject was the same, and each quite creditably reproduced what his eyes had seen, the result was four totally different pictures, as different from each other as the personalities of the four painters. Whence the narrator drew the conclusion that there is no such thing as objective vision, and that form and colour are always apprehended differently according to temperament.

For the art historian, there is nothing surprising in this observation. It has long been realised that every painter paints "with his blood." All the distinction between individual masters and their "hand" is ultimately based on the fact that we recognise such types of individual creation. With taste set in the same direction (*we* should probably find the four Tivoli landscapes rather similar, of a Preraphaelite type), the line will be in one case more angular, in another rounder, its movement here rather halting and slow, there more streaming and urgent. And, just as proportions tend now to the slender, now to the broad, so the modelling of the human body appeals to the one as something rather full and fleshy, while the same curves and hollows will be seen by another with more reticence, with much more economy. It is the same with light and colour. The sincerest intention to observe accurately cannot prevent a colour looking now warmer, now cooler, a shadow now softer, now harder, a light now more languid, now more vivid and glancing. . . .

The Most General Representational Forms

This volume is occupied with the discussion of these universal forms of representation. It does not analyse the beauty of Leonardo but the element

Heinrich Wölfflin, *Principles of Art History: The Problem of the Development of Style in Later Art,* translated by M. D. Hottinger (New York: Dover Publications) pp. 1–120. Excerpts. Originally published as *Kunstgeschichtliche Grundbegriffe* (Berlin 1915). Translation first published in 1932 by G. Bell and Sons Ltd., London. Reprinted by permission of Bell & Hyman Ltd., London.

[1]Ludwig Richter (1803–1884), German Romantic painter. [BW]

in which that beauty became manifest. It does not analyse the representation of nature according to its imitational content, and how, for instance, the naturalism of the sixteenth century may be distinguished from that of the seventeenth, but the mode of perception which lies at the root of the representative arts in the various centuries.

Let us try to sift out these basic forms in the domain of more modern art. We denote the series of periods with the names Early Renaissance, High Renaissance, and Baroque, names which mean little and must lead to misunderstanding in their application to south and north, but are hardly to be ousted now. Unfortunately, the symbolic analogy bud, bloom, decay, plays a secondary and misleading part. If there is in fact a qualitative difference between the fifteenth and sixteenth centuries, in the sense that the fifteenth had gradually to acquire by labour the insight into effects which was at the free disposal of the sixteenth, the (classic) art of the Cinquecento and the (baroque) art of the Seicento are equal in point of value. The word classic here denotes no judgment of value, for baroque has its classicism too. Baroque (or, let us say, modern art) is neither a rise nor a decline from classic, but a totally different art. The occidental development of modern times cannot simply be reduced to a curve with rise, height, and decline: it has two culminating points. We can turn our sympathy to one or to the other, but we must realise that that is an arbitrary judgment, just as it is an arbitrary judgment to say that the rose-bush lives its supreme moment in the formation of the flower, the apple-tree in that of the fruit.

For the sake of simplicity, we must speak of the sixteenth and seventeenth centuries as units of style, although these periods signify no homogeneous production, and, in particular, the features of the Seicento had begun to take shape long before the year 1600, just as, on the other hand, they long continued to affect the appearance of the eighteenth century. Our object is to compare type with type, the finished with the finished. Of course, in the strictest sense of the word, there is nothing "finished": all historical material is subject to continual transformation; but we must make up our minds to establish the distinctions at a fruitful point, and there to let them speak as contrasts, if we are not to let the whole development slip through our fingers. The preliminary stages of the High Renaissance are not to be ignored, but they represent an archaic form of art, an art of primitives, for whom established pictorial form does not yet exist. But to expose the individual differences which lead from the style of the sixteenth century to that of the seventeenth must be left to a detailed historical survey which will, to tell the truth, only do justice to its task when it has the determining concepts at its disposal.

If we are not mistaken, the development can be reduced, as a provisional formulation, to the following five pairs of concepts:

(1) The development from the linear to the painterly, *i.e.* the develop-

ment of line as the path of vision and guide of the eye, and the gradual depreciation of line: in more general terms, the perception of the object by its tangible character—in outline and surfaces—on the one hand, and on the other, a perception which is by way of surrendering itself to the mere visual appearance and can abandon "tangible" design. In the former case the stress is laid on the limits of things; in the other the work tends to look limitless. Seeing by volumes and outlines isolates objects: for the painterly eye, they merge. In the one case interest lies more in the perception of individual material objects as solid, tangible bodies; in the other, in the apprehension of the world as a shifting semblance.

(2) The development from plane to recession. Classic[2] art reduces the parts of a total form to a sequence of planes, the baroque emphasises depth. Plane is the element of line, extension in one plane the form of the greatest explicitness: with the discounting of the contour comes the discounting of the plane, and the eye relates objects essentially in the direction of forwards and backwards. This is no qualitative difference: with a greater power of representing spatial depths, the innovation has nothing directly to do: it signifies rather a radically different mode of representation, just as "plane style" in our sense is not the style of primitive art, but makes its appearance only at the moment at which foreshortening and spatial illusion are completely mastered.

(3) The development from closed to open form. Every work of art must be a finite whole, and it is a defect if we do not feel that it is self-contained, but the interpretation of this demand in the sixteenth and seventeenth centuries is so different that, in comparison with the loose form of the baroque, classic design may be taken as *the* form of closed composition. The relaxation of rules, the yielding of tectonic strength, or whatever name we may give to the process, does not merely signify an enhancement of interest, but is a new mode of representation consistently carried out, and hence this factor is to be adopted among the basic forms of representation.

(4) The development from multiplicity to unity. In the system of a classic composition, the single parts, however firmly they may be rooted in the whole, maintain a certain independence. It is not the anarchy of primitive art: the part is conditioned by the whole, and yet does not cease to have its own life. For the spectator, that presupposes an articulation, a progress from part to part, which is a very different operation from perception as a whole, such as the seventeenth century applies and demands. In both styles unity is the chief aim (in contrast to the pre-classic period which did not yet understand the idea in its true sense), but in the one case unity is achieved by a harmony of free parts, in the other, by a union of parts in a single

[2]"Klassisch." The word "classic" throughout this book refers to the art of the High Renaissance. It implies, however, not only an historical phase of art, but a special mode of creation of which that art is an instance. [Tr.]

theme, or by the subordination, to one unconditioned dominant, of all other elements.

(5) The absolute and the relative clarity of the subject. This is a contrast which at first borders on the contrast between linear and painterly. The representation of things as they are, taken singly and accessible to plastic feeling, and the representation of things as they look, seen as a whole, and rather by their non-plastic qualities. But it is a special feature of the classic age that it developed an ideal of perfect clarity which the fifteenth century only vaguely suspected, and which the seventeenth voluntarily sacrificed. Not that artistic form had become confused, for that always produces an unpleasing effect, but the explicitness of the subject is no longer the sole purpose of the presentment. Composition, light, and colour no longer merely serve to define form, but have their own life. There are cases in which absolute clarity has been partly abandoned merely to enhance effect, but "relative" clarity, as a great all-embracing mode of representation, first entered the history of art at the moment at which reality is beheld with an eye to other effects. Even here it is not a difference of quality if the baroque departed from the ideals of the age of Dürer and Raphael, but, as we have said, a different attitude to the world. . . .

Linear and Painterly

If we wish to reduce the difference between the art of Dürer and the art of Rembrandt to its most general formulation, we say that Dürer is a draughtsman and Rembrandt a painter. In speaking thus, we are aware of having gone beyond a personal judgment and characterised a difference of epoch. Occidental painting, which was draughtsmanly in the sixteenth century, developed especially on the painterly side in the seventeenth. Even if there is only one Rembrandt, a decisive readjustment of the eye took place everywhere, and whoever has any interest in clearing up his relation to the world of visible forms must first get to grips with these radically different modes of vision. The painterly mode is the later, and cannot be conceived without the earlier, but it is not absolutely superior. The linear style developed values which the painterly style no longer possessed and no longer wanted to possess. They are two conceptions of the world, differently orientated in taste and in their interest in the world, and yet each capable of giving a perfect picture of visible things.

Although in the phenomenon of linear style, line signifies only part of the matter, and the outline cannot be detached from the form it encloses, we can still use the popular definition and say for once as a beginning— linear style sees in lines, painterly in masses. Linear vision, therefore, means that the sense and beauty of things is first sought in the outline— interior forms have their outline too—that the eye is led along the boundaries and induced to feel along the edges, while seeing in masses takes place where the attention withdraws from the edges, where the outline has be-

come more or less indifferent to the eye as the path of vision, and the primary element of the impression is things seen as patches. It is here indifferent whether such patches speak as colour or only as lights and darks.

The mere presence of light and shade, even if they play an important part, is still not the factor which decides as to the painterly character of the picture. Linear art too, has to deal with bodies and space, and needs lights and shadows to obtain the impression of plasticity. But line as fixed boundary is assigned a superior or equal value to them. Leonardo is rightly regarded as the father of chiaroscuro, and his *Last Supper* in particular is the picture in which, for the first time in later art, light and shade are applied as a factor of composition on a large scale, yet what would these lights and darks be without the royally sure guidance which is exercised by the line? Everything depends on how far a preponderating significance is assigned to or withdrawn from the edges, whether they *must* be read as lines or not. In the one case, the line means a track moving evenly round the form, to which the spectator can confidently entrust himself; in the other, the picture is dominated by lights and shadows, not exactly indeterminate, yet without stress on the boundaries. Only here and there does a bit of palpable outline emerge: it has ceased to exist as a uniformly sure guide through the sum of the form. Therefore, what makes the difference between Dürer and Rembrandt is not a less or more in the exploitation of light and shade, but the fact that in the one case the masses appear with stressed, in the other with unstressed edges.

As soon as the depreciation of line as boundary takes place, painterly possibilities set in. Then it is as if at all points everything was enlivened by a mysterious movement. While the strongly stressed outline fixes the presentment, it lies in the essence of a painterly representation to give it an indeterminate character: form begins to play; lights and shadows become an independent element, they seek and hold each other from height to height, from depth to depth; the whole takes on the semblance of a movement ceaselessly emanating, never ending. Whether the movement be leaping and vehement, or only a gentle quiver and flicker, it remains for the spectator inexhaustible.

We can thus further define the difference between the styles by saying that linear vision sharply distinguishes form from form, while the painterly eye on the other hand aims at that movement which passes over the sum of things. In the one case, uniformly clear lines which separate; in the other, unstressed boundaries which favour combination. Many elements go to produce the impression of a general movement—we shall speak of these—but the emancipation of the masses of light and shade till they pursue each other in independent interplay remains the basis of a painterly impression. And that means, too, that here not the separate form but the total picture is the thing that counts, for it is only in the whole that that mysterious interflow of form and light and colour can take effect, and

it is obvious that here the immaterial and incorporeal must mean as much as concrete objects.

When Dürer . . . places a nude as a light object on a dark ground, the elements remain radically distinct: background is background, figure is figure, and the Venus or Eve we see before us produces the effect of a white silhouette on a dark foil. Conversely, if a nude in Rembrandt stands out on a dark ground, the light of the body seems as it were to emanate from the darkness of the picture space: it is as if everything were of the same stuff. The distinctness of the object in this case is not necessarily impaired. While the form remains perfectly clear, that peculiar union between the modeling lights and darks can have acquired a life of its own, and without the exigencies of the object being in any way prejudiced, figure and space, corporeal and incorporeal, can unite in the impression of an independent tonal movement. . . .

But with all that the decisive word is not yet said. We must go back to the fundamental difference between draughtsmanly and painterly representation as even antiquity understood it—the former represents things as they are, the latter as they seem to be. . . .

Plane and Recession

If we say that a development took place from a plane type into a recessional type, we have said nothing in particular, for it goes without saying that the means of representation of the object in the round and of recession in space were only gradually brought to perfection. The phenomenon we have in mind is that other—that just that stage of art which entered into full possession of the means of representing pictorial space, the sixteenth century, recognised the combination of forms in a plane as a principle, and that this principle of composition in the plane was dropped by the seventeenth century in favour of a definitely recessional type of composition. In the former case, the will to the plane, which orders the picture in strata parallel to the picture plane; in the latter, the inclination to withdraw the plane from the eye, to discount it and make it inapparent, while the forward and backward relations are emphasised, and the spectator is compelled to co-relate in recession.

It seems paradoxical, and yet fully corresponds to the facts—the sixteenth century is more planimetric than the fifteenth. While the undeveloped imagination of the primitives is certainly as a whole bound to the plane, yet continually makes attempts to break its spell, we see art, as soon as it has mastered perspective and spatial depth, consciously and consistently acknowledging the plane as the true form of beholding. It can be neutralised here and there by recessional motives, yet it penetrates the whole as binding basic form. Recessional motives in earlier art look for the most part incoherent, and the horizontal stratification there appears as mere poverty: now, on the other hand, plane and recession have become

one element, and just because the whole is interspersed with foreshortened forms, we feel that the acquiescence in the plane type is a matter of free choice, and obtain the impression of wealth simplified to the greatest repose and explicitness.

Nobody who comes from the Quattrocentists will forget the impression which Leonardo's *Last Supper* makes in this sense. Although the table with the group of disciples had certainly always been placed parallel to the picture edge, the alignment of the figures and their relation to the picture space here for the first time achieves that wall-like compactness which forces the plane upon us. . . .

Yet the classic plane style had its limited period, just like the classic line style, with which, since all line is bound to the plane, it has a natural affinity. There comes a moment when the plane relation slackens and the receding sequence of the picture forms begins to speak, where the contents of the picture can no longer be grasped in plane sections, but the nerve lies in the relation of the foreground to the background parts. That is the style of depreciated plane. An ideated foreground plane will always be present, but the possibility is no longer allowed to arise that the form unites in a plane. Whatever could operate in this sense—whether in the single figure or in the sum of many figures—is arrested. Even where this effect seems inevitable, as, for instance, where a number of human figures stands along the edge of the stage—care is taken that they do not settle into a row and that the eye is continually forced to form recessional relations.

If we leave out of account the imperfect solutions of the fifteenth century we obtain here two types of representational methods as different as the linear and painterly. Certainly, we can rightly ask whether they are really two styles, each of individual value and neither replaceable by the other, or whether the recessional representation contains only a greater measure of space-creating resources, without being an essentially new mode of representation. Properly understood, the two concepts are complete contrasts which derive from decorative feeling and cannot be understood on the basis of mere imitation. It is not a question of the degree of recession in the space represented, but in what way recession is made effective. . . .

The Characteristic Motives

If we attempt to compare the characteristic transformations, the simplest case would be the transposition of the alignment in two-figure scenes into a diagonal recession. This takes place in the story of Adam and Eve, in the Angel's Greeting of the Annunciation, in St. Luke painting the Virgin, and whatever other name the situation may bear. . . .

[Another example] is the development of the theme of the painter and his model, a subject known to earlier art as St. Luke and the Virgin. If

we wish to draw the comparison here between northern pictures, and at the same time take a rather greater interval of time, we can contrast with Vermeer's baroque schema the plane schema of a painter of the school of Dirk Bouts,[3] where the principle of the stratification of the picture in parallel planes is carried out—in the figures as in the setting—in absolute purity, although with some constraint, while for Vermeer, the transposition into recession is the natural method of treatment. The model is placed far back in the room, but lives only in relation to the man for whom she poses, and thus, from the outset, a vigorous into-the-picture movement comes into the scene, materially supported by the lighting and the perspective. The highest light is placed in the background, and in the clash of the strongly opposed size values of the girl and the near curtain with the table and chair, the picture acquires an interest of a decidedly recessional character. A closing wall parallel to the picture plane is certainly there, but has no essential importance for visual orientation. . . .

Architecture

The transference to architecture of.the concepts plane and recession seems to meet with some difficulties. Architecture is always dependent on recession, and planimetric architecture sounds dangerously like nonsense. On the other hand, even if we admit that a building as a body is subject to the same conditions as a plastic figure, we should have to say that a tectonic structure, which usually provides a frame and background for sculpture itself, could never, even to provide a comparison, so far depart from frontality as baroque sculpture does. And yet examples which justify our concepts are not far to seek. What else is it but a deviation from frontality when the posts of the porch of a villa no longer look forward but turn towards each other? With what other words can we describe the process which the altar passes through in which a purely frontal construction becomes more and more interspersed with recessional elements until, in the end, in rich baroque churches, there stand enclosures which draw the essence of their interest from the recession of the forms? And if we analyse the plan of a baroque staircase and terrace, such in the Spanish Steps in Rome, not to speak of any other detail, the spatial recession is brought out merely by the multiple orientation of the steps in such a way that the classically strict layout with straight flights looks flat beside it. The system of flights and ramps which Bramante planned for the court of the Vatican could offer the Cinquecentist contrast. In its place, we might compare the neo-classic straight-walled lay-out of the Pincio Terraces with the Spanish Steps. Both

[3]More familiar to American readers is the similar painting of this subject by Roger van der Weyden, Boston, Museum of Fine Arts. [BW]

give form to space, but in the one case the plane speaks, in the other, the depth.

In other words, the objective existence of solids and voids contains in itself no indication of style. Italian classic art possesses a perfectly well-developed feeling for volume, but it forms volume in a different spirit from the baroque. It seeks stratification in planes, and all depth is here a consequence of such plane sequences, while the baroque from the outset avoids the impression of the planimetric and seeks the real essence of the effect, the salt of the work, in the intensity of the perspectives in depth. . . .

The art of recession is never fully contained in the purely frontal view. It urges to sideways views, in interiors as in exteriors.

Naturally, it was never possible to prohibit the eye from looking at a classical building more or less cornerwise, but the building does not demand it. If this brings about an increase of interest, that is not prepared for from within, and the pure frontal aspect will always make itself felt as the one lying in the nature of the thing. A baroque building, on the other hand, even when there is no doubt as to where its principal face stands, always plays with the impulse to movement. It reckons from the outset with a series of pictures, and that is due to the fact that beauty no longer resides in purely planimetric values and that recessional motives only become fully effective by the change of standpoint.

A design such as that of the Carlo Borromeo church in Vienna, with the two free columns in front of the façade, looks worst in its geometric elevation. Doubtless the intersections of the cupola by the columns were intended, these first occur in the half-side view, and the configuration renews itself at every step.

That is also the sense of those corner towers which, kept low, often flank the dome in circular churches. We might recall S. Agnese in Rome, where, space being limited, a wealth of charming pictures arises for the spectator moving through the Piazza Navona. The Cinquecentist twin towers of S. Biagio in Montepulciano, on the other hand, were clearly not conceived with this (painterly-pictorial) intention.

The erection of the obelisk in the square in front of St. Peter's in Rome is also a baroque arrangement. Certainly it primarily fixes the middle of the square, but it also takes account of the axis of the church. Now we can imagine that the needle simply remains invisible if it coincides with the middle of the church façade; that proves that this view was simply no longer regarded as the normal one. But more forcible is the following consideration: according to Bernini's plan the entrance part of the colonnade, now open, should also have been closed in, at least partially, by a central portion which would have left broad approaches open on both sides. But these approaches are, of course, laid out obliquely to the church façade, that is, the first view was of *necessity* a side view. Compare the

approach drives to châteaux such as Nymphenburg: they are held to the side, a water-piece lies in the main axis. Here, too, architectural painting provides the parallel examples.

The baroque does not intend the body of the building to settle into definite views. By rounding off the corners, it obtains oblique planes which lead the eye on. Whether we take up our stand in front or at the side, there are always foreshortened details in the picture. . . .

15

Julius S. Held

TYPES AND TECHNIQUES
OF RUBENS' DRAWINGS

IT IS A SOUND PRINCIPLE to learn from the best. Julius Held based his description of how an artist draws on the work of Peter Paul Rubens, one of the greatest artists ever to put chalk or pen to paper. From reading Held's description of the way Rubens made and used drawings, we can gain insight into the creative process itself.

Held's first source for his analysis is the surviving body of Rubens drawings. These include drawings of many types, ranging from preliminary studies, which could almost be described as "scribbles," to finished works. Thus the understanding of Rubens drawings that we gain is largely a stylistic one. It is based on very close examination of the way each drawing looks. (Questions of iconography—why Rubens chose particular subjects or portrayed them in a particular form—are not discussed here.)

Stylistic analysis is then backed up by documentary material. Held quotes from letters and commentaries, even from what we know of Rubens' will, to help in defining the use of drawings in Rubens' work and in his workshop.

Peter Paul Rubens, 1577–1640, was a painter and diplomat who almost alone created a great school of art in a decaying Flemish society. Rubens' formal education ended when he was 13 but he left school with a mastery of Latin, some Greek, and an extensive knowledge of ancient literature. His career as diplomat and special ambassador in the troubled international politics of a war-filled era would have been enough to earn him a place in history. He mastered languages with ease; he was knighted by three governments.

The Medieval idea that art is a blue-collar craft, not a suitable em-

ployment for nobles and rich men, had not entirely disappeared in the seventeenth century. Renaissance Italy had helped to secure a higher status for the artist, but in northern Europe Rubens was something of an anomaly. It is clear that he always considered painting more important than service at court; nevertheless, the old prejudice helps explain why his children were unlikely to become artists. Rubens had risen into the highest social class: courtiers' children did not work with their hands. Nevertheless Rubens allowed for the possibility that one of his children might succeed him.

Why did Rubens draw? This is the first subject that Held explores. It is clear that Rubens did not think of drawings as finished works, as twentieth century artists often do. Held suggests three functions for a Rubens drawing: it may be the artist's first thought; it might be intended to serve as a guide for Rubens' numerous assistants; or it might even have been thought of as a legacy for his children. Rubens' idea that his artistic career could be passed on, like a furniture factory, to the next generation may seem strange today, but it was not an unusual thought in the seventeenth century. We should remember that Rubens was running such a large workshop that it almost resembled a factory. And the number of artists who were children of artists has always been substantial.

The second subject Held addresses gets us so close to Rubens that we seem to be looking over his shoulder as he works. How did Rubens draw? When he wanted to paint a picture of the Virgin and Child, or of figures from mythology, such as the wine god Silenus, how did he begin to organize his compositions, to define the forms the final work would assume?

It is a fairly modern idea—although it originates, as Held points out, in the writings of Leonardo—that we can get closest to an artist by looking at his "first thoughts" in drawing, rather than at his finished works. This idea is based upon a view of art as an expression of genius, not art as a craft. (After all, nobody prefers a half-finished chair to the varnished and upholstered product!) From the Italian Renaissance Rubens learned to draw freely and to capture in drawing the imagination Leonardo had demanded of art.

Yet some very mundane considerations enter into understanding Rubens' studies. It is important to notice that Held tells us what size Rubens' paper was, and what materials he used in drawing. These facts help to build up a picture of the artist at work, just as much as the information about the repetition and variation Rubens used in his first "scribbles."

Rubens made many other kinds of drawings in addition to preliminary sketches. In subsequent chapters, Held describes drawings made from a model, portrait drawings, drawings designed to be rendered as prints, and depictions of sculpture and architecture. You can explore these interesting topics by reading the rest of Held's study.

Included in this selection are the scholarly notes that Held used to support and amplify his conclusions. (A few additional notes, largely translations of foreign languages, are added by the editor.) As you read the selection, examine the notes to see the kinds of additional information they supply, for this is a fine example of scholarly practice.

From
Rubens: Selected Drawings

If we want to understand the rôle which drawing played in Rubens' art, we must always keep in mind one basic truth. The only productions which Rubens recognized as finished work were his paintings in oil, either of the "easel" size or the still larger ones made for the decoration of walls and ceilings in palaces and churches, for altars, or for the temporary structures erected in the great pageants of his time; to these must be added tapestries and portraits, the latter mostly of the large, formal kind. No matter how much we may admire today the brilliance of his oil-sketches or the beauty and variety of his drawings, we ought to realize that these works were almost never produced as ends in themselves, but as preparations for the more finished products. It is interesting that a contemporary of Rubens—and one of his early admirers—admonished young painters "to consider all drawing but as a servant and attendant, and as the way of painting, not the end of it."[1]

That does not mean that Rubens was unaware of the special attraction which these unfinished, or intermediate, solutions may have; it is well known that once when Rubens in a contract was given the choice of either delivering the preparatory sketches (which, to be sure, were very numerous) or to paint an additional large altar-piece, he painted the large canvas and kept the sketches. That a drawing was for Rubens an object of beauty as well as one of specific usefulness can be inferred from a passage in the famous letter to Sustermans explaining the significance of every figure and every object in his Allegory of War in the Palazzo Pitti in Florence. "If I remember correctly," he wrote, "you will find on the ground under the feet

Rubens: Selected Drawings, with an introduction and critical catalogue by Julius S. Held (London: Phaidon Press Ltd., 1959). Excerpts from Chapter II, "Types and Techniques of Ruben's Drawings," pp. 15–26.

[1]Edward Norgate, *Miniatura, or the Art of Limning*, Oxford, 1919, 83. G. Glück expressed this idea, perhaps a little too drastically, when he said: "There are absolutely no drawings by Rubens' hand without a particular purpose, either in connection with the origin of or the plan for a picture, or an illustration." (*Essays*, 180, footnote.) See also J. S. Held, *Les Arts Plastiques*, VI, 1953, 107 ff.

of Mars a book and a drawing on paper to indicate that he tramples on literature and on other things of beauty."[2]

No higher sign of Rubens' appreciation of the aesthetic significance of drawings could be found than this allegorical use of a drawing to symbolize the "things of beauty." Needless to say, Rubens collected drawings by older masters and surely not only for study and imitation.

The fact remains, nevertheless, that for Rubens drawings had to fulfil first of all specific functions in the production of paintings and in the organization of his studio. Nothing could reveal better Rubens' conception of the value of drawings than the disposition of his own provided for by him in his will. While the actual words of the will are lost, we are well informed about many of its provisions. The drawings were apparently divided into two large groups. One of them is briefly described in the inventory made shortly after the master's death in 1640: "A very large number of drawings of the most important pieces made by the late Mons. Rubens." This group was among the possessions sold soon after his death in the house of his widow. It consisted most likely of copies by pupils of Rubens' paintings such as are found still in many of the larger collections of drawings, especially in the Louvre. The theory that these were copies is all but confirmed when we see in the inventory that the drawings are immediately followed by another group of works, most likely paintings, which were listed as: "a number of *copies* made after the originals of the late Mons. Rubens."

The second group of drawings was not put up for sale at this time as can be seen by the formal accounting of Rubens' estate made in 1645 by the notary Toussaint Guyot. This is the group which most assuredly contained Rubens' original drawings. It is worth while to quote the pertinent passage literally: "But the drawings which he had collected and made he ordered to be held and preserved for the benefit of any of his sons who would want to follow him in the art of painting, or, failing such, for the benefit of any of his daughters who might marry a recognized painter; thus they should be kept until the youngest of his children should have reached his eighteenth year. If by that time none of his sons should have followed him in his art

[2] *"Credo, sebben mi ricordo, che V. S. trovera ancora nel suolo, di sotto i piedi di Marte, un libro, e qualche disegno in carta, per inferire che egli calca le belle lettere et altre galanterie"* (*Correspondence,* VI, 208). Miss Magurn's recent translation of this passage (". . . to imply that he treads underfoot all the arts and letters' in *The Letters of Peter Paul Rubens,* Cambridge, 1955, p. 409) does not quite do justice to the distinction Rubens was making between the meaning of the book and the drawing. Indeed, although Rubens speaks in his letter diffidently only of *"qualche disegno in carta,"* he was much more specific in the painting itself. It has apparently never been noticed that there is a clearly recognizable drawing on the sheet of paper at the feet of Mars. To signify the destruction of all beauty in times of war, Rubens drew on the discarded piece of paper a clearly recognizable composition of the Three Graces. While thus using a concrete and time-honoured image for the idea of beauty in a general sense, it remains significant that this image appears in the form of a crumpled drawing—which in times of peace presumably would be honoured as much as the book, on which the foot of Mars is actually resting.

and none of his daughters should have married a recognized painter, the drawings should be sold and the receipts divided in the same manner as his other assets . . ."[3]

Rubens could hardly have had any illusions about the artistic talents of his older children, but when he died those by Hélène Fourment were still very young, and one was not yet born. Was he motivated by a secret hope for an artistic successor, or is his will a veiled expression of disappointment at the absence of such a child at the time of his writing? This is most unlikely. Sir Peter Paul Rubens, "Secretary of His Catholic Majesty, in his Privy Council," and the Manor-Lord of the Property of Steen, must have known full well that by his own social advancement he had made it practically impossible for any of his sons or sons-in-law to return to the status of a painter. He himself had never forgotten—no matter how brilliant his career as diplomat and statesman had been—that he was primarily an artist. His children, however, must have thought of their father as a squire and a nobleman and regarded the profession of painting as far beneath them.

The stipulation about the disposal of his drawings, in other words, was only an evidence of his customary good sense. One of Rubens' most significant characteristics was his ability to attend to his affairs in an orderly and businesslike way and to make proper use of his faculties and of his resources. Since drawings were useful tools in the routine of a workshop and, as such, assets potentially of greater value than they would be as mere objects of a collector's curiosity, it would have been improper and unwise to sell them as long as there was a chance that they might be used again in the studio. They were to be dispersed only when it was clear beyond any doubt that no other benefits could be derived from them; until then Rubens felt it his duty to protect them.[4]

Thus the importance of the master's will lies in the clarity with which

[3] The sale of the drawings took place in August 1657 (supposedly on the 28th of August, though I have been unable to find documentary evidence for this date). It fetched 6557 *guilders* and 16 *stuivers*. Strictly speaking, Rubens' youngest child, Constantia-Albertina, born posthumously on February 3, 1641 reached her eighteenth year only in February 1659. Since she had been in a convent since the middle of 1657, there was no reason for waiting any longer with the sale, the less so since her next old brother, Petrus-Paulus, had reached his eighteenth year on March 1, 1655. These data were first published by Rooses (*Rubens Bulletin*, V, 1897, 56–57) but since he had earlier in a more frequently consulted publication (R., V, 3ff) spoken of the sale as having taken place in 1659, this date is still occasionally given in the literature (see, for instance, *The Burlington Magazine*, XCIII, 1951, 17).

[4] Rubens was not the only Flemish artist who took these precautions. According to F. Jos. van den Branden, *Geschiedenis der Antwerpsche Schilderschool*, Antwerp, 1883, 282, Frans Pourbus made a similar stipulation in his will of September 17, 1581. He left to his two sons, Frans and Moses, all his drawings with the proviso that if Moses should not become an artist, Frans who was then only twelve years old, should have them all. As it turned out, Frans indeed followed his father's trade. Rubens' care for the proper disposal of his drawings evidently accords with established practice, though he appears to have been unusually circumspect and mindful of all possible future conditions where the drawings might be of use.

it expresses the view that the primary function of drawings is to serve as models for study, possibly also for the instruction of pupils, and as reference material. Rubens himself used his own drawings again and again; indeed, it would be of great interest if we knew how he filed them, for it was surely done so that a desired motif could be found quickly among hundreds, if not thousands, of items.

While the usefulness of a drawing was by no means exhausted once it had served its original purpose, it is of course necessary first to see it in the context of its origin. This involves a knowledge of the whole working process of the master. A widespread but nonetheless questionable theory holds that the greatness of an artist is measured chiefly by the degree of his originality. It is often silently assumed that his main concern should be the avoidance of tradition. Whenever we see a great artist turning to the past we are inclined to assume that he did it only "pour mieux sauter."[5] Yet the freedom of action implied in Cézanne's famous "Il faut refaire Poussin sur nature,"[6] was possible and valued only after the middle of the nineteenth century. It is admittedly difficult for people who have come to equate traditional art with poor, or at least with dull art, to do full justice to an artist for whom there was no greater goal than to continue a great tradition.

Rubens was such an artist. Perhaps it would be a more adequate statement if we were to say that he carried on two traditions. The heritage of Flanders remained strong in his art to the very end. But it is certain that he himself preferred to think he was the heir to a longer and greater tradition reaching across the great masters of the Renaissance back to the culture of the Ancients. His real teachers were not Adam van Noort or Otto van Veen, and not even Pieter Bruegel, but Leonardo and Michelangelo, Raphael and Giulio Romano, Titian and Tintoretto, and the great sculptors of classical antiquity. There is probably more than justifiable pride and self-confidence in the famous phrase with which he solicited, long before he actually obtained it, the commission to decorate Whitehall Palace. By asserting that by nature he was "more gifted for the very large works than for the little curiosities," he claimed confidently membership in the only school and tradition which until then had been recognised as capable of working in the monumental style, the Italian, and he may have chosen this very formulation as an answer to Michelangelo's quip (reported in Francisco de Hollanda's first Dialogue) that the artists of the North were good at painting small details ("masonry . . . grass . . . rivers and bridges . . . with many figures" . . .) but that they lacked boldness, substance, and vigour.

As a painter in the monumental tradition, Rubens follows the tech-

[5]*Pour mieux sauter*—"the better to go beyond" (what was done before). [BW]

[6]*Il faut refaire Poussin sur nature*—"Poussin must be remade by going back to nature." [BW]

nical procedures which the Italian artists had evolved before him. The various classifications that we can make among his drawings, which have their fixed rôles in the preparation of paintings, can all be found in Italian art of the sixteenth century. It is true that the painted oil-sketch was used far more frequently by Rubens than by any earlier Italian painter, but even this is not a novel element (nor, for that matter, a Northern tradition) but the development of a practice first introduced, it seems, in the studios of Tintoretto and Barocci.[7]

Much has been written about the rôle of these oil-sketches in Rubens' art. One of the most extreme theories, repeatedly expressed by Van Puyvelde, claims that oil-sketches completely replaced compositional drawings after Rubens' return from Italy. *"Rubens pensait le pinceau à la main"*[8] is a charming formulation, but it is not true if it is meant to exclude other methods of creative "thought." The chief function of the oil-sketch, though not its only one, as Van Puyvelde himself said correctly, was to submit the artist's ideas to his clients and to his collaborators (*Esquisses*, 14, 55.) Van Puyvelde's contention, however, that Rubens *started* the working process with oil-sketches, or that he painted his small easel pictures without any preparation, is not borne out by the evidence. Everyone will agree that Rubens must have been a speedy worker. But to call Rubens' speed, as Van Puyvelde does repeatedly (*Esquisses*, 15, 58),[9] a facility for improvisation comparable to the "eloquence of a born orator" is to do an injustice to one of the most deliberate of artists, who probably abhorred the idea of rhetorical "improvisation" as much as Poussin did.

If Rubens was ever tempted to rely on improvisation and on what Bellori called his "furia di penello,"[10] it was in November, 1634, when he received the commission to make sketches for the elaborate decoration of the city of Antwerp for the triumphal entry of Cardinal Infante Ferdinand, scheduled to take place the following January. (Actually it was delayed until April.) If we look attentively at the sketches which have been preserved we see plainly that Rubens drew the outlines of the compositions in black chalk on the light ground of his panels. These lines have disappeared where oil-paint was subsequently applied, but where there is no covering layer other than varnish they still stand out as clearly as if they were drawn on paper. That this was a common practice with Rubens, and that he drew with chalk on the prepared panels even when he was not pressed for time, can be observed in several sketches, especially the fine one he made for the title-

[7]See Meder, 180, 292, 532, 553; B. Degenhart, *Europäische Handzeichnungen*, Zürich, 1943, 24; H. Tietze, Arte Veneta, V, 1951, 55.

[8]See Van Puyvelde, *Revue Belge*, XXI, 1952, I, 53. ("Rubens thought with brush in hand." [BW]).

[9]Leo van Puyvelde, *Les Esquisses de Rubens* (Basel, Les Editions Holbein, 1940). [BW]

[10]*Furia di penello*—"scribbling frenzy." [BW]

page of the *Pompa Introitus Ferdinandi*[11] in the Fitzwilliam Museum in Cambridge. In the centre of the sketch where later the title of the book was engraved, he had originally drawn in chalk the same scene which appears in oil-colours in the pediment above. Closer inspection shows that the pediment itself and even the caryatids were first started lower down the panel. For some reason, as he worked, the whole design was moved upward. Where the first lines were not later covered up by layers of colour it is still possible to study them with ease; they are very similar to the first chalk-lines which we can distinguish in some late pen-drawings. Chalk lines of the first rough draft, and even inscriptions in chalk, can be clearly seen on the Antwerp sketch of the Victory Chariot of Calloo.

In view of these observations there is no reason to question the veracity of the often quoted report by the young Danish physician Otto Sperling about a visit he had made to Rubens' house in 1621. The house and studio of Rubens were evidently "musts" on sight-seers' lists of Antwerp attractions; like other travellers, Sperling included it in his tour, and he had the good fortune of being introduced to the artist and to watch him at work. Without stopping work, Rubens answered questions, listened to a reader, and dictated letters. In one room Sperling saw "many young painters who worked on different pieces on which Sr. Rubens *had drawn with chalk* and put a spot of colour here and there; the young men had to execute these paintings which then were finished off with lines and colours added by Rubens himself." That we can no longer detect these preliminary chalk drawings under their later coats of colour does not prove that they did not exist. It so happens that we know from a contemporary source—and one close to Rubens, at that—that artists were wont to take good care that these first drawings would not show later on. In his notes on painting, Dr. Theodore Turquet de Mayerne warned the artists that "auant que paindre, il fault bien essuier le tableau nettement a fin que ladicte pierre ne tache et macule les couleurs."[12] No matter how thinly Rubens painted, the chances of finding traces of his first outlines on the canvasses are evidently slim.

Preliminary Studies

Although occasionally Rubens may have made no other drawings than those he traced directly on his panels or canvases, as a rule he prepared his

[11]*Pompa Introitus Ferdinandi*—"Triumphal Entry of Ferdinand." [BW]

[12]E. Berger, *Quellen für die Maltechnik während der Renaissance und deren Folgezeit*, Munich, 1901, 278. Berger thinks that most of these preliminary drawings were made with white chalk which is more easily absorbed by the oil (p. XXXVIII). Van Mander (ed. Floerke, I, 320) explicitly mentions chalk (crijt) as the medium used by Frans Floris for the preliminary drawings which he made for the benefit of his students. It is likely, however, that coal was also used a great deal for reasons which Cennino Cennini already had given (*Il Libro del Arte*, transl. by D. V. Thompson, New Haven, 1933, 75). See also Meder, 296–297—*Auant que paindre . . . couleurs*—"Before painting, the canvas must be well cleaned so that the aforesaid stone [drawing material] will not stain or smudge the colors."—[BW]

pictures carefully in drawings on paper and in oil-sketches on panel. We can reconstruct the normal procedure in principle, although it is unlikely that we have for any of Rubens' works a record of the preliminary phases as complete as we have for Géricault's Raft of the Medusa, for instance, or for Seurat's Grande Jatte, or Picasso's Guernica. Incomplete though the material may be, it contains representative examples of all the stages through which any of Rubens' thoughts might have passed on the way to their final pictorial realization. Needless to say, only pedantry would expect Rubens to have proceeded always in the same manner; but no matter how flexible his procedure was and how many short-cuts he may have chosen in individual cases, there was a basic pattern which we can still perceive with great clarity.

Like all artists of his time, Rubens used sketchbooks, and the pages of one of these are still preserved in London. Three sketchbooks by Rubens were listed in the inventory of his pupil Erasmus Quellinus, made in 1679.[13] A copy of a sketchbook which contained theoretical writings was still extant in the late nineteenth century. It is certain, however, that most of Rubens' drawings were not made in sketchbooks but on single sheets. The evidence for this statement is quite simple, and I believe incontrovertible. When there are drawings on both sides of a sheet, the top of one side nearly always coincides with the bottom of the other. In other words, when Rubens turned a leaf, it was not turned horizontally as one turns the pages of a book, but vertically. He may have turned the pages either towards himself, or away, but never from right to left. Only a draftsman using loose sheets would have developed this habit.

Most of these sheets have been preserved only as fragments; the size of the original sheets can be seen in a few pieces which evidently have not been cropped, such as the Kermesse, which is on a paper of about 50 by 58 cm. [about 20 by 23 in.] . . . Rubens used these sheets full size only in the most unusual cases. Even at half the size they were still large.

Rubens normally began by drawing hardly more than the barest outlines of his figures in thin lines with quill or chalk.[14] There is no marked preference as far as I can see for either of these tools. Both are found in examples from all periods of Rubens' activity, though in his youth he seems to have used the pen more frequently for beginning his drawings. That chalk was used as freely and easily as pen to give form to his first thoughts

[13]Denucé, *Inventories*, 291: "*Teecken boeck van Rubbens; Een cleyn teeckenboecken van 71 bladeren, met root cryt; Noch een cleyn boecken van Rubbens, met architectuer*" (Drawing book by Rubens; a small drawing book with 71 leaves, done in red chalk; another small drawing book, by Rubens, with architecture.) Although the author of the second book is not mentioned, I believe that the context makes it most likely that it too was by Rubens.

[14]For the use of this term see the foreword to the critical catalogue, p. 91: "In the critical catalogue the words *chalk* and *ink* in particular have been used broadly; to specify the medium more precisely often would have required microscopic examination or chemical testing."

has not generally been realized. The reason for this lies in the fact that the first thin lines made in chalk have become well-nigh invisible in many cases, either because they were wiped off on purpose, or because of abrasion. It often takes a very attentive scanning of the surface to detect the traces of the first drawing in chalk. The beautiful study of Carousing Soldiers in the collection of Frits Lugt, for example, which in the literature is described only as a drawing in pen and ink, was actually first sketched in black chalk. In some instances Rubens seems also to have used lead pencil. In pure pen-drawings the lightness of the first outlines is often hidden beneath the coarser lines made later; a good example to gauge the difference in thickness between the first lines and those made slightly later—even though both kinds are still within what may be termed the trial-and-error phase of a work—is the Stockholm drawing [Figure 13] with Studies of the Virgin and Child.

Rubens rarely left the first thin sketch without making changes. Generally he continued drawing on top of it, developing some figures or groups more thoroughly, repeating certain sections, trying out alternatives, and frequently using wash to bring order into the chaos. Rubens never hesitated to draw into and over figures which he had outlined before. Some of his drawings are in multiple layers that recall palimpsests. In the Silenus and Aegle [Figure 14],[15] Rubens had drawn in the upper right corner the same reclining nymph which one sees clearly in the centre and the lower left; but her body is barely recognizable among the swirling lines of other figures drawn over her. The Descent from the Cross was drawn twice in versions which partly overlap. In the Stockholm Virgin and Child [Figure 13] there are at least four different versions of the theme in the right half of the sheet, overlapping and interpenetrating each other.

There are many pages on which elaborately drawn figures and groups stand beside rough outlines; the Raising of Lazarus, in Berlin, is a particularly instructive example, since all its parts deal with the same theme. There are some almost amorphous chalk-lines, belonging to the first sketch, most clearly visible in the centre under the large layer of bistre wash. A tiny pen-sketch, long on spirit but short on detail, is in the upper right corner. Even in the main group there is considerable variation in degree of finish, from the barely indicated apostles to the strongly modeled figures of Lazarus.

Lazarus himself is a good example of Rubens' habit of multiplying the members or head of a figure until it resembles an idol of Buddhist mythology. Lazarus' head was drawn in three different positions; . . . The figure which served for Mercury in the Education of Marie de Médicis [Figure 15] a drawing which fits into two different categories, apparently has three pairs of legs

[15]Silenus, a fat and humorous embodiment of the god of wine, is forced to sing by the nymph Aegle. [BW]

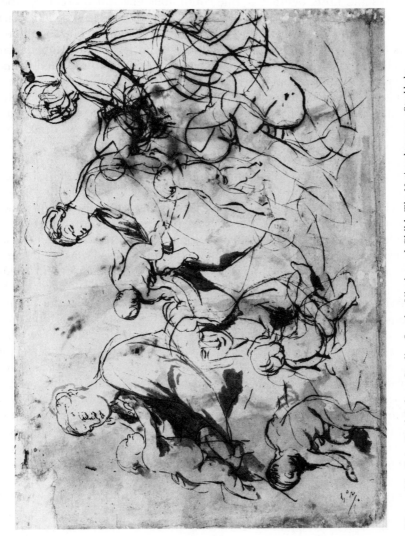

Figure 13 *Peter Paul Rubens, Studies for the Virgin and Child. The Nationalmuseum, Stockholm.* Photo: Statens Konstmuseer. Reproduced by permission of the Nationalmuseum, Stockholm.

171

Outlines are sometimes drawn in single strokes of pen or chalk with a neatness reminiscent of Ingres. At other times the figures almost disappear in a cloud of rushing and whirling lines which fail to define form but suggest movement more convincingly than the lines of Balla's scottie.[16] For greater speed, Rubens developed certain graphic abbreviations. He often drew eyes and nose together in one continuous line which breaks in four right angles;[17] mouths are rendered by a very short line, if at all. When seen in profile, noses are fairly long, and sharply pointed. The shoulder is always a very conspicuous round form in the construction of Rubens' figures. However, for a master who has been said to think in rounded forms, he drew surprisingly often in straight lines and sharp angles, especially in his first sketches; in subsequent stages he would round off the angular rhythms of his first lines. (I have mentioned a few other peculiarities before in contrast to Van Dyck.) It is clearly impossible, however, to draw up a complete list of Rubens' personal shorthand devices which, to be sure underwent certain changes during the forty years of his activity. The master's style was surprisingly flexible. His graphic formulae are distinguished by variety rather than conformity. . . .

The chief appeal of these preliminary studies lies in the insight which they furnish into Rubens' creative process in general and into the genesis of individual works in particular. It is exciting to watch the artist as he skillfully woos his mental image in ever new attempts at visualization. There is never anything labored in these efforts. New possibilities present themselves quickly and the hand is limited only by its physiological speed, not by a scarcity of ideas. Like Dürer, from whom we also borrow the phrase, Rubens must have been "inwendig vol Figur" (full of forms within). We think of Dürer's sheet with nine different images of St. Christopher (Berlin) when looking at the six different poses of Thisbe's suicide; St. Christopher himself was drawn twice by Rubens on one sheet and also formed the subject of one of his finest oil-sketches. The studies for the Visitation with their increasingly large and flowing forms or the sheet with the various deeds of Hercules are of this same sort. One of the most beautiful of these drawings is the sheet with seventeen pairs of dancers in the British Museum; here we no longer witness an effort to find a single solution. His imagination fired by the subject, Rubens seems to have continued drawing for the sheer delight of mentally watching a couple of dancers whose dance expresses their love and whose love lends wings to their dance.

The sketchy freedom of these first "thoughts" Rubens owes to Italy.

[16]Giacomo Balla (1871–1958), Italian Futurist painter. The dog is painted with multiple legs, like a running cartoon figure. [BW]

17 ⊓⌐

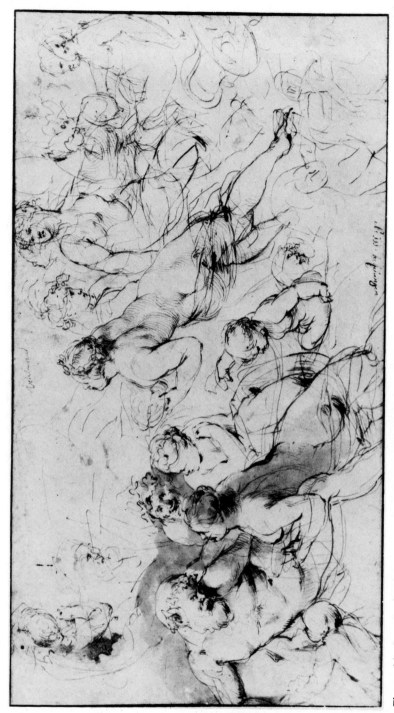

Figure 14 *Peter Paul Rubens, Silenus and Aegle. Royal Library, Windsor Castle.*

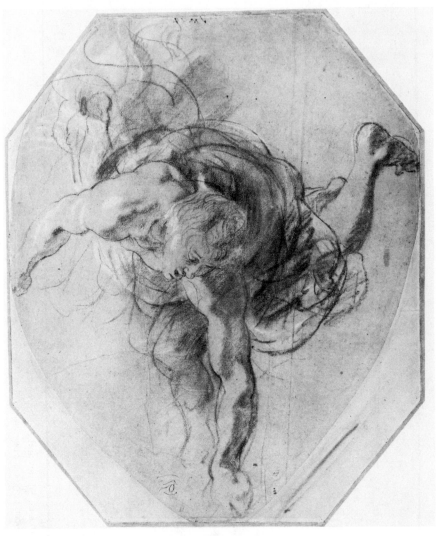

Figure 15 *Peter Paul Rubens*, Mercury Descending. *The Victoria and Albert Museum, London.*
Reproduced by courtesy of the Board of Trustees of the Victoria and Albert Museum, London.

As E. Gombrich has recently shown in a fascinating study, the "unfinished" and sometimes chaotic character of designs for compositions may well have been consciously created by Leonardo.[18] This was the visible expression of Leonardo's belief in the superiority of invention, or imagination, over execution. Since invention results from an intense action of the creative faculties, drawing, the visual equivalent of this process, was the more convincing, the less it had the appearance of neatness and finality. Indeed, from the indefiniteness itself may spring new mental stimuli, "keeping alive" the flow of imagination. By Rubens' time, the particular overtones of conscious novelty and psychological justification were surely no longer connected with this manner of drawing. A century of practice by Italian artists had firmly established the custom and had demonstrated its usefulness. Yet it was still primarily an Italian method; and it was only by eight years of close association with the Italian tradition on the very soil of the peninsula that Rubens could assimilate it fully.

As we can never be sure we have all the drawings made for any one project, it is impossible to say how many preliminary sketches on the average Rubens made before he found a satisfactory solution. For the Presentation in the Temple we have three rough sketches, two of them close together and placed in such a way that one seems to be almost the mirror-image of the other. During these first stages in the genesis of a picture reversing a design in order to test new possibilities was apparently not unusual. The best example is furnished by the two drawings of the Continence of Scipio[19] though in this case the second version contains also many significant advances over the first. (The finished painting followed neither of these plans.) Two quick studies are known for the Last Communion of St. Francis; three drawings have been identified for the Altar of the Carmelites in Antwerp,[20] and Rubens also made an oil-sketch now in New York; three drawings have for their subject Venus lamenting Adonis, but we do not know if a painting corresponding to the scheme of these drawings was ever executed.[21] In other cases, though we have only one drawing, the main group or action is sketched several times on the same sheet. From all this it would appear that Rubens was quick to find a satisfactory form for his ideas; from the drawings of the Magnanimity of Scipio we can also learn how easily he introduced variations into compositional patterns and how

[18]E. Gombrich, Conseils de Léonard sur les esquisses de tableaux, *L'Art et la Pensée de Léonard de Vinci, Actes du Congrès Léonard de Vinci,* Paris-Alger, 1954, p. 3 ff.

[19]Scipio Africanus Major (234?–183 B.C.), Roman general: a popular moral *exemplum* in Renaissance art. [BW]

[20]One was exhibited—without record of ownership—in Amsterdam, 1933, no. 79. Two others are in Vienna (*Catalogue,* Exhibition Antwerp, 1956, nos. 142, 143.)

[21]There is a painting showing Adonis lying on the ground with Venus kneeling beside his head in a private collection in Paris (Evers, II, fig. 27) and an exquisite, little-known and unpublished sketch for it in Dulwich.

rapidly his second versions acquired precision and descriptive detail. What seems to be fairly certain is that for any new project Rubens made at least one first draft in the media of pen or chalk. This gives us a measure of the losses. What has been preserved is evidently but a tiny fraction of what must once have existed.

While we deplore this loss, we can readily account for it. It was precisely this kind of drawing which was least likely to be preserved. In the daily routine of the studio these early and often amorphous scribbles played only a minor rôle. Their loss meant less than losses in other categories. The sketchiness that makes them so fascinating to us must have been in Rubens' eyes their chief shortcoming. Any subsequent drawing or oil-sketch diminished their value. Once they had fulfilled their function they could easily be discarded like the first draft of a manuscript. For other types of drawings there was a continued usefulness in the studio; not so for them, or at least not for the most tentative of them. Those preserved may owe their survival more to the devotion of ardent disciples than to any care given to them by Rubens himself.

It is obvious that the amusingly descriptive term "crabbelinge" or "crabbeleye" (scribble) which occurs in seventeenth-century inventories applies to this kind of preliminary drawing. We should remember, however, that these "scribbles" may range from first hasty notations to fairly elaborate drawings which could well have been submitted to patrons for their approval. Normally Rubens seems to have made an oil-sketch for that purpose since it would also give an idea of the appearance the work would have in colour. (Rubens himself surely did not need the sketches to study colour effects, any more than a composer needs to hear sounds for his instrumentation.)

To patrons who lived out of town, and surely to those abroad, he probably sent a drawing for the sake of speed and safety. Two such drawings with inscriptions by Rubens have been preserved (G.-H. nos. 40, 41);[22] they have been dated in the Italian years by many scholars, including Glück and Haberditzl, because the text is in Italian. Since, however, Rubens almost always corresponded in that tongue, we are free to date the pieces by their style. They were probably done between 1612 and 1615. On one of them Rubens explains to the recipient "you must remember that the work will turn out very different from these sketches (scizzi) which have been drawn only lightly at the first try to show you the general idea (il pensiero); the subsequent drawings and the picture, too, will be made with all possible care and diligence." (Despite these reassuring words, he does not seem to have obtained the commission.) It shows how familiar he was with the language of Italian studios to find him using the characteristic term "pen-

[22]Numbers refer to G. Glück and F. M. Haberditzl, *Die Handzeichnungen von Peter Paul Rubens* (Berlin: J. Bard, 1928). [BW]

siero" in connection with these preparatory drawings; we should not, however, too literally take his statement that he had made the drawings "da primo colpo." The drawings were done rather neatly, almost like his models for engravers, in pen and ink with the addition of some slight wash. Rubens had either prepared them on other sheets, or—in view of the relative plainness of the designs—had made some thin preliminary studies in pencil which were later erased. What he meant by the "subsequent drawings" which he would do with great care is not quite clear. Oldenbourg thought that he referred to large-scale cartoons; it is equally possible that Rubens had in mind the precise drawings from the model which, as we shall see, he customarily made at a later stage.

Sometimes he provided drawings for other artists to use in their work. One such drawing, evidently the central group for a Feeding of the Five Thousand (G.-H. no. 103), he mailed with some others to a "Mons. Felix," who probably was a Flemish painter since the accompanying letter was written in Flemish. Rubens wrote: "You must be content with these drawings no matter how weak and pale they be, since I am prevented because of other occupation to do more with them. You will have to make shift with them and you can make the composition wider or narrower to suit the proportion of your work." He signed "your friend and servant Pietro Paulo Rubens" and by adding the date made this the only drawing still preserved which is dated exactly: January 18, 1618, done in Antwerp. We do not know whether "Mons. Felix" ever used the drawing (if he did, it was probably for a picture in which still-life and landscape elements prevailed); we are grateful to him, though, for having preserved this document—and for not having made his alterations on top of Rubens' drawing.

The process of change and of growth of Rubens' compositions extended occasionally into the sketches painted in oils. While the majority of them show evolved compositions, there are not a few in which Rubens was still experimenting; some, indeed, look as if Rubens had started them without previous drawings. The sketch for the lion hunt in the collection of the Marquess de Cholmondeley is such a piece. Several figures in the upper half of the panel are indicated only in outlines, and a still earlier phase, corresponding to the very first rapid sketches in pen or chalk, is visible in the lower half of the panel. Here for once there is no functional distinction between drawing and oil-sketch.[23] Other sketches in oil, belonging clearly to the formative stage in the development of compositional ideas are the Adoration of the Trinity by All Saints in Rotterdam,[24] the Conversion of

[23]For the functional distinctions within the oil sketches see two very instructive articles by E. Haverkamp Degemann, *Bulletin Museum Boymans*, Rotterdam, V. 1954, 2 and ibid., VIII, 1957, 83. In the first one of these articles the author distinguishes no less than seven different types.

[24]E. Haverkamp Begemann, *Olieverfschetsen van Rubens*, [Catalogue of an Exhibition at the] Museum Boymans, Rotterdam, 1953–1954. [BW]

St. Paul in the collection of Count Seilern,[25] both so full of changes made during the execution that it is very difficult to "read" the design. The Rotterdam sketch represents an unusual situation where an oil-sketch preceded a more finished drawing. The reason for this irregularity may lie in the fact that the "end-product" in this case was an engraving—one of the illustrations which Rubens designed and C. Galle engraved for the new edition of the Breviarium Romanum of 1614 (G.-H. no. 70).[26] We shall return to Rubens' preparation of engravings in a separate section.

[25]A. Seilern, [Catalogue of] *Flemish Paintings at 56 Princes Gate, London, S.W. 7*, London, 1955. [BW]

[26]L. Burchard, *Sitzungsberichte der Kunstgeschichtlichen Gesellschaft*, Berlin, 1926–1927, p. 3, No. 23, thought that the sketch was made for a picture which was never executed—or is lost—and that it served only later as the point of departure for the design of the Missal. Evers (II, 217) did not accept this view; and I also feel that there is no need for such a hypothesis.

16

Robert Adam and *Robert Oresko*

ROBERT ADAM
AND NEO-CLASSICAL
ARCHITECTURE

ARCHITECT ROBERT ADAM WAS the right man in the right place to achieve fame in his own lifetime and to inspire repeated classical revivals. Born in Scotland in 1728, he grew up in the flowering of Scots culture in arts and social sciences which marked that country's contribution to the Age of Enlightenment. He was clearly a genius whose architectural designs reflect a remarkable delicacy and sense of proportion. The eighteenth century's reputation as an era of fine taste owes much to Adam's inspiration.

The eighteenth century was also an age of great patrons. Adam's architectural designs for building, remodeling, and decorating England's great country houses [Figure 16] could not have existed without the patrons who had the means and taste to commission his work. Drawing upon a wide variety of classical sources—largely Roman, as Oresko points out, but also Greek and Renaissance—Adam imaginatively combined quotation and innovation. The works he built and designed have been copied and adapted by many others.

More to the point, perhaps, Adam's designs belong to the opening phase of an exciting new style in all the arts at the end of the eighteenth and the early nineteenth centuries—the style we call Neo-Classicism. That style pervaded all artistic media around 1800: the paintings of Jacques-Louis David, the sculpture of Houdon, even decorative arts like Wedgwood's famous pottery. All are inspired re-creations based on Roman precedents.

Classicism in other forms, of course, had inspired much of the Italian Renaissance and had arrived (rather late) in England in the Italianate

classicism of Baroque architect Inigo Jones (1573–1652). Jones had studied the temples and public buildings still visible in Rome, as well as the prescriptions for such buildings in the writings of Vitruvius, a Roman architect. In this course he followed his greatest Italian source, the Venetian architect Andrea Palladio (1518–1580). To such examples of Classical building practice Adam was able to add a new source of classicism, for examples of Roman *domestic* architecture had recently come to light in the cities of Herculaneum and Pompeii.

Adam's special lightness and delicacy derive from his study of Roman houses and villas. But they also owe much to his extraordinarily visual approach to architectural design. In the brief note on "Movement in Architecture" which he added to the text of his *Works,* Adam describes architecture as a landscape to be looked at "like a picture."

Adam's career followed a typical eighteenth-century pattern. Educated at Edinburgh University [then College], he left (without degree) after two years because of the War of 1745, the last attempt to restore the Stuart kings. Adam then joined his father's architectural firm. Probably the most significant event in his education was his Grand Tour in the mid-1750s, when he visited Rome and Herculaneum, learned to draw and paint architectural subjects, and gathered material for his first publication: *Ruins of the Palace of the Emperor Diocletian at Spalatro in Dalmatia,* 1764.

Adam was the leading British architect by 1758. That he was well aware of the importance of his contributions to architectural theory and design is clear from his decision to publish a compendium of his designs (*The Works in Architecture of Robert and James Adam, Esquires,* 1778).

When a new edition of the *Works* was published in 1975, Robert Oresko, its editor, wrote a very substantial introduction from which the selection accompanying Adam's own essay is drawn. It can be read as a tribute to a great architect and as a guide to understanding the Neo-Classical spirit in its best aspects.

From
Movement in Architecture

Movement is meant to express, the rise and fall, the advance and re-cess, with other diversity of form, in the different parts of a building, so as to add greatly to the picturesque of the composition. For the rising and falling, advancing and receding, with the convexity and concavity, and other forms of the great parts, have the same effect in architecture, that hill and dale, fore-ground and distance, swelling and sinking have in land-scape: That is, they serve to produce an agreeable and diversified contour, that groups and contrasts like a picture, and creates a variety of light and shade, which gives great spirit, beauty and effect to the composition.

Robert Adam, "Movement in Architecture," *The Works in Architecture of Robert and James Adam, Esquires,* Volume I, London, printed for the Authors, MDCCLXXVIII.

From

The Works in Architecture of Robert and James Adam

Following Robert Adam's death on 3 March 1792, the *Gentleman's Magazine* printed an obituary lamenting the passing of one of Britain's great architects and designers. "Mr Adam," it concluded, "produced a total change in the architecture of this country." Robert Adam would have agreed. In the preface to the first volume of *The Works in Architecture of Robert and James Adam* the brothers announced with characteristic firmness and self-assurance that their designs had "brought about, in this country, a kind of revolution in the whole system of this useful and elegant art." Art historians have questioned the originality of the Adam innovations and have modified their view of the speed with which they were adopted, but it is still undeniable that English architecture and especially English interior design were radically different after Robert Adam's three decades in London.

While the arts in France, Italy, Bavaria and Austria were dominated by the florid patterns and curved forms of the Rococo, Britain, in the first half of the eighteenth century, remained on the steady course charted by Lord Burlington, William Kent and other members of the solid English Palladian school. These architects and theorists looked upon Inigo Jones, Andrea Palladio and beyond them to Vitruvius as their household deities; the writings and works of these three masters constituted for the Burlingtonians an architectural canon, inviolable in both its precise, albeit limited, vocabulary of detail and the methods by which these specific parts could be arranged and combined into a single, whole unit. Certainly Robert Adam saw his own work, at least in part, as an attack upon what was by 1760 the architectural *ancien régime*. He disparaged Jones and Palladio in letters dated as early as 1756, and his brother and future colleague, James Adam, after visiting Vicenza, recorded his disappointment with Palladio's designs, which he found "ill-adjusted both in their plans and elevations."

The Works in Architecture of Robert and James Adam, edited with an Introduction by Robert Oresko (London and New York: St. Martin's Press, 1975). Excerpt pp. 9–46. Reprinted by permission of Academy Editions, London, and St. Martin's Press, New York.

Robert Adam objected to the unrelenting and dreary heaviness, what he saw as the inherent stodginess, of the strictly controlled Palladian forms. These characteristics were most clearly represented in his mind by the massive and deeply carved entablatures and pediments of façade design and by the rigidly compartmented ceilings, dominating marble fireplaces, vigorous stucco work and elaborate door frames, often crowned by a broken pediment, which were so prevalent in Palladian interior decoration. But Adam's critical reaction to Palladianism extended beyond his dislike of its specific stylistic components and developed into an attack upon the Palladian method of artistic expression. According to Adam, the architectural schools of the Renaissance, Mannerist and Baroque periods had fossilised the rules and standards implicit in the masterpieces of classical Greece and Rome. These theorists, by codifying the artistic laws of the ancients, had removed the sense of freedom and liberty of expression which, in Adam's view, were essential to the creative process. In turn, this rigidity had resulted in the perpetuation of designs which were at once uninspired and monotonously heavy. "The great masters of antiquity," he wrote, "were not so rigidly scrupulous, they varied the proportions as the general spirit of their composition required, clearly perceiving that, however necessary these rules may be to form the taste and to arrest the licentiousness of the scholar, they often cramp the genius, and circumscribe the ideas of the master." . . .

The classical world was quite clearly the strongest single inspiration for Robert Adam's genius. The influence of the antique is apparent in every Adam room from the most precise details and fixtures to the undefinable ambiance and general spirit. A few examples, representative of his entire *œuvre*, must suffice. A frieze from the Forum of Trajan was included in the gallery of Croome Court, the trophies of Octavianus Augustus were adapted for the Syon House ante-room decoration, while, on a slightly larger scale, a carpet designed for the gallery at Syon was probably derived from an Ostia mosaic. Innumerable ceiling patterns were antique transplants, . . . But perhaps the importance of the ancient world for Adam's vision was most firmly and unequivocally asserted in the south façade of Kedleston, into which was imbedded a model of the Arch of Constantine.

It should be obvious, even from this highly selective list of classical borrowings, that Adam's antique inspiration was largely Roman, not Greek. . . . Indeed, one of Adam's most striking contributions to concepts of design dealt with Roman domestic interiors, which he rightly pointed out were totally different from and much more restrained than the grandiose temple schemes thoughtlessly applied by Baroque architects to the interiors of private homes.

But if the classical strain was by far the most pronounced in Adam's

schemes, it was not the only outside influence. Although the intensity and sincerity of his disapproval of various aspects of Renaissance and Baroque style must never be discounted, these periods left many telling and unmistakeable marks upon Adam's own designs. The most obvious legacy from the *cinquecento* were the flat panels of *grottesche*, elaborately decorative and convoluted arabesque, which Adam derived principally from the designs of Raphael, Giulio Romano and Giovanni da Udine. Although Adam's *grottesche* may have lacked the vigour of those in the Vatican *loggie* or the Villa Madama, the debt to the high Renaissance is clear. . . .

Adam, still an impressionable young man while on the Grand Tour, was also deeply influenced by Giovanni Battista Piranesi. Although its roots were firmly planted during the years Adam was abroad, the friendship with Piranesi did not end with the Scot's return home in 1758. . . . The Italian's knowledge of and enthusiasm for archaeological remains provided a common bond of interest. [Figure 16]

But probably the most important and wide-reaching effect Piranesi had upon his friend was the transmission of his notion of artistic licence. The concept of abstracting the elements of classical culture and then rearranging them into a pattern of one's own was developed and expounded largely by Piranesi. . . .

As we have seen already, Robert Adam was convinced that this combination and re-combination of specific elements to fit specific situations was the precise method used by the great masters of antiquity before their motifs were formalised into an unnatural and ostensibly inviolable régime by the Renaissance theorists. In a famous letter to Lord Kames, Adam discussed his use of the doric order and mentioned that "I have ventured to alter some parts of this order, particularly in its mouldings; rejecting some of the common ones, and adopting and substituting others in their stead." . . .

It was the graceful achievement of a unified whole through the blending of divergent elements which was Adam's primary contribution to the development of design. The rooms which he decorated were carefully orchestrated in terms of ornament, colour and furniture. The painstaking attention to detail is apparent in all of his work. Large patches of white were avoided because Adam found them too glaring when compared to his gentle and muted blues and greens or to the more striking Etruscan combination of ochre, black and cream. Similarly, Adam paid close attention to the furnishings of the rooms he designed and decorated. Although the number of houses for which he provided the entire range of furniture is very small, Adam was at times consulted on the fitting-out of his rooms and more than occasionally designed those pieces, such as tall mirrors and tables, which formed a composition and were considered to be wall decoration, thus removed from the province of the cabinet maker. It was this

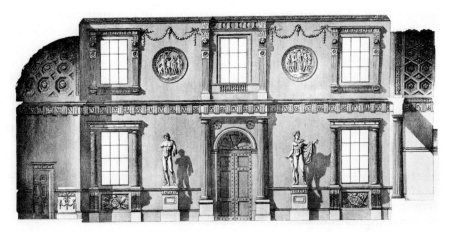

Figure 16 *Giovanni Battista Piranesi, Section of one side of the Hall at Syon.*
From Robert Adam, *Works in Architecture* (1779). Reproduced by permission of the British Library.

control over as many aspects as possible of the decoration that gave an Adam room its unique sense of completeness and total conception, an achievement which resulted in Adam's reputation being more solidly grounded upon his interior designs for buildings than upon his exterior schemes. Adam was only rarely asked by a client to plan a building from the ground up. Most often, as at Kedleston, he took over the construction of the house from another architect, or, as at Syon, he was commissioned to transform only the interiors of an existing building. Adam increasingly came to be viewed as an artist uniquely equipped to solve specific difficulties, one who could construct a consistently elegant, Neo-Classical interior in Jacobean shaped rooms and could make the box-like limits of London town houses seem spacious and graceful. His most notable achievements are embodied in his interior designs.

This concentration on interiors must have come as a deep disappointment to Adam, who longed to plan and construct from the beginning a giant, public commission for the capital. The great opportunity, such as that given to his rival, Sir William Chambers, at Somerset House, eluded him. Several reasons have been put forward to explain this neglect, including the supposed antipathy of George III. . . . For whatever causes, Adam felt blocked in his desire to plan on a grand scale and turned, perhaps in part as compensation, to a series of privately financed, almost town planning ventures. . . .

Adam's responsibilities at . . . country houses varied from commission to commission. . . . At Syon, Adam triumphed over the demands of a house existing since the fifteenth century. [Figure 16] Using such devices as col-

umnar screens he modified mis-shapen rooms to fit symmetrical and classical standards, and, through the careful use of steps, linked rooms which had been built on slightly different levels. The duke of Northumberland, the owner of Syon, ultimately called a halt to Adam's expenditure, but the great domed hall, planned for the central court, though unexecuted at Syon, appeared transformed in other Adam plans. Kedleston provided one of Adam's few opportunities to work with exterior elevations, and his use of the triumphal Arch of Constantine as the leading motif was a perfect Neo-Classical solution. . . .

In some ways Robert Adam's career seems remarkably parallel to that of a man he attacked as a purveyor of Palladianism, Inigo Jones. Both were native born British artists who ripened their sensitivities during tours of Italy, both forged elements of the antique and *cinquecento* styles into unique personal visions and both returned to Britain and helped to effect a total revolution in the style and taste of their own times. Robert Adam was certainly one of the most important British Neo-Classicists, and the changes which he brought about in design can be seen as a major contribution to the acceptance of this style. Yet, on another level, his achievement lies in his role as the liberator of architecture and design from what had become merely ossified standards of procedure. His reliance upon and firm faith in the intuition and genius of the individual artist marked his style as one of the most uniquely personal and elegant statements in the history of British art and architecture.

17

Andrei Voznesensky

I AM GOYA

ALTHOUGH GOYA DIED IN 1828, he has left us a vision of the world in turmoil that seems to reflect the wars and devastation of our own century. In such paintings as *The Third of May, 1808* (1815) and in etchings whose subjects are war, superstition, and human folly, this Spanish artist's message seems as immediate as the evening newscast. In one painting, faceless soldiers shoot unarmed peasants. A print shows the bodies of the dead lying on the battlefield, food for vultures [Figure 17]. In another Goya depicts a corpse hanging from the gallows. The superstitious, overcoming their fear of the dead, garner his teeth for their supposed magical powers.

War is not a heroic subject in Goya's pictures. The heroic image of warfare as a kind of gigantic tournament (see, for instance, *The Battle of San Romano* painted in the Renaissance by Paolo Uccello) has vanished. The fiction that no matter how hard fought, war ends in a gracious and gentlemanly treaty (as in Velasquez's *Surrender of Breda*, 1634–1635), has been replaced by a harsh and painful reality. Goya's images seem to anticipate twentieth-century events: Vietnamese peasants in flames, suicide trucks exploding in a Marine barracks in Lebanon, hungry refugees driven back and forth along the borders of warring African or Central American states. In these wars there are no victors, only victims.

When a twentieth-century Russian poet, Andrei Voznesensky, wanted to write a poem about the early years of World War II in his homeland, he found inspiration in Goya's imagery. The Second World War devastated Russia. Hitler's armies invaded in the summer of 1941. Unable to stop the German advance, Russian troops fell back, leaving behind burnt fields and cities so that no resources should be available to the conquerors. By December the Nazis had surrounded Leningrad. The bitterly cold Russian

187

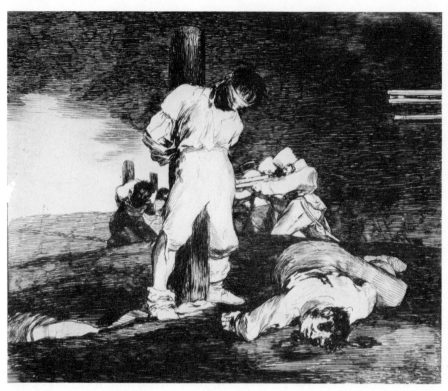

Figure 17 *Francisco Goya,* Y no hay remedio (And there is no remedy), Desastros, *plate 15. The British Museum, London.*
Reproduced by courtesy of the Trustees of the British Museum.

winter and shortages of food and arms then halted their progress. There the German army camped through two winters, while the defenders of Leningrad starved inside the city.[1]

During the German occupation Russians faced cold, starvation, and mass slaughter. Voznesensky's moving and beautiful poem uses images from Goya's works to express the poet's empathy with the people of his suffering country. Goya had created images that helped the poet see and understand events of his own time. This suggests that the poem is also a tribute to Goya, artist and prophet.

Credit should also be given to Stanley Kunitz's English translation. No poem can actually be translated from one language to another, and what you are reading is really a cooperative creative work, brought into being by two talented writers.

[1]In spring, 1943, Russian troops repulsed the German attack on Stalingrad [now Volgograd]. Russia's victory at Stalingrad marked a turning point in World War II—the end of German success in the Russian campaign.

I Am Goya

I am Goya
of the bare field, by the enemy's beak gouged
till the craters of my eyes gape
I am grief

I am the tongue
of war, the embers of cities
on the snows of the year 1941
I am hunger

I am the gullet
of a woman hanged whose body like a bell
tolled over a blank square
I am Goya

O grapes of wrath!
I have hurled westward
 the ashes of the uninvited guest!
and hammered stars into the unforgetting sky—like nails
I am Goya

Andrei Voznesensky, "I Am Goya," *Antiworlds and the Fifth Ace*, Patricia Blake and Max Hayward, eds. (New York: Basic Books, 1966) p. 3. Copyright © 1963 by Encounter Ltd. "I Am Goya" translated by Stanley Kunitz. Reprinted by permission of Stanley Kunitz.

18

Charles Baudelaire (1821–1867)

THE PAINTER OF MODERN
LIFE

A VERY FEW WORKS OF LITERATURE and criticism make an impression by means of their titles alone—an impression so strong that the words remain in our minds like a manifesto. Such is the case with Baudelaire's "The Painter of Modern Life." In the middle of the nineteenth century, when well-known artists were producing acres of exotic, historical, and allegorical canvas, Baudelaire called for an art based upon the forms, costumes, actions, even facial expressions, of his own day.

Baudelaire wrote this essay after seeing works by Constantin Guys, "M.C.G." [Figure 18]. Guys was a painter, but was better known as a journalist and illustrator. In his work Baudelaire saw a potential that Guys perhaps never really fulfilled. To us, this promise seems to be realized in the works of such artists as Courbet, Manet, and Daumier.

To be a painter of modern life, Baudelaire explains, the artist must stop relying entirely upon the art of the past. Instead he must look at—and must have the gift for *seeing*—the world in which he lives: for "nearly all our originality comes from the stamp that time impresses upon our sensibility." The things we see around us are so ordinary, so familiar, that we might be tempted to make our art more impressive by dressing it up in the style of long ago. Today, "costume" and science fiction films do this all the time: very ordinary stories are transported to the past or to the equally unfamiliar future to enhance their appeal. Baudelaire argued that a great artist's strength lies in seeing the wonderful special quality of his *own* time. Renaissance artists had painted Renaissance people in their familiar dress; Roman sculptors had portrayed their subjects in the clothes and with the

facial expressions of their era. The lasting, "eternal," qualities of Renaissance or Roman works is paradoxically bound up with their ability to reflect the changing, "temporal," world. By portraying his own world the artist acquires a deep involvement in his subject, an emotional commitment. The depth of feeling he communicates then enables his art to last.

"Involvement," "intensity"—these are the key words to Baudelaire's criticism. Baudelaire's own poetry (most familiar, *The Flowers of Evil*, 1857) shows us his intense feelings and emotional expression. Baudelaire is in many ways part of the romantic movement. His interest in Edgar Allen Poe (the writer of "Man of the Crowd," referred to on p. 192, and better known to most of us as the author of stories like "The Pit and the Pendulum") shows that he was not a narrow supporter of some kind of "realism" that excluded color and adventure. Baudelaire loved the paintings of Delacroix, even though their inspiration was often drawn from literary and exotic sources rather than from "modern life," because Delacroix used his subjects to create intense feeling, primarily through color. It is the hack traditionalists whose art failed, and whose pictures seemed, to Baudelaire, mere trivia dressed up for effect. That is why he placed Jacques-Louis David, too, among the great artists, even though David's pictures show people in Roman dress. The very specific Roman subjects required it. But a later classicist, Ingres, did not please Baudelaire; he felt there was not enough intensity left in the classical tradition by the middle of the nineteenth century.

How does Baudelaire describe the method an artist should use to become aware of his world? Baudelaire used several comparisons. The first is the idea of the artist as a convalescent. Long serious illness was a more common event 150 years ago than it is today. But anyone who has spent a week or more in a hospital knows the vivid sensation of "returning to the world" with all its sights, smells, and colors. Baudelaire's second comparison is the artist-as-child. To children the world is not familiar, it is new, and every experience is rich and exciting.

"The Painter of Modern Life" was originally published November–December 1863, but it was probably written between November 1859 and February 1860. It is a great example of art criticism because it makes us eager to see the pictures described, and because it changes the way we see familiar works. According to the editor of Baudelaire's essays, Charvet, a great critic must represent an age and its values, or must discover new ideas about art, or must initiate or stimulate a new movement in art. Baudelaire's essay should be read with these criteria in mind.

Baudelaire wrote about an individual artist, and then broadened his subject to lead us to a general discussion of art. His writing is passionate, imaginative, and involved. When we read his works, we become involved too. Great critics are rare, perhaps even rarer than great artists. This essay introduces you to one of them.

From

The Painter of Modern Life

An Artist, Man of the World,
Man of Crowds, and Child

. . . Today I want to talk to my readers about a singular man, whose originality is so powerful and clear-cut that it is self-sufficing, and does not bother to look for approval. None of his drawings is signed, if by signature we mean the few letters, which can be so easily forged, that compose a name, and that so many other artists grandly inscribe at the bottom of their most carefree sketches. But all his works are signed with his dazzling soul, and art-lovers who have seen and liked them will recognize them easily from the description I propose to give of them. M. C. G.[1] loves mixing with the crowds, loves being incognito, and carries his originality to the point of modesty. . . . To begin to understand M. G., the first thing to note is this: that curiosity may be considered the starting point of his genius.

Do you remember a picture (for indeed it is a picture!) written by the most powerful pen of this age[2] and entitled *The Man of the Crowd*? Sitting in a café, and looking through the shop window, a convalescent is enjoying the sight of the passing crowd, and identifying himself in thought with all the thoughts that are moving around him. He has only recently come back from the shades of death and breathes in with delight all the spores and odours of life; as he has been on the point of forgetting everything, he remembers and passionately wants to remember everything. In the end he rushes out into the crowd in search of a man unknown to him whose face, which he had caught sight of, had in a flash fascinated him. Curiosity had become a compelling, irresistible passion.

Now imagine an artist perpetually in the spiritual condition of the convalescent, and you will have the key to the character of M. G.

But convalescence is like a return to childhood. The convalescent, like the child, enjoys to the highest degree the faculty of taking a lively interest in things, even the most trivial in appearance. Let us hark back, if we can,

Baudelaire: Selected Writings on Art and Artists, translated and with an introduction by P. E. Charvet (Harmondsworth, England: Penguin Books, 1972). Excerpts from "The Painter of Modern Life," pp. 390–435. Copyright © P. E. Charvet, 1972. Reprinted by permission of Penguin Books Ltd.

[1]Constantin Guys (1805–1892). Born in Holland; was correspondant for the *Illustrated London News* during the Crimean War. (*M.* = Monsieur, i.e., Mr.) [BW]

[2]Edgar Allen Poe (1809–1849), American poet and novelist. [BW]

by a retrospective effort of our imaginations, to our youngest, our morning impressions, and we shall recognize that they were remarkably akin to the vividly coloured impressions that we received later on after a physical illness, provided that illness left our spiritual faculties pure and unimpaired. The child sees everything as a novelty; the child is always "drunk." Nothing is more like what we call inspiration than the joy the child feels in drinking in shape and colour. . . . Genius is no more than childhood recaptured at will, childhood equipped now with man's physical means to express itself, and with the analytical mind that enables it to bring order into the sum of experience, involuntarily amassed. To this deep and joyful curiosity must be attributed that stare, animal-like in its ecstasy, which all children have when confronted with something new, whatever it may be, face or landscape, light, gilding, colours, watered silk, enchantment of beauty, enhanced by the arts of dress.

When, as he wakes up, M. G. opens his eyes and sees the sun beating vibrantly at his window-panes, he says to himself with remorse and regret: "What an imperative command! What a fanfare of light! . . . Light I have lost in sleep! and endless numbers of things bathed in light that I could have seen and have failed to!" And off he goes! And he watches the flow of life move by, majestic and dazzling. He admires the eternal beauty and the astonishing harmony of life in the capital cities. . . . He gazes at the landscape of the great city, landscapes of stone, now swathed in mist, now struck in full face by the sun. He enjoys handsome equipages, proud horses, the spit and polish of the grooms, . . . the smooth rhythmical gait of the women, the beauty of the children, full of the joy of life and proud as peacocks of their pretty clothes; in short, life universal. . . . And so, walking or quickening his pace, he goes his way, for ever in search. In search of what? We may rest assured that this man, such as I have described him, this solitary mortal endowed with an active imagination, always roaming the great desert of men, has a nobler aim than that of the pure idler, a more general aim, other than the fleeting pleasure of circumstance. He is looking for that indefinable something we may be allowed to call "modernity," for want of a better term to express the idea in question. The aim for him is to extract from fashion the poetry that resides in its historical envelope, to distil the eternal from the transitory. If we cast our eye over our exhibitions of modern pictures, we shall be struck by the general tendency of our artists to clothe all manner of subjects in the dress of the past. Almost all of them use the fashions and the furnishings of the Renaissance, as David[3] used Roman fashions and furnishings, but there is this difference, that David, having chosen subjects peculiarly Greek or Roman, could not do otherwise than present them in the style of antiquity, whereas the painters

[3]Jacques-Louis David (1748–1852), French Neo-Classical painter. (See illustration in your textbook.) [BW]

of today, choosing, as they do, subjects of a general nature, applicable to all ages, will insist on dressing them up in the fashion of the Middle Ages, of the Renaissance, or of the East. This is evidently sheer laziness; for it is much more convenient to state roundly that everything is hopelessly ugly in the dress of a period than to apply oneself to the task of extracting the mysterious beauty that may be hidden there, however small or light it may be. Modernity is the transient, the fleeting, the contingent; it is one half of art, the other being the eternal and the immovable. There was a form of modernity for every painter of the past; the majority of the fine portraits that remain to us from former times are clothed in the dress of their own day. They are perfectly harmonious works because the dress, the hairstyle, and even the gesture, the expression and the smile (each age has its carriage, its expression and its smile) form a whole, full of vitality. You have no right to despise this transitory fleeting element, the metamorphoses of which are so frequent, nor to dispense with it. If you do, you inevitably fall into the emptiness of an abstract and indefinable beauty, like that of the one and only woman of the time before the Fall. If for the dress of the day, which is necessarily right, you substitute another, you are guilty of a piece of nonsense that only a fancy-dress ball imposed by fashion can excuse. Thus the goddesses, the nymphs, and sultanas of the eighteenth century are portraits in the spirit of their day.

No doubt it is an excellent discipline to study the old masters, in order to learn how to paint, but it can be no more than a superfluous exercise if your aim is to understand the beauty of the present day. The draperies of Rubens or Veronese will not teach you how to paint . . . fabric produced by our mills, supported by a swaying crinoline, or petticoats of starched muslin. The texture and grain are not the same as in the fabrics of old Venice. . . . We may add that the cut of the skirt and bodice is absolutely different, that the pleats are arranged into a new pattern, and finally that the gesture and carriage of the woman of today give her dress a vitality and a character that are not those of the woman of former ages. In short, in order that any form of modernity may be worthy of becoming antiquity, the mysterious beauty that human life unintentionally puts into it must have been extracted from it. It is this task that M. G. particularly addresses himself to.

I have said that every age has its own carriage, its expression, its gestures. This proposition may be easily verified in a large portrait gallery. . . . But it can be yet further extended. In a unity we call a nation, the professions, the social classes, the successive centuries, introduce variety not only in gestures and manners, but also in the general outlines of faces. Such and such a nose, mouth, forehead, will be standard for a given interval of time, the length of which I shall not claim to determine here, but which may certainly be a matter of calculation. Such ideas are not familiar enough to portrait painters; and the great weakness of M. Ingres, in partic-

ular, is the desire to impose on every type that sits for him a more or less complete process of improvement, in other words a despotic perfecting process, borrowed from the store of classical ideas. . . . If a painter, patient and scrupulous but with only inferior imaginative power, were commissioned to paint a courtesan of today, and, for this purpose, were to get his inspiration (to use the hallowed term) from a courtesan by Titian or Raphael, the odds are that his work would be fraudulent, ambiguous, and difficult to understand. The study of a masterpiece of that date and of that kind will not teach him the carriage, the gaze, the come-hitherishness, or the living representation of one of these creatures that the dictionary of fashion has, in rapid succession, pigeonholed under the coarse or light-hearted rubric of unchaste, kept women, Lorettes.[4] [Figure 18]

The same remark applies precisely to the study of the soldier, the dandy, and even animals, dogs or horses, and of all things that go to make up the external life of an age. Woe betide the man who goes to antiquity for the study of anything other than ideal art, logic and general method! By immersing himself too deeply in it, he will no longer have the present in his mind's eye; he throws away the value and the privileges afforded by circumstance; for nearly all our originality comes from the stamp that time impresses upon our sensibility. The reader will readily understand that I could easily verify my assertions from innumerable objects other than women. What would you say, for example, of a marine painter (I take an extreme case) who, having to represent the sober and elegant beauty of a modern vessel, were to tire out his eyes in the study of the overloaded, twisted shapes, the monumental stern, of ships of bygone ages, and the complex sails and rigging of the sixteenth century? And what would you think of an artist you had commissioned to do the portrait of a thorough-bred, celebrated in the solemn annals of the turf, if he were to restrict his studies to museums, if he were to content himself with looking at equine studies of the past in the picture galleries, in Van Dyck, Bourguignon, or Van der Meulen?[5] . . .

Women: Honest Ones, and Others

Thus M. G., having undertaken the task of seeking and explaining beauty in modernity, enjoys depicting women in all their finery, their beauty enhanced by every kind of artifice, regardless of what social class they belong to. Moreover, in the whole of his works, just as in the throng and bustle of

[4]*Lorette*: a word coined about 1840, meaning a woman of easy virtue. Like many slang terms, it has since disappeared.

[5]Anthony Van Dyck, 1599–1641, well-known seventeenth-century painter. (See illustration in your textbook.) Bourguignon (Jacques Courtois, 1621–1676, called "Borgognone"), and Adam Frans van der Muelen, c. 1632–1690, painters of military and equestrian subjects. [BW]

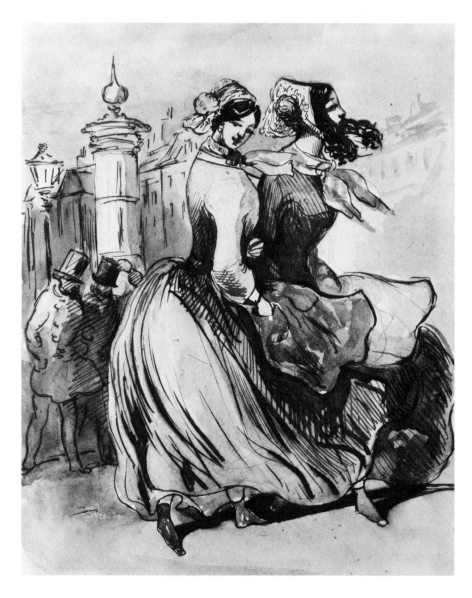

Figure 18 *Constantin Guys*, Two Lorettes. *The Metropolitan Museum of Art, New York, bequest of Mrs. H. O. Havemeyer, 1929. The H. O. Havemeyer Collection (29.100.601).*
Reproduced by permission of The Metropolitan Museum of Art.

human life itself, the differences of class and breeding, whatever may be the apparatus of luxury used by the individual, are immediately apparent to the eye of the spectator.

At one moment we see, bathed in the diffused light of the auditorium, a group of young women of the highest social circles, the brightness reflected in their eyes, in their jewellery and on their shoulders, framed in their boxes, resplendent as portraits. Some of them are grave and serious, others fair and feather-brained. Some display their precocious charms with aristocratic nonchalance, others, in all innocence, their boyish busts. All are biting their fans, and have a far-away look in their eyes, or a fixed stare; their postures are theatrical and solemn, like the play or opera they are pretending to listen to.

Another time we see smartly dressed families strolling along the paths of the public gardens, the wives without a care in the world, leaning on the arms of their husbands, whose solid contented air betrays the self-made man, full of money and self-satisfaction. Here the general air of wealth takes the place of haughty distinction. Little girls with match-stick arms and ballooning skirts, looking like little women by their gestures and appearance, are skipping, playing with hoops or pretending to be grown-ups on a visit, performing in the open air the social comedy their parents perform at home.

Or again, we are shown a lower level of society, where chits of actresses from the suburban theatres, proud as peacocks to appear at last in the glare of the footlights, slim, frail, scarcely grown-up, are shaking down, over their virginal, sickly bodies, absurd garments which belong to no period, but are the joy of their owners.

Or, at a café door, we see, leaning against the broad windows lit from without and within, one of those lounging half-wits; his elegance is the work of his tailor, and the distinguished cut of his jib, that of his hairdresser. Beside him, her feet resting on the indispensable footstool, sits his mistress, a great cow of a woman, in whom almost nothing is lacking (but that "almost nothing" meaning almost everything, in a word: distinction) to make her look like a high-born lady. Like her pretty boyfriend, she has, filling the whole orifice of her little mouth, an outsize cigar. Neither of these two beings has a thought in his head. Can one even be sure they are looking at anything—unless, like Narcissuses[6] of fat-headedness, they are contemplating the crowd, as though it were a river, offering them their own image. In reality they exist much more for the joy of the observer than for their own. . . .

We are betting on a certainty when we say that in a few years the drawings of M. G. will become precious archives of civilized life. His works

[6]Narcissus: in Greek mythology, a beautiful youth who abandoned all other activities to admire his own reflection in a clear pool. [BW]

will be sought after by discerning collectors, as much as those of all those exquisite artists who, although they have confined themselves to recording what is familiar and pretty, are nonetheless, in their own ways, important historians. Several of them have even sacrificed too much to the "pretty-pretty," and have sometimes introduced into their compositions a classic style foreign to the subject; several have deliberately rounded the angles, smoothed over the harshness of life, toned down its flashing colours. Less skilful than they, M. G. retains a profound merit, which is all his own; he has deliberately filled a function which other artists disdain, and which a man of the world above all others could carry out. He has gone everywhere in quest of the ephemeral, the fleeting forms of beauty in the life of our day, the characteristic traits of what, with the reader's permission, we have called "modernity." Often bizarre, violent, excessive, but always full of poetry, he has succeeded, in his drawings, in distilling the bitter or heady flavour of the wine of life.

19

Kenyon Cox/Meyer Schapiro
THE 1913 ARMORY SHOW

IN 1913, MODERN ART ARRIVED in America. Although a handful of American expatriates living in Paris were among the first patrons of artists like Picasso and Matisse, the 1913 Armory Show introduced new European technical innovations to the American public overnight. American artists as well as their audience were still at least a generation behind Europe in the development of painting styles, and sculpture languished even further behind. Suddenly the Armory exhibition asked viewers in New York, Chicago, and Boston to jump from looking at Impressionism to looking at a diverse group of styles so new that not even the artists who had produced the works knew what they would do the next day.

"Cubists and Futurists Are Making Insanity Pay," the reaction of Kenyon Cox (American muralist, 1856–1919), is a good example of the anger the Armory Show aroused. Some of that anger was simply the frustration that we all feel when we don't understand the world around us. A challenge to our accepted view is painful. For artists like Cox, who had written a book called *The Classic Point of View* two years earlier, the Armory show was a threat to his whole life's work. Cox's murals for the Columbian Exposition in Chicago (1893), for example, were characterized by allegorical figures in classical poses, subdued colors, and firm outlines.

Insanity was apparently Cox's first diagnosis of the new art: anarchy, his second. This brings us to the question of politics in art. Why has "modern" art been characterized as a threat to political structures? When Cox compares the artists like Duchamp [Figure 19] or Brancusi to anarchists "who would overthrow all social laws," he is voicing a fear that will be heard

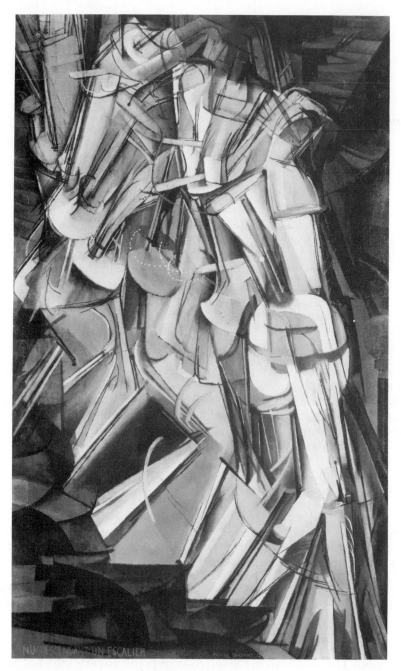

Figure 19 *Marcel Duchamp,* Nude Descending a Staircase, *no. 2. Philadelphia Museum of Art, Louise and Walter Arensberg Collection.*
Reproduced by permission of the Philadelphia Museum of Art.

many times in our century. The sense of the individual and of individual rights in religion, politics, and taste is repeatedly seen as a danger to the social fabric. Above all in totalitarian societies—Germany under Hitler, the Soviet Union today—art that seems to express the explorations of an individual mind is forbidden.

When Schapiro wrote "The Introduction of Modern Art," America was in the middle of an era of repression known loosely as the McCarthy era, after one of its chief proponents, Senator Joseph R. McCarthy (1908–1957). The Cold War was flourishing. "Rooting out" Communists from government and the arts preoccupied the front pages of the newspapers. Once more, modern art came under attack [Schapiro points out] as "meaningless," "pornographic," and atheistic. A parallel with the behavior of Fascist and Communist regimes is obvious: Schapiro's article warned us against equating the new, or unexpected, in art with attempts to overturn the government. Since the 1950s saw the development of *another* threateningly new style in America, the Abstract Expressionism of artists like Pollock, Rothko, and de Kooning, the reception of the Armory Show works and the complex of social and political motives for their rejection had a modern parallel.

It is interesting to observe that Cox's and Schapiro's descriptions of the art at the Armory agree in many ways. Both, for instance, see clearly that no matter how revolutionary its appearance, Cubism was the product of a development that had begun in the nineteenth century. Romantic art had stressed the artist's right to personal expression, and Impressionism had changed the way paint was applied to canvas.

Schapiro's article provides an unusually clear explanation of what modern art looked like when it was seen for the first time and why it was subject to such violent attack. It can serve as a warning to all of us against narrowness of taste and fear of the new.

From
"The New York Times"
An Interview with Kenyon Cox

Cubists and Futurists Are Making Insanity Pay

March 16, 1913: Kenyon Cox, Member of the National Academy, and Recognized Here and Abroad as One of America's Foremost Painters, Gives a Straight-from-the-Shoulder Opinion of the New Movements in Art.

What does the work of the Cubists and Futurists mean? Have these "progressives" really outstripped all the rest of us, glimpsed the future, and used a form of artistic expression that is simply esoteric to the great laggard public? Is their work a conspicuous milestone in the progress of art? Or is it junk? . . .

How the Public Acted

A good part of New York grinned as it passed along from one paint-puzzle to another . . . In circles where art had never before been discussed, one heard the question:
"Have you seen the Cubists and the Futurists? Yes? Well, could you make anything out of it?"
The answer usually was:
"Why, I don't know much about art, but it looked to me like a mess of nonsense." . . .
A *Times* reporter went last week to ask Kenyon Cox, recognized both here and abroad as being in the lonely forerank of American art, to throw some light on this dark problem. . . . Mr. Cox took a reflective puff or two, . . . and then came the straight-from-the-shoulder opinion.
"The Cubists and the Futurists simply abolish the art of painting. They deny not only any representation of nature, but also any known or traditional form of decoration.

"They maintain that they have invented a symbolism which expresses their individuality, or as they say, their souls.

"If they have really expressed their souls in the things they show us, God help their souls! . . .

"There is one point, and one on which I feel strongly: This is not a sudden disruption or eruption in the history of art. It is the inevitable result of a tendency . . . to abandon all discipline, all respect for tradition, and to insist that art shall be nothing but an expression of the individual.

"It began with the Impressionists denying the necessity of any knowledge of form or structure . . . The next step was for the Post-Impressionists to revolt again . . . to maintain that it does not matter how things look, the only point of importance being how you feel about them. . . .

There was a pause. Then the old corncob was reached for, refilled, lighted.

"There is another element that comes into it . . . Up to the time of Matisse, the revolutionaries, I believe, were for the most part sincere enough . . . But with Matisse, and with the later work of Rodin, and, above all, with the Cubists and the Futurists, it is no longer a matter of sincere fanaticism. These men have seized upon the modern engine of publicity and are making insanity pay. . . ."

From
The Introduction of Modern Art in America

The great event, the turning-point in American art called the Armory Show, was briefly this. In December 1911, some American artists who were dissatisfied with the restricted exhibitions of the National Academy of Design formed a new society, the American Association of Painters and Sculptors, in order to exhibit on a broader basis, without jury or prizes. The members did not belong to a particular school of art; several of them had shown at the National Academy itself. They came together not simply from opposition to the aesthetic of the Academy (although there was a stirring towards modernity among them) but from a collective professional need: to create a more open market, so to speak, a means of exhibition accessible to the unacademic and not yet established men. The most active elements in the new society were the younger and more advanced artists; but not the most advanced ones, who seem to have been less concerned about exhibitions or societies at that moment.

This aim of the Association was soon overlaid by another, which none of the members perhaps foresaw. Their first exhibition, planned as a great show of American painting and sculpture at the Sixty-ninth Regiment Armory in New York—a show inspired by a new confidence of American artists in the importance of their work and of art in general—became an international show in which European paintings and sculptures far surpassed in interest and overshadowed the American. The change in the intention of the Show was due to the idea of the president, Arthur B. Davies, to exhibit also some recent European work. But while traveling abroad for this purpose, Davies and his collaborator, Walt Kuhn, were so impressed by the new European art, which they had known only slightly, and by the great national and international shows of the newest movements in art, held in 1912 in London, Cologne, and Munich, that they borrowed much more than they had first intended. They were caught up by the tide of advancing art and carried beyond their original aims into a field where

Meyer Schapiro, "The Introduction of Modern Art in America: The Armory Show." Reprinted as "Rebellion in Art," *America in Crisis,* Daniel Aron, ed. (New York: Alfred A. Knopf, 1952). Also reprinted in *The Armory Show International Exhibition of Modern Art 1913, Volume III: Contemporary and Retrospective Documents* (New York: Arno Press, 1972).

they could not maintain themselves; their own work, while unacademic, was submerged by the new art. In the great public that attended the Show in New York, Chicago, and Boston in the spring of 1913, this foreign painting and sculpture called out an extraordinary range of feelings, from enthusiasm for the new to curiosity, bewilderment, disgust, and rage. For months the newspapers and magazines were filled with caricatures, lampoons, photographs, articles, and interviews about the radical European art. Art students burned the painter Matisse in effigy, violent episodes occurred in the schools, and in Chicago the Show was investigated by the Vice Commission upon the complaint of an outraged guardian of morals. So disturbing was the exhibition to the society of artists that had sponsored it that many members repudiated the vanguard and resigned; among them were painters like Sloan and Luks, who the day before had been considered the rebels of American art. Because of the strong feelings aroused within the Association, it broke up soon after, in 1914. The Armory Show was its only exhibition. For years afterwards the Show was remembered as a historic event, a momentous example of artistic insurgence. It excited the young painters and sculptors, awakened them to fresh possibilities, and created in the public at large a new image of modernity. It forced on many an awareness that art had just undergone a revolution and that much they had admired in contemporary art during the last decades was problematic, old-fashioned, destined to die. In time the new European art disclosed at the Armory Show became the model of art in the United States. . . . The Show, coming at a moment of intense ferment in European art, lifted people out of the narrowness of a complacent provincial taste and compelled them to judge American art by a world standard. The years 1910 to 1913 were the heroic period in which the most astonishing innovations had occurred; it was then that the basic types of the art of the next forty years were created. Compared to the movement of art at that time, today's modernism seems a slackening or stagnation. About 1913 painters, writers, musicians, and architects felt themselves to be at an epochal turning-point corresponding to an equally decisive transition in philosophical thought and social life. This sentiment of imminent change inspired a general insurgence, a readiness for great events. The years just before the first World War were rich in new associations of artists, vast projects, and daring manifestoes. The world of art had never known so keen an appetite for action, a kind of militancy that gave to cultural life the quality of a revolutionary movement or the beginnings of a new religion. The convictions of the artists were transmitted to an ever larger public, and won converts for whom interest in the new art became a governing passion. . . .

What was the nature of this new art? In what lay its novelty and its challenge to the art it came to supplant?

The great variety of this rapidly developing modern art obscured its character and inspired vague or onesided interpretations. How could one

enclose in a single formula the clear, bright works of Matisse and the intricate Nude of Duchamp? The creators had no ultimate common goal, but advanced from canvas to canvas, following up new ideas that arose in the course of their work, hardly imagining what would emerge in the end; they seemed to be carried along by a hidden logic that unfolded gradually, yielding forms surprising to themselves. . . .

Friendly critics praised the courage and vitality and integrity of the modern artists—qualities that might have been found in the art of any time—without venturing to analyze the new styles. The hostile criticism— narrow and shortsighted as it was—in denouncing the deviations from past art, pointed more directly to the essential novelty: the image was distorted or had disappeared altogether; colors and forms were unbearably intense; and the execution was so free as to seem completely artless. It was in the advanced work of the Cubists and of Kandinsky and Matisse that these features stood out most; among the sculptors, Brancusi was the arch-modern. The nature of the new art was not sufficiently defined by these peculiarities—nor is it our purpose here to undertake a better definition—but through them we may come closer to the issues in the conflicting judgments of the Show.

In only a few works had representation been abandoned entirely. But in many that preserved recognizable object-forms, these were strangely distorted. It is not easy to say which was more disturbing, nature deformed or the canvas without nature. Both seemed to announce the end of painting as an art.

For millennia, painting had been an art of image-making. The painter represented imaginary religious, mythical, or historical subjects, or he imaged the world before him in landscapes, portraits, and still-lifes. The word "picture," which literally means: "what is painted," had come to stand for any representation, even a verbal or mental one. All through the nineteenth century, however, artists and writers had proposed that the true aim of painting should not be to tell a story or to imitate a natural appearance, but to express a state of feeling, an idea, a fancy, or, aspiring to the condition of music, to create a harmony of colors and forms. Yet the image remained the indispensable foundation of painting. . . .

In the twentieth century the ideal of an imageless art of painting was realized for the first time, and the result was shocking—an arbitrary play with forms and colors that had only a vague connection with visible nature. Some painters had discovered that by accenting the operative elements of art—the stroke, the line, the patch, the surface of the canvas—and by disengaging these from the familiar forms of objects, and even by eliminating objects altogether, the painting assumed a more actively processed appearance, the aspect of a thing made rather than a scene represented, a highly ordered creation referring more to the artist than to the world of external things. The picture also became in this way a more powerful,

direct means of conveying feeling or, at least, the interior patterns of feel-ing; the strokes and spots, in their degree of contrast, in their lightness or weight, their energy or passivity, were unmistakably "physiognomic." And in paintings that still preserved some representation, beside the new self-evidence of the painter's marks with their vague intimations and tendencies of feeling, the image acquired an aspect of fantasy or of some obscure region of thought. It was such positive effects rather than a search for some presumed absolute or long-lost ideal essence of art that guided the artists in their approach to abstraction. They were neither geometers nor logicians nor philosophers, but painters who had discovered new possibilities in the processes of their art. Much was said about purity or form in itself, but in practice this meant a particular economy and rigor in employing the new means. . . .

The artists who abandoned the image completed a long process of dethronement of an ancient hierarchy within the subject-matter of art. In Western tradition, the greatest works had been judged to be those with the noblest subjects. Art with themes of religion, history, and myth was con-ceded an intrinsic superiority. By the middle of the nineteenth century, with the decline of aristocratic and religious institutions, the more intimate themes of persons, places, and things had come to be regarded as no less valid than the others; only the personal and the artistic mattered in judging a work of art. . . .

* * *

It would be surprising if such an art, introduced full-grown to an unprepared public and to artists who were bound to tradition, met with no resistance.

The modernists took this for granted; they knew that all the advanced movements of the nineteenth century, since the Romantic, had been vio-lently attacked, and it had become a platitude of criticism that in every age innovators have had to fight against misunderstanding. This view of the original artist as a martyr, and of the development of art as a bitter struggle between partisans of opposed styles, is hardly borne out by history. The great artists of the Renaissance who created the new forms were recognized early in their careers and received important commissions—Masaccio, van Eyck, Donatello, Leonardo, Raphael and Titian are examples. . . . The hos-tility to novel contemporary art, the long-delayed public recognition of most original recent artists, point rather to singularities of modern culture. Among these are the great span in the cultural levels of those who support art; the ideological value of competing styles as representative of conflict-ing social viewpoints; and the extraordinary variability of modern art, which requires from its audience a greater inner freedom and openness to others and to unusual feelings and perceptions than most people can achieve under modern conditions, in spite of the common desire for wider

experience. But most important of all perhaps is the changed relation of culture to institutional life. Past art, attached to highly organized systems of church, aristocracy, and state, or to the relatively closed, stable world of the family, remained in all its innovations within the bounds of widely accepted values, and continued to express feelings and ideas that had emerged or were emerging within these institutions; while independent modern art, which constructs a more personal, yet unconfined world, often critical of common ideas, receives little or no support from organized groups and must find its first backers among private individuals—many of them artists and amateurs—for whom art is an altogether personal affair. . . .

<center>* * *</center>

From the account of the Show and the history of modern art, sketched here briefly,[1] it is clear that the Show was no crisis for the American modernists, but a kind of triumphal entry. To have created these works, to have reached the public, to have gained supporters, was already an achievement. . . . In what sense then was the Armory Show a crisis in American art? . . . It was mainly for those who attacked the new work as a monstrous degradation of art by lunatics and charlatans that the Armory Show was a crisis. Yet if their vehement criticisms were correct, the strange art should hardly have caused them concern. The exhibition of mad or insincere work is no challenge to a serious artist. Incompetent painting is quickly forgotten. A true crisis would have been the failure of the aggrieved artists to produce any good art at all. It would then have been not only a crisis in their own art, but a total crisis of art, since they believed that the fate of American art was in their hands alone.

Yet many artists were deeply disturbed. . . . As defenders of tradition they knew also that their own art lacked the freshness and conviction they admired in the great painters of the past, and which these new men showed in an evident way, even if they broke all the rules. We suspect that to some more sensitive and intelligent conservative artists, the wildness of the new art, like the mysterious originality of the great masters who were beyond rules, seemed peculiarly demonic and inspired, even if crude.

If this new path was the right one, then the established American artists were on the wrong path. Their whole education seemed useless. For centuries the artist's training had been in the study of the nude figure, in drawing and painting from careful observation of the model, and in the copying of works of the old masters. All this severe preparation was now irrelevant. . . .

Today, almost forty years after the Armory Show,[2] modern art is still a recurring problem for the public, although so many more painters and

[1]Omitted from this selection.
[2]Written in 1952.

sculptors practice this art. The hostile criticisms made in 1913 have been renewed with great virulence. We hear them now from officials of culture, from Congress and the president. The director of the Metropolitan Museum of Art has recently condemned modern art as "meaningless" and "pornographic," and as a sign of the decay of civilization in our time. These criticisms are sometimes linked in an unscrupulous way with attacks on Communism, foreign culture, and religious doubt. They have a parallel in the attempts of the totalitarian regimes in Europe to destroy modern art as an unpalatable model of personal freedom of expression and indifference to the state. The Nazis suppressed this art as "cultural Bolshevism"; the Russian government and its supporters in the West denounced it as an example of "cosmopolitanism" or "bourgeois decadence"; Catholic spokesmen have rejected it as a manifestation of godless individualism. But no serious alternative has arisen to replace it. Those who demand a traditional and consoling art, or an art useful to the State, have nothing to hold to in contemporary painting and sculpture, unless it be some survivals of the academicism of the last century, or hybrid imitations of the modern art of fifty years ago by mediocre conforming painters, works that the enemies of the modern can hardly support with enthusiasm.

20

Sergei Eisenstein

LEONARDO'S DESCRIPTION OF "THE DELUGE" AS A FILM SCRIPT

RUSSIAN FILM DIRECTOR Sergei M. Eisenstein (1898–1948) is a towering figure among those who contributed to the early development of the cinema. As a young man he studied engineering and architecture; then his interests shifted to, among other things, Renaissance art, the Japanese language, and the theater. Following the Russian Revolution of 1917, Eisenstein directed amateur theatricals in the Red Army. This led first to his employment in the experimental theater that sprang up after the Revolution, and then to his becoming a film director. Among the most famous of his silent films is *Potemkin* (1925), a story of a sailors' rebellion during the unsuccessful 1905 Russian Revolution.

Except for a few trips to Europe and one to America, Eisenstein lived all his life in Russia. Although he was an ardent supporter of the Revolution, he was an artist first, a Communist second, a conformist never. His creative independence repeatedly brought him into conflict with official Communist doctrines on art. As a result a number of his films from the 1930s and 1940s were left unfinished when he died. Among the sound films he was able to complete are *Alexander Nevsky* (1937) and *Ivan the Terrible* (1941–1946), both based on Russian history.

Eisenstein's influence on filmmakers is worldwide.[1] He inspired other artists not only by the example that his films provided, but also through his teaching and his writings on film technique and theory. *Film Sense,* Eisen-

[1]See Yon Barna, *Eisenstein, The Growth of a Cinematic Genius* (Bloomington, Ind.: University Press, 1973; repr., Boston: Little, Brown, 1975).

stein's first book, was published in 1942. This book is three things at once. It is a teaching manual for the beginning film-maker. It is a contribution to the aesthetic theory of film, the visual art that exists in time (the *temporal* dimension) as well as in space (the *spatial* dimension). And it is a defense of the idea that film is a fine art.

We have only to use the word "movies" instead of "film" to understand why Eisenstein felt it was important to establish his chosen medium's right to the status of a "fine art." The movies began around the turn of the century as a toy, a curiosity. They developed into a popular art or entertainment that was not taken seriously—not worthy to be classed with novels or plays, but rather with amusements like today's game arcades or television soaps.

Eisenstein wanted to prove that the film must be taken seriously as an expressive medium, capable of depth and complexity, with an aesthetic of its own. One way to prove this is to compare film to other creative media like painting, plays, and poetry. In *Film Sense* Eisenstein refers to poets, novelists, composers, and painters from ancient and modern times. These comparisons help the reader to understand a new idea by referring to a familiar one. They also provide a kind of status-by-association. The very act of putting Leonardo da Vinci and the movies in one sentence helps to give the latter a legitimate place among the arts.

Eisenstein's theory of film is based upon the premise that film is primarily a visual medium, an art made of pictures, like the art of painting. Unlike painting, however, the film image exists in *time* like a musical composition. Although you might stand in front of the *Mona Lisa* for half an hour, you would not say that the *Mona Lisa* is thirty minutes long. Beethoven's Fifth Symphony *is* easily described as about thirty minutes long. Like a symphony, a film is composed of the arrangement of separate parts in an orderly temporal relation.

The theory of *montage,* or editing, of film explains how the separate images of the film form a composition in space and time. Each rectangle on a strip of moving picture film contains a picture that could be printed like an ordinary 35mm photograph (the *frame*). Unlike a photograph or a painting, however, which tries to sum up its subject in one picture, the frames are shown in rapid sequence so that the viewer sees a moving and changing image.

An uninterrupted strip of frames is called a *shot.* Spatial composition can change during a shot. A standing actor can sit down, or can run to one side and disappear. However, the filmmaker has another major compositional technique. After film has been exposed, it is cut apart into short pieces which are then glued together (the *sequence*). This process, which sounds so simple, is one of the most important parts of filmmaking. By joining shots in a particular order, the filmmaker creates a whole that is different from its parts. The new composite is the work of art. Think of the examples from Leonardo's "Deluge." A shot of "gloomy air . . . shot through by lightning" is followed by a shot of "many . . . stopping their ears with their hands . . ." A new idea arises from the juxtaposition of these two shots: the idea of fear. Eisenstein shows us that Leonardo's description

could be used as a *shooting script* (a filmmaker's outline of the work he is making). Leonardo has provided not one image but a *sequence* of visual images, some up close, some seen from a great distance, and these images comment upon and enhance one another.

It is exciting to recall that film is a medium born in our own century, and to notice how rapidly a new medium can evolve from a curiosity to great art. In Eisenstein's writings, as in his films, we are privileged to follow the thoughts of one of the creators who made that evolution possible.

From
The Film Sense

. . . This example is a certain remarkable "shooting-script." In it, from a cumulative massing of contributory details and pictures, an image palpably arises before us. It was not written as a finished work of literature, but simply as a note of a great master in which he attempted to put down on paper for his own benefit his visualization of The Deluge.

The "shooting-script" to which I refer is Leonardo da Vinci's notes on a representation of The Deluge in painting. I choose this particular example because in it the *audio-visual* picture of The Deluge is presented with an unusual clarity. Such an accomplishment of sound and picture co-ordination is remarkable coming from any painter, even Leonardo:

> Let the dark, gloomy air be seen beaten by the rush of opposing winds wreathed in perpetual rain mingled with hail, and bearing hither and thither a vast network of the torn branches of trees mixed together with an infinite number of leaves.

> All around let there be seen ancient trees uprooted and torn in pieces by the fury of the winds.

> You should show how fragments of mountains, which have been already stripped bare by the rushing torrents, fall headlong into these very torrents and choke up the valleys, until the pent-up rivers rise in flood and cover the wide plains and their inhabitants.

> Again there might be seen huddled together on the tops of many of the mountains many different sorts of animals, terrified and subdued at last

Sergei Einsenstein, *The Film Sense,* Jay Leyda, ed. and trans. (New York: Harcourt, Brace, and Company, 1942). Excerpts from Chapter I, "Word and Image," originally published as "Montage in 1938," *Iskusstvo Kino,* 1939, no. 1, pp. 37–49, and reprinted in Lev Kuleshov, *Fundamentals of Film Direction,* 1941. Copyright 1942, 1947 by Harcourt Brace Jovanovich, Inc., renewed 1970, 1975 by Jay Leyda. Reprinted by permission of the publisher.

Note: Chapters 1–4 of *Film Sense* all appeared, under different titles, in various issues of *Iskusstvo Kino,* 1939–1941.

to a state of tameness, in company with men and women who had fled there with their children.

And the fields which were covered with water had their waves covered over in great part with tables, bedsteads, boats and various other kinds of rafts, improvised through necessity and fear of death,

upon which were men and women with their children, massed together and uttering various cries and lamentations, dismayed by the fury of the winds which were causing the waters to roll over and over in mighty hurricane, bearing with them the bodies of the drowned;

and there was no object that floated on the water but was covered with various different animals who had made truce and stood huddled together in terror, among them wolves, foxes, snakes and creatures of every kind, fugitives from death.

And all the waves that beat against their sides were striking them with repeated blows from the various bodies of the drowned, and the blows were killing those in whom life remained.

Some groups of men you might have seen with weapons in their hands defending the tiny footholds that remained to them from the lions and wolves and beasts of prey which sought safety there.

Ah, what dreadful tumults one heard resounding through the gloomy air, smitten by the fury of the thunder and the lightning it flashed forth, which sped through it, bearing ruin, striking down whatever withstood its course!

Ah, how many might you have seen stopping their ears with their hands in order to shut out the loud uproar caused through the darkened air by the fury of the winds mingled together with the rain, the thunder of the heavens and the raging of the thunderbolts!

Others were not content to shut their eyes but placing their hands over them, one above the other, would cover them more tightly in order not to see the pitiless slaughter made of the human race by the wrath of God.

Ah me, how many lamentations!

How many in their terror flung themselves down from the rocks! You might have seen huge branches of the giant oaks laden with men borne along through the air by the fury of the impetuous winds.

How many boats were capsized and lying, some whole, others broken in pieces, on the top of men struggling to escape with acts and gestures of despair which foretold an awful death.

Others with frenzied acts were taking their own lives, in despair of ever being able to endure such anguish;

some of these were flinging themselves down from the lofty rocks,

others strangled themselves with their own hands;

some seized hold of their own children,

and with mighty violence slew them at one blow;

some turned their arms against themselves to wound and slay; others falling upon their knees were commending themselves to God.

Alas! how many mothers were bewailing their drowned sons, holding them upon their knees, lifting up open arms to heaven, and with divers cries and shrieks declaiming against the anger of the gods!

Others with hands clenched and fingers locked together gnawed and devoured them with bites that ran blood, crouching down so that their breasts touched their knees in their intense and intolerable agony.

Herds of animals, such as horses, oxen, goats, sheep, were to be seen already hemmed in by the waters and left isolated upon the high peaks of the mountains, all huddling together,

and those in the middle climbing to the top and treading on the others, and waging fierce battles with each other, and many of them dying from want of food.

And the birds had already begun to settle upon men and other animals, no longer finding any land left unsubmerged which was not covered with living creatures.

Already had hunger, the minister of death, taken away their life from the greater number of animals, when the dead bodies already becoming lighter began to rise from out the bottom of the deep waters, and emerged to the surface among the contending waves; and there lay beating one against another, and as balls puffed up with wind rebound

back from the spot where they strike, these fell back and lay upon the other dead bodies.

And above these horrors the atmosphere was seen covered with murky clouds that were rent by the jagged course of the raging thunderbolts of heaven, which flashed light hither and thither amid the obscurity of the darkness.[1]

The foregoing was not intended by its author as a poem or literary sketch. Péladan, the editor of the French edition of Leonardo's *Trattata della Pittura*, regards this description as an unrealized plan for a picture, which would have been an unsurpassed "chef d'œuvre of landscape and the representation of elemental struggles."[2] None the less the description is not a chaos but is executed in accordance with features that are characteristic rather of the "temporal" than of the "spatial" arts.

Without appraising in detail the structure of this extraordinary "shooting-script," we must point, however, to the fact that the description follows a quite definite *movement*. Moreover, *the course of this movement* is not in the least fortuitous. The movement follows a definite order, and then, in corresponding *reverse order*, returns to phenomena matching those of the opening. Beginning with a description of the heavens, the picture ends with a similar description, but considerably increased in intensity. Occupying the center is the group of humans and their experiences; the scene develops from the heavens to the humans, and from the humans to the heavens, passing groups of animals. The details of largest scale (the close-ups) are found in the center, at the climax of the description (" . . . *hands clenched and fingers locked together . . . bites that ran blood . . .*"). In perfect clarity emerge the typical elements of a montage composition.

The content within each frame of the separate scenes is enforced by the increasing intensity in the action.

Let us consider what we may call the "animal theme": animals trying to escape; animals borne by the flood; animals drowning; animals struggling with human beings; animals fighting one another; the carcasses of drowned animals floating to the surface. Or the progressive disappearance of terra firma from under the feet of the people, animals, birds, reaching its culmination at the point where the birds are forced to settle on the humans and animals, not finding any unsubmerged and unoccupied land. This passage forcibly recalls to us that the distribution of details in a picture on a single plane also presumes movement—a compositionally directed

[1]*The Notebooks of Leonardo da Vinci,* arranged and rendered into English by Edward MacCurdy (Garden City, N.J.: Garden City Publishing Company, 1941). The broken arrangement of this passage represents Eisenstein's adaptation into script form.

[2]Leonardo da Vinci, *Traité de la Peinture* (Paris: Delagrave, 1921). Footnote by Joséphin Péladan, p. 181.

movement of the eyes from one phenomenon to another. Here, of course, movement is expressed less directly than in the film, where the eye *cannot* discern the succession of the sequence of details in any other order than that established by him who determines the order of the montage.

Unquestionably though, Leonardo's exceedingly sequential description fulfills the task not of merely listing the details, but of outlining the trajectory of the future movement of the attention over the surface of the canvas. Here we see a brilliant example of how, in the apparently static simultaneous "co-existence" of details in an immobile picture, there has yet been applied exactly the same montage selection, there is exactly the same ordered succession in the juxtaposition of details, as in those arts that include the time factor.

Montage has a realistic significance when the separate pieces produce, in juxtaposition, the generality, the synthesis of one's theme. This is the image, incorporating the theme.

Turning from this definition to the creative process, we shall see that it proceeds in the following manner. Before the inner vision, before the perception of the creator, hovers a given image, emotionally embodying his theme. The task that confronts him is to transform this image into a few basic *partial representations* which, in their combination and juxtaposition, shall evoke in the consciousness and feelings of the spectator, reader, or auditor, that same initial general image which originally hovered before the creative artist.

21

Françoise Gilot

PICASSO AT WORK

PICASSO DOMINATES THE HISTORY of twentieth-century art. Innovative painter, sculptor, printmaker, his works and his almost equally fascinating life have been the subjects of innumerable studies and memoirs.

Pablo Ruiz Picasso was born in Spain in 1881, son of an art teacher. Legends have grown up about his youth as they have about the childhoods of great artists of the past (see Vasari, Chapter 11). Some of them are even true. For example, his precocious talent is well documented. Picasso at age 14 really did complete the entrance examination for the Barcelona College of Art in one day—an exam for which the school allowed a full month.

In 1900 Picasso left Spain for the first time. Paris provided his introduction to modern art—the Impressionists and Post-Impressionists. He made intermittent trips to Spain over the next years but lived most of the time in France. Eventually, political events confirmed his French residence even more strongly. The Spanish Civil War (1936–1939), which brought Franco and his Fascists to power in Picasso's homeland, made him a true exile.

Picasso's long life and continued vigor again remind us of some of the great artists of the past, such as Michelangelo and Titian. He continued to work until his death at 92 (1973), producing in his last years paintings and prints that seemed to flow from a bottomless well of invention. Neither his creative force nor his appetite for life ever left him. It seems that he could not imagine dying: he left no will, and, as a result, disputes over his estate took years to settle.

One aspect of Picasso's life rivals the excitement of his works in popular imagination. Beginning in 1904, a series of beautiful, intelligent, young women shared his life and appear in his art. Picasso repeatedly fell in love with women in their early twenties—and of course each time the difference between his age and his lover's increased.

In the 1930s Picasso's woman was Dora Maar, herself a painter. Dora appears as many of the violently distorted female heads Picasso painted between 1936 and 1944. His agony over Spain's suffering under Franco, and then of France under Nazi rule, must have motivated the angular and torn bodies we see also in works like *Guernica* (1937). Some observers suggest that Picasso's troubled relationship with Dora, together with his realization that he was no longer young, contributed to the violence and hostility in his depictions of her face. For the first time Picasso turned to the theme of the old artist and his young model, as if mocking himself.

Picasso began seeing the lovely young painter Françoise Gilot while he was still involved with Dora. His image of her differs radically from his depictions of Dora. From the first he saw Françoise as a creature of symmetry and hence stability. A suggestion of the classicism that had inspired some of his works in the early twenties reappears. Françoise is shown with an oval face, sparkling eyes, smooth contours.

La Femme Fleur [Figure 20] was painted in May, 1946, soon after Françoise had agreed to live with Picasso. Picasso had equated the flower with the idea of women, and more particularly with the female sex organs, years before. According to Penrose, his biographer,[1] the comparison dates to 1901. It is in any case not an unfamiliar idea in Western culture.

Now Picasso celebrated his new amorous passion by painting Françoise as a flower. According to Penrose he "saw her as a woman or a flower or the sun with her face as the source of light." It is appropriate that Picasso recalled a suggestion made by his old friend and rival, Henri Matisse (1869–1954). Matisse was above all a great colorist. His suggestion that Françoise should be painted with green hair coincides perfectly with the botanical motif Picasso sought.

Françoise left Picasso in 1953: she is supposed to have said that she did not wish to spend the rest of her life with a historic monument. Picasso made a series of mocking images in which a dried-up old artist (he was now 72) contemplates a young model. In 1955 Jacqueline Roque became his companion and presided over his household until his death.

Despite the acrimonious parting, Françoise writes as an intelligent and involved observer whose artistic training enables her to record telling details of the artist at work. It is clear from her recollections that Picasso "thought with brush in hand" (cf. Rubens, Chapter 15, page 167). Although Picasso is known to have worked at great speed, *La Femme Fleur* took about a month to complete; all the preliminary sketches are underneath the finished painting we see today.

[1]Roland Penrose, *Picasso, His Life and Work,* third edition (Berkeley, Calif.: University of California Press, 1981).

Françoise also brings Picasso to life by her precise description of his idiosyncracies. Each artist has his own way of arranging a palette, of mixing paints, of testing out new ideas. Now we can see how Picasso accomplished the mechanics of painting at this time in his life. The remarks that Françoise attributes to Picasso may not have been said exactly as they appear in her memoir, but they certainly do convey the nature of his thoughts. It was a happy moment in his life, and in hers, and we can now learn how that moment was immortalized in *La Femme Fleur*.

From
Life with Picasso

He began to paint the portrait of me that has come to be called *La Femme Fleur*.[1] [Figure 20] I asked him if it would bother him to have me watch him as he worked on it.

"By no means," he said. "In fact I'm sure it will help me, even though I don't need you to pose."

Over the next month I watched him paint, alternating between that portrait and several still lifes. He used no palette. At his right was a small table covered with newspapers and three or four large cans filled with brushes standing in turpentine. Every time he took a brush he wiped it off on the newspapers, which were a jungle of coloured smudges and slashes. Whenever he wanted pure colour, he squeezed some from a tube on to the newspaper. From time to time he would mix small quantities of colour on the paper. At his feet and around the base of the easel were cans—mostly tomato cans of various sizes—that held greys and neutral tones and other colours which he had previously mixed.

He stood before the canvas for three or four hours at a stretch. He made almost no superfluous gestures. I asked him if it didn't tire him to stand so long in one spot. He shook his head.

"No," he said. "That's why painters live so long. While I work I leave my body outside the door, the way Moslems take off their shoes before entering the mosque."

Occasionally he walked to the other end of the atelier and sat in a wicker armchair with a high Gothic back that appears in many of his paintings. He would cross his legs, plant one elbow on his knee and, resting his chin on his fist, the other hand behind, would stay there studying the painting without speaking for as long as an hour. After that he would generally go back to work on the portrait. Sometimes he would say, "I can't carry that plastic idea any further today," and then begin work on another

Françoise Gilot, with Carlton Lake, *Life with Picasso* (New York: McGraw-Hill, 1964). Excerpt pp. 116–19. Reprinted by permission of McGraw-Hill Book Company, New York, and Laurence Pollinger Ltd., London. Also reprinted in Marilyn McCully, *A Picasso Anthology: Documents, Criticism, Reminiscences* (Princeton, N.J.: Princeton University Press, 1982) pp. 229–33.

[1]Z. XIV. 167. (The reference is to Christian Zervos, *Picasso*, Cahiers d'Art, Paris: 1932–1978. Catalogue of Picasso's works. [BW])

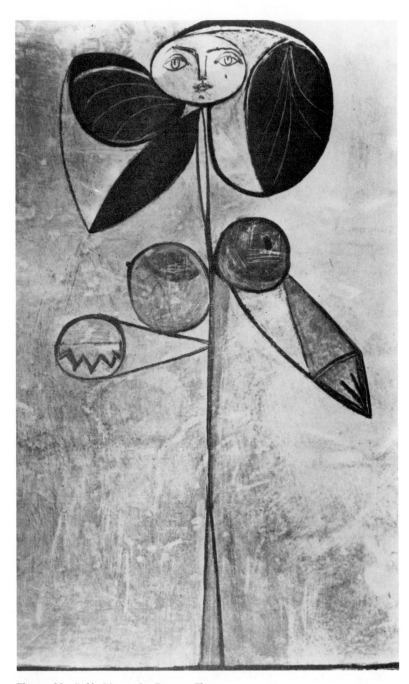

Figure 20 *Pablo Picasso*, La Femme Fleur.
Photo: Arts Council of Great Britain.

painting. He always had several half-dry unfinished canvases to choose from. He worked like that from two in the afternoon until eleven in the evening before stopping to eat.

There was total silence in the atelier, broken only by Pablo's monologues or an occasional conversation; never an interruption from the world outside. When daylight began to fade from the canvas, he switched on two spotlights and everything but the picture surface fell away into the shadows.

"There must be darkness everywhere except on the canvas, so that the painter becomes hypnotized by his own work and paints almost as though he were in a trance," he said. "He must stay as close as possible to his own inner world if he wants to transcend the limitations his reason is always trying to impose on him."

Originally, *La Femme Fleur* was a fairly realistic portrait of a seated woman. You can still see the underpainting of that form beneath the final version. I was sitting on a long, curved African tabouret shaped something like a conch shell and Pablo painted me there in a generally realistic manner. After working a while he said, "No it's just not your style. A realistic portrait wouldn't represent you at all." Then he tried to do the tabouret in another rhythm, since it was curved, but that didn't work out either. "I don't see you seated," he said. "You're not at all the passive type. I only see you standing," and he began to simplify my figure by making it longer. Suddenly he remembered that Matisse had spoken of doing my portrait with green hair and he fell in with that suggestion. "Matisse isn't the only one who can paint you with green hair," he said. From that point the hair developed into a leaf form and once he had done that, the portrait resolved itself in a symbolic floral pattern. He worked in the breasts with the same curving rhythm.

The face had remained quite realistic all during these phases. It seemed out of character with the rest. He studied it for a moment. "I have to bring in the face on the basis of another idea," he said, "not by continuing the lines of the forms that are already there and the space around them. Even though you have a fairly long oval face, what I need, in order to show its light and its expression, is to make a wide oval. I'll compensate for the length by making it a cold colour—blue. It will be like a little blue moon."

He painted a sheet of paper sky-blue and began to cut out oval shapes corresponding in varying degrees to this concept of my head: first, two that were perfectly round, then three or four more based on his idea of doing it in width. When he had finished cutting them out, he drew in, on each of them, little signs for the eyes, nose, and mouth. Then he pinned them on to the canvas, one after another, moving each one a little to the left or right, up or down, as it suited him. None seemed really appropriate until he reached the last one. Having tried all the others in various spots, he knew

where he wanted it, and when he applied it to the canvas, the form seemed exactly right just where he put it. It was completely convincing. He stuck it to the damp canvas, stood aside and said, "Now it's your portrait." He marked the contour lightly in charcoal, took off the paper, then painted in, slowly and carefully, exactly what was drawn on the paper. When that was finished, he didn't touch the head again. From there he was carried along by the mood of the situation to feel that the torso itself could be much smaller than he had first made it. He covered the original torso by a second one, narrow and stemlike, as a kind of imaginative fantasy that would lead one to believe that this woman might be ever so much smaller than most.

He had painted my right hand holding a circular form cut by a horizontal line. He pointed to it and said, "That hand holds the earth, half-land, half-water, in the tradition of classical paintings in which the subject is holding or handling a globe. I put that in to rhyme with the two circles of the breasts. Of course, the breasts are not symmetrical; nothing ever is. Every woman has two arms, two legs, two breasts, which may in real life be more or less symmetrical, but in painting, they shouldn't be shown to have any similarity. In a naturalistic painting, it's the gesture that one arm or the other makes that differentiates them. They're drawn according to what they're doing. I individualize them by the different forms I give them, so that there often seems to be no relationship between them. From these differing forms one can infer that there is a gesture. But it isn't the gesture that determines the form. The form exists in its own right. Here I've made a circle for the end of the right arm, because the left arm ends in a triangle and a right arm is completely different from a left arm, just as a circle is different from a triangle. And the circle in the right hand rhymes with the circular form of the breast. In real life one arm bears more relation to the other arm than it does to a breast, but that has nothing to do with painting."

Originally the left arm was much larger and had more of a leaf shape, but Pablo found it too heavy and decided it couldn't stay that way. The right arm first came out of the hair, as though it were falling. After studying it for a while, he said, "A falling form is never beautiful. Besides, it isn't in harmony with the rhythm of your nature. I need to find something that stays up in the air." Then he drew the arm extended from the centre of the body stem, ending in a circle. As he did it, he said, half-facetiously, lest I take him too seriously, "You see now, a woman holds the whole world— heaven and earth—in her hand." I noticed often at that period that his pictorial decisions were made half for plastic reasons, half for symbolic ones. Or sometimes for plastic reasons that stemmed from symbolic ones, rather hidden, but accessible once you understood his humour.

In the beginning the hair was divided in a more evenly balanced way, with a large bun hanging down on the right side. He removed that because he found it too symmetrical. "I want an equilibrium you can grab for and catch hold of, not one that sits there, ready-made, waiting for you. I want to

get it just the way a juggler reaches out for a ball," he said. "I like nature, but I want her proportions to be supple and free, not fixed. When I was a child, I often had a dream that used to frighten me greatly. I dreamed that my legs and arms grew to an enormous size and then shrank back just as much in the other direction. And all around me, in my dream, I saw other people going through the same transformations, getting huge or very tiny. I felt terribly anguished every time I dreamed about that." When he told me that, I understood the origin of those many paintings and drawings he did in the early 1920s, which show women with huge hands and legs and sometimes very small heads: nudes, bathers, maternity scenes, draped women sitting in armchairs or running on the beach, and occasionally male figures and gigantic infants. They had started through the recollection of those dreams and been carried on as a means of breaking the monotony of classical body forms.

When Pablo had finished the portrait he seemed satisfied. "We're all animals, more or less," he said, "and about three-quarters of the human race look like animals. But you don't. You're like a growing plant and I'd been wondering how I could get across the idea that you belong to the vegetable kingdom rather than the animal. I've never felt impelled to portray anyone else this way. It's strange, isn't it? I think it's just right, though. It represents *you*."

22

Rosalind E. Krauss

TOTEM, FIGURE, AND FORM IN THE WORK OF DAVID SMITH

DAVID SMITH (1906–1965) WAS an American sculptor whose contribution to twentieth-century art is equivalent to that of painters like Jackson Pollock. Smith began his career as a painter, studying at the Art Student's League in New York until 1932. In the 1930s he began to add three dimensional materials to the surfaces of his paintings. His increasingly three dimensional work contributed to breaking down the boundaries between sculpture and painting.

Smith is responsible for making or exploiting many technical innovations. Fortuitously, he had worked as a welder in a locomotive factory (a craft he used again in the defense industry during the Second World War). His industrial experience helped him develop new methods such as assemblage (putting together sculpture out of separate or "found" parts) and welding. The working of the material and the finish or surface of his metalwork were always important to him. Smith also explored sculpture as an open structure, a "drawing in space," with an open, sketchy, quality foreign to traditional methods. He began the process of separating sculpture from a base that controlled and as it were framed the work, leading the way to the environmental pieces of the next generation of artists.

A hundred years earlier, Baudelaire had called upon the artists of his day to abandon historical costumes and scenes and discover the world around them. Now in the middle of the twentieth century works like Smith's suggested another step. They gave rise to the idea that artists should use the materials and methods characteristic of their own time, as well as themes (no longer necessarily representations) appropriate to the

current day. As Sam Hunter of the Museum of Modern Art wrote in 1957, "Traditional sculptural forms no longer can tell us enough about the texture and sensations of modern experience. The very use of metals, with their industrial associations, puts the artist in a direct relationship with his actual environment."[1] Hunter's words reflect the experiences of artists like Smith who by then had been using modern materials for a decade.

Smith, however, was not just an exploiter of novelty. He used new forms to express ideas that were important to him—above all, ideas in the realms of politics and of psychology. In the 1930s he had stood apart from social realist forms of protest art, but incorporated similar content in his early sculpture. He drew from varied European sources, including Cubism and Surrealism. Psychology, history, and an interest in the nonwestern world led him to the idea of the *totem*—art as symbol and as sacred object—in the great sculpture series of the 1950s where we can watch his concepts developing from one work to the next.

The newest materials and methods were used for ideas like the totem that are associated with ancient and tribal societies: a paradoxical idea. Smith's sculpture is at once the most modern and the most primitive. This paradox is resolved in Krauss's essay by relating Smith's ideas to a great modern construct, Freudian psychological theory. Krauss explains Freud's use of the idea of the totem and Smith's adoption of those ideas in his powerful suggestions of human form.

Krauss's essay does not stop with an analysis of Smith's iconographic sources in psychology and mythology, however. Her intent is to show us how the composition of Smith's work functions "to translate the taboos of totemism into the language of form." A brilliant description of Smith's *Blackburn* enables us to reach a deeper understanding of the artist's achievement.

Krauss is an historian specializing in modern art, and an authority on Smith, whose work as a whole forms the subject of the monograph cited in her notes. Because they deal with art that is being made in the present, historians of modern art cannot fall back on the "judgment of the ages." They must function as critics performing the historian's traditional tasks of describing and explaining the work of the artist. Krauss, like Baudelaire, must both arouse interest in new art and stimulate our appreciation of it. In this essay she succeeds.

[1]Sam Hunter, *Irons in the Fire* (Exhibition Catalogue, Houston, Contemporary Arts Museum, Oct. 17–Dec. 1, 1957). Introduction (unpaged). Quoted in Wayne Anderson, *American Sculpture in Process: 1930/1970* (Boston: New York Graphic Society; Little, Brown; 1957).

From
Passages in Modern Sculpture

In 1950 David Smith constructed *Tanktotem I*. . . . Suspending two disklike elements on a tall, vertical stem, *Tanktotem I* earns its title by conjuring up the image of the human figure. . . .

Tanktotem I was the first of a long series to which Smith gave the designation "totem." As is true of every object in the series, the work locates itself at a strange border halfway between the human figure and the abstract sign.

In these two respects—the interest in the totem and the treatment of matter to create an emblem or sign—Smith's work is intimately tied into the concerns of the generation of American artists of which he was a part—the abstract-expressionists. At some time in their careers, generally early on, most of Smith's contemporaries, sculptors and painters alike, made objects which they either labeled "totem" or gave titles that indirectly indicated a concern with totem practice. One thinks of the sculptors Louise Nevelson, David Hare, Seymour Lipton, Isamu Noguchi, and Louise Bourgeois in this connection and of the painters Jackson Pollock, Adolph Gottlieb, Mark Rothko, Clyfford Still, and Barnett Newman. Especially among the painters one finds an abiding concern with the emblem; for Rothko and Gottlieb, the emblem as such became a basis for their mature painting—in that they composed their works by suspending a simple, frontalized shape in a neutral, undifferentiated space. Like other more familiar emblems—the red cross, for example, or hazard indicators along a highway— the emblem in their work makes no direct formal contact with the edges of the field on which it occurs. Furthermore, the emblem is understood as resting on the surface of that field, and unlike representational images, which may depict real objects at a scale that is larger or smaller than the one they actually have, the emblem stubbornly exists at the scale in which it literally manifests itself and in the material of which it is made.

All these qualities—frontality, centralization, and literal size and surface—characterize the developed work of most of the abstract-ex-

Rosalind E. Krauss, *Passages in Modern Sculpture* (New York: Viking Press, 1977). Excerpts from Chapter 5, "Tanktotem: Welded Images," pp. 147–66. Copyright © 1977 by Rosalind E. Krauss. Reprinted by permission of Viking Penguin Inc.

pressionist painters; even those who, like Pollock and Newman, eventually dropped some of these emblematic features continued to work with the most central aspect of the sign or emblem. And that is its mode of address. For while we can think of a traditional picture or a photograph as creating a relationship between author and object that exists independent of an audience, addressing no one in particular, we must think of a sign or emblem as existing specifically in relation to a receiver. It takes the form of a directive addressed *to* someone, a directive that exists, so to speak, in the space of confrontation between the sign or emblem and the one who views it.

David Smith's exposure to surrealism in the 1930s and 1940s called his attention both to a sculpture concerned with a strategy of confrontation and to a subject matter involving such magical objects as fetishes and totems. . . . But like his painter contemporaries, Smith entirely reworked these sources. Out of them he fashioned a sculptural statement that became a *formal* counterpart to what Smith saw as the essence of totemism itself. Thus the form of his work and the notion of the totem became two interlocking and reciprocal metaphors which pointed to the same thing: a statement about how the work could not be possessed.[1] To see how this operated one must turn first to what Smith understood as the structure of totemism, and then to the kind of formal expression with which it unfolded in his work. . . .

Given Smith's interest in the work of Freud, it is probable that his view of totemism was drawn primarily from *Totem and Taboo,* a text that insistently tied primitive practices into the modern structure of relationships as they were described by psychoanalysis. . . .

Briefly, Freud described the way totemism operated within primitive cultures as a system to outlaw incest, by insuring that members of a given tribe or clan would not marry or cohabitate with each other, but would be forced to seek partners outside their own tribal families. Each tribe would identify itself with a particular totem object—usually an animal—and each tribe member would take on the name of that object so that man and totem were one. Once that identification was made, the laws that applied to the totem animal logically applied to the human bearer of its name. And these laws, the taboos, were mostly prohibitory, protecting the totem and making it inviolate. The totem was not only established as a sacred or venerated object; it was also set apart from all other objects that could be physically appropriated. Usually the chosen animal could not be killed or eaten, or even touched. For some tribes, the taboo extended as far as prohibiting a tribesman's approaching or even looking at the totem. Since the tribesmen and women carried the name of the totem as well, the laws of taboo, by

[1]For a more detailed discussion of Smith's work see Rosalind Krauss, *Terminal Iron Works: The Sculpture of David Smith* (Cambridge: MIT Press, 1971).

extension, applied to themselves, making incestuous union a direct violation of the tribal law. Freud saw in totemism the manifestation of a particular desire coupled with a system of preventing its consummation.

In Smith's eyes, this structuring of the relationship between two members of a set so that the appropriation or violation of the one by the other is outlawed became important during the 1940s for both personal and political reasons. World War II was raging, and Smith identified its carnage in the sexual and cannibalistic terms that made totemism suddenly relevant. What then began to take place within Smith's art was the formulation of a sculptural strategy to translate the taboos of totemism into a language of form. And the goal of this formal endeavor seems to have been to contravert the by-then established transactions between viewer and sculptural object, which, as we have seen, had developed into a system of either intellectual appropriation as in constructivism or sensuous possession as in the work of Henry Moore.

By 1949–50 Smith had consolidated this formal language. In a work called *Blackburn: Song of an Irish Blacksmith,* [Figures 21, 22] he describes the

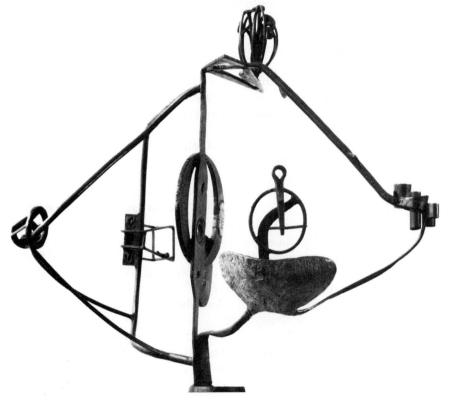

Figure 21 *David Smith,* Song of an Irish Blacksmith, *front view. Wilhelm Lehmbruck Museum, Duisburg.*
Photo copyright Bernd Kirtz. Reproduced by permission.

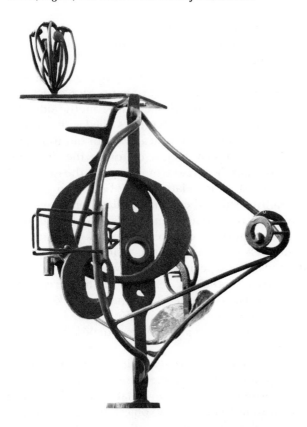

Figure 22 *David Smith,* Song of an Irish Blacksmith, *side
view. Wilhelm Lehmbruck Museum, Duisburg.*
Photo copyright Bernd Kirtz. Reproduced by permission.

human figure in a sculptural syntax that one might call a grammar of
extreme visual disjunction. This disjunction depends on the fact that the
two major views of the work—full-front [Figure 21] and profile [Figure
22]—cannot be related to each other through the constructivist mode of
internal transparency that had become the major resource for abstract
sculptural composition over the preceding four decades. . . . *Blackburn* pro-
jects its front image of the human torso as a kind of open frame, in which
all sculptural detail appears to be pushed to the peripheries of the work,
leaving its interior an open void through which the eye easily passes to the
space beyond. From this view the work reads as a hieratic image of the
human figure, frontalized, nearly symmetrical, noncorporeal—the body
reduced to a silhouette of bent steel rod. The open space, or absence of its
interior, contrasts with the mechanistic steel elements (cotter pins, hinge
sections) that meet at points along its exterior rim. . . . [T]he full-face view
of *Blackburn* is completely unrevealing. It does not prepare the viewer to
experience the object's other perspectives, its other sides. Prediction about

those other views simply cannot occur in *Blackburn.* The sculptor seems to have turned his back on the obsessive concern with information we have seen in other constructed sculpture.

If the side view of *Blackburn* cannot be calculated from the front, this is because the side view contains a whole complex of expression which the front face of the work has both negated and disdained. From the side, the interior of the torso is noisy with figurative incident; it is filled with a clutter of metal shape, like a shelf in a machine shop heaped with old tools and new parts. Densely packed with a jagged overlay of forms, the side view gives the effect of agitated confusion, whereas from the front the torso had appeared serene and uncluttered. The relationship of head to body is different on each side as well. Instead of the frontal declaration of symmetry, there is on the side an eccentric displacement of the head that underscores the rich tension generated by the profile of the work. Confronted by the profile of *Blackburn* one feels that one is not so much seeing another *view* of the work, as that one is almost seeing another work.

From the time of *Blackburn* to the last years of Smith's career, the same formal and thematic concerns continued to shape his works. . . . In *Blackburn,* Smith rejects . . . formal continuity, substituting for it a sensation of schismatic break between one facet and the next, depending on the principle of radical *discontinuity.*

It is by insisting upon the discontinuity that Smith captures and incorporates into *Blackburn* the fundamental law of totemism, rather than merely resuscitating the surface primitivism of its original forms. Totemism worked to establish laws of distance between the object and its viewer, to create taboos against the possible appropriation of both totem and its human counterpart, to maintain the tabooed object as something apart. By refusing to endow the work with the inevitability of formal relationships we saw in constructivism—by which sculpture was delivered over to the spectator's intellectual grasp—Smith announces his own aesthetic separateness. . . .

The sign, perhaps even the success, of Smith's creation of a formal language that would act to thwart the surrealist impulses toward possession, was that Smith's mature work was for so long understood as purely abstract sculpture. Throughout the 1950s and 1960s his major pieces appeared, to others, to be nonrepresentational,[2] which seems to have been

[2]Clement Greenberg wrote that "Smith returned periodically to the scheme—not so much the forms or contours—of the human figure as though to a base of operations." However, Greenberg viewed much of the late work as escaping direct figurative reference. Of the 1961 *Zig IV,* Greenberg said, "In it he escapes entirely from allusions to the natural world (which includes man) that abound elsewhere in his art." (See Greenberg, "David Smith," *Art in America,* LIV, January–February 1966, pp. 32 and 28, respectively.) Yet *Zig IV* is as referential as anything else in Smith's oeuvre. It extends yet another theme that grew within his art over a period of three decades: the theme of the phallic canon.

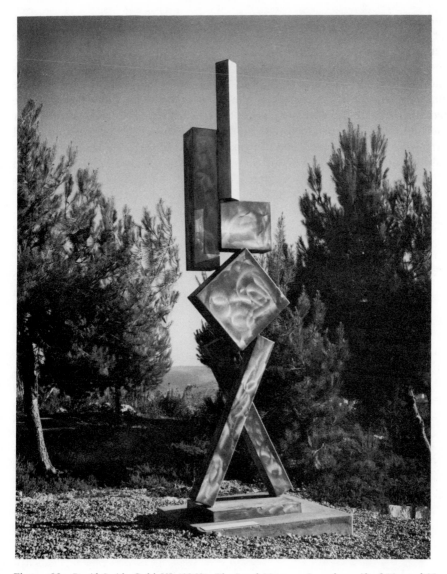

Figure 23　*David Smith,* Cubi VI *(1963). The Israel Museum, Jerusalem, gift of Mr. and Mrs. Meshulam Riblis, New York.*
Reproduced by permission of the Israel Museum.

caused by a heightening of the principle of discontinuity. The discontinuity that exists between the separate views of *Blackburn* began to work within any given view, to disrupt the coherence between separate elements, to prevent the viewer from seeing them coalesce into a recognizable image. For a long time this is the way the *Cubis* were read—that last series in which

Smith assembled monumental sculpture from building blocks which he fabricated of gleaming stainless steel. The broad, planar surfaces of these sculptures glinted with the meandering tracks of a carborundum wheel, and radiated a world of optical defraction, a sense of the image submerged and lost beneath a web of burnished line. Critics were tempted to draw an analogy between the surfaces of the *Cubis* and the imageless painting of Jackson Pollock. But *Cubi VI* [Figure 23] is not abstract. It clearly continues the theme of the upright totem figure, using the glitter of the burnished surface as one more resource to insure a sense of formal distance between viewer and object. . . .

INDEX